Opt Art

Robert Bosch

ART

From Mathematical Optimization to Visual Design

PRINCETON UNIVERSITY PRESS
Princeton and Oxford

Published by Princeton University Press
41 William Street, Princeton, New Jersey 08540
6 Oxford Street, Woodstock, Oxfordshire OX20 1TR

press.princeton.edu

Library of Congress Control Number: 2019931240
ISBN 978-0-691-16406-9

British Library Cataloging-in-Publication Data is available

Editorial: Vickie Kearn, Susannah Shoemaker, and Lauren Bucca
Production Editorial: Mark Bellis
Text and Jacket Design: Chris Ferrante
Production: Jacqueline Poirier
Publicity: Sara Henning-Stout and Kathryn Stevens
Copyeditor: Alison Durham

Jacket and frontispiece credit: Robert Bosch, Leonardo's *Mona Lisa*,
54 complete sets of double-nine dominos, 2019

This book has been composed in STIX fonts, Gotham, and Alternate Gothic

Printed on acid-free paper. ∞

Printed in the United States of America

10 9 8 7 6 5 4 3 2 1

The more constraints one imposes, the more one frees one's self of the chains that shackle the spirit.

IGOR STRAVINSKY

CONTENTS

PREFACE

This book is an account of my ongoing research into how mathematical and computer-science-based optimization techniques can be used to design visual artwork. It contains many equations and inequalities, but all of them are linear, which are the simplest and easiest to understand. It also contains hundreds of images, the vast majority of which I created using the techniques described within.

At the end of the book, there is a long list of references for anyone who wishes to delve deeper into more technical writings on the subject. Many chapters grew out of articles I've written for the Bridges Math/Art conference series and for the Journal of Mathematics and the Arts.

I have benefited enormously from my collaborations with many wonderful, brilliant, and creative people: Kurt Anstreicher, Derek Bosch, Tim Chartier, Martin Chlond, Robert Fathauer, Craig Kaplan, Robert Lang, Doug McKenna, Henry Segerman, Michael Trick, Tom Wexler, and my current and former students Melanie Hart Buehler, Michael Cardiff, Abagael Cheng, Adrienne Herman Cohen, Urchin Colley, Sarah Fries, Gwyneth Hughes, Sage Jenson, Aaron Kreiner, Nikrad Mahdi, Julia Olivieri, Andrew Pike, Mäneka Puligandla, Karen Ressler, Michael Rowan, Harry Rubin-Falcone, Rachael Schwartz, Ari Smith, Jason Smith, Natasha Stout, Elbert Tsai, and Zhifu Xiao.

I am immensely grateful for my colleagues at Oberlin College—its faculty, staff, and students—and my friends in the Bridges and Gathering for Gardner (G4G) communities. I am equally grateful to William Cook's Concorde team and Gurobi Optimization for allowing me to use their extraordinary software packages, and to Vickie Kearn, Susannah Shoemaker, Lauren Bucca, and the rest of the terrific team at Princeton University Press (Mark Bellis, Elizabeth Blazejewski, Alison Durham, Chris Ferrante, Sara Henning-Stout, Dimitri Karetnikov, Meghan Kanabay, Katie Lewis, Jacquie Poirier, Kathryn Stevens, Erin Suydam,

and Matthew Taylor) for their expertise, enthusiasm, and patience. Without Oberlin College, Bridges, G4G, Concorde, Gurobi, and PUP, I wouldn't have been able to carry out this project.

I couldn't have even envisioned this project if I hadn't encountered the work of Ken Knowlton, computer graphics pioneer and mosaicist extraordinaire. His domino mosaics blew me away when I first encountered them at age 17, and again at age 21, and then a third time at age 37, when I finally realized that I had acquired the mathematical tools to be able to make them myself.

I wouldn't have had the confidence to commit myself to this project if I hadn't met Annalisa Crannell and Marc Frantz and participated in their 2005 Viewpoints workshop at Franklin and Marshall College.

And I wouldn't have kept at this project without the encouragement of those who commissioned artwork; exhibited my pieces; invited me to give talks or workshops; conversed with me about mathematics, art, or writing; asked me questions that pushed me to dive deeper; evaluated portions of the manuscript; or just told me to keep going. So thank you to the Bosch and Fried families, to Jim and Debbi Walsh, to Laura Albert, Roger Antonsen, Pau Atela, Julie Beier, Nick Bennett, Sharon Blecher, Gail Burton, Case Conover, Bill Cook, Randy Coleman and Rebecca Cross, Simon Ever-Hale, Gwen Fisher, Julian Fleron, Nat Friedman, Joey Gonzalez-Dones, Susan Goldstine, Henry Lionni Guss, James Gyre, George Hart, Allison Henrich, Judy Holdener, Jerry Johnson, Ava Keating, Josh Laison, Cindy Lawrence, Erin McAdams, Doug McKenna, Colm Mulcahy, Mike Naylor, James Peake, Jennifer Quinn, Dana Randall, Reza Sarhangi, J. Cole Smith, David Swart, David Stull, Eve Torrence, Mike Trick, John Watkins, Carolyn Yackel, and the seven anonymous reviewers of my book proposal and manuscript.

This book has been a labor of love, and like most labors of love, it has been fueled by love: the love of my mother, Charlotte Woebcke Bosch (1933–2016); the love of my brother, Derek Bosch; the love of my son, Dima Bosch; and most especially, the love of my best friend, wife, soul mate, and unending source of inspiration, Kathy Bosch.

Opt Art

CHAPTER 1

Optimization and the Visual Arts?

Optimization is the branch of mathematics and computer science concerned with optimal performance, with finding the best way to complete a task. As such, it is extremely applicable, as everyone from time to time attempts to perform some task at the highest level possible. A UPS driver, for instance, may sequence their stops to minimize total distance traveled, time spent on the road, fuel costs, pollutant emissions, or even the number of left turns. Finding an optimal tour, or at least one that is close to optimal, will benefit not only the driver and UPS, but also their customers (through lower prices) and the rest of society (through reduced pollution).

Some optimization problems are easy, while others are extremely difficult. Which is the case depends in large part on the *constraints*—the rules, the restrictions, the limitations—that specify the underlying task. If every stop on the UPS driver's list falls on the same thoroughfare, then finding the optimal route—and proving it to be optimal—is trivial. But if the city is filled with one-way streets, the stops are scattered throughout the city, and some stops must be made during specified time windows, then determining how to perform this task at a high level can require considerable algorithmic ingenuity and computing power.

Optimization has been put to good use in a great number of diverse disciplines: from advertising, agriculture, biology, business, economics, and engineering to manufacturing, medicine, telecommunications, and transportation (to name but a few). Numerous excellent books describe these important, practical applications, and if you turn to the bibliography, you will find my favorites.

The book you hold in your hands is quite different. It is a highly personal account of my more than sixteen-year-long obsession with using mathematical and computer-science-based optimization techniques to create visual artwork. As obsessions go, it is a harmless one, and not

nearly as strange as it sounds! Within these pages, I will provide evidence that supports a bold claim: that the mathematical optimizer and the artist have more similarities than differences.

The mathematical optimizer studies problems that involve optimizing—that is, maximizing or minimizing—some quantity of interest (profit or total cost, for example, in business applications). The optimizer's goal is to come up with an optimal solution—perhaps a way of making the profit as large as possible or the total cost as low as possible. In some cases, the optimizer will be satisfied with a *local optimum*, a solution that is better than all neighboring solutions. If you find a local optimum, you can be confident that when you present it to the board, no one sitting there will be able to improve upon your solution by making minor tweaks to it. But in other cases, the optimizer will not rest until they find a *global optimum*, a solution that is provably better than every other solution. If you find a global optimum, you will be able to get a good night's sleep before the board meeting, for you will be certain that no one there—or anywhere—will be able to find a solution that is better than yours.

The artist is also a problem solver and a seeker of high-quality solutions. The creation of a piece of artwork can be considered a problem to be solved. And isn't it difficult to imagine an artist who, when creating a piece, does *not* try to do their best? For some small number of artists, the goal may be to maximize profit, but for most, the goal may be to make the piece as beautiful as possible, or to have as great an emotional impact on viewers as possible. Beauty and emotional impact are impossible to quantify, but haven't we all been in the presence of the critic, the museum-goer, or the gallery-opening shmoozer who in a burst of enthusiasm blurts out something like, "Don't you just *love* this piece? Don't you think that if the artist had added anything more to it, or had left anything out, it would have failed to have the same impact?" (an assertion, to the mathematical optimizer, about local optimality).

Mathematical optimizers are mindful of the roles that constraints play. They know that in some cases, if they impose additional constraints on an optimization problem, the problem will become much more difficult, but in other cases it will become considerably easier. Some constraints seem to be structured in such a way that in their presence, algorithms have trouble working their way to the best part of the *feasible region* (the set of all feasible solutions—the solutions that satisfy all the constraints), whereas

other constraints provide the equivalent of handholds and toeholds that form an easily traversed path to optimality.

Artists are similarly mindful. Artists are well aware that they must deal with constraints. They must work within budgets. They must meet deadlines. If they enter competitions or juried shows, they must make sure that their pieces satisfy the rules of entry. If they take commissions, they must follow their clients' instructions. And no matter what media they choose to work with, they must deal with the particular constraints—imposed by the laws of physics—that govern how those media work. Painting with watercolors is different from painting with oils, and painting on rice paper is different from painting on canvas.

So, given that artists are creative, we might think that if it were up to them, they would do away with constraints. After all, constraints *constrain*. They restrict. They limit our choices. It would seem that constraints inhibit creativity.

But actually there is much evidence to the contrary. Many artists embrace constraints. Some need deadlines to be able to finish their work, and some believe that when their choices are limited, they are much more focused and creative. Joseph Heller (while paraphrasing T. S. Eliot) wrote,

> When forced to work within a strict framework the imagination is taxed to its utmost—and will produce its richest ideas.

And the psychologist Rollo May wrote,

> Creativity arises out of the tension between spontaneity and limitations, the latter (like the river banks) forcing the spontaneity into the various forms which are essential to the work of art or poem.

In fact, many artists go so far as to create their own constraints. Consider George-Pierre Seurat. While viewing his painting *A Sunday on La Grande Jatte–1884* from up close, one sees a mass of colorful dots. While backing away from it, one's eyes merge all of the dots into an image of a group of Parisians relaxing on an island on the Seine. To create this masterpiece, Seurat set himself the task of producing the best possible depiction of what he saw on the riverbank, subject to two highly restrictive, self-imposed constraints: he had to keep his colors separate,

and he could only apply paint to the canvas with tiny, precise, dot-like brush strokes. Seurat's self-imposed constraints gave rise to a spectacular piece of artwork, the most widely reproduced example of what we now call Pointillism.

In the mosaicking arena, self-imposed constraints abound. Every time a mosaicist states, "I will build a mosaic out of _____," another self-imposed constraint is born (or at least conceived). In 400 BCE, the ancient Greeks were building mosaics out of differently colored pebbles, and around 200 BCE, they started building them out of specially man-ufactured tiles (tesserae) made out of ceramic, stone, or glass. Today's mosaicists still use these traditional materials, but they also use whatever else they have on hand: dice, dominos, LEGO bricks, Rubik's Cubes, toy cars, spools of thread, baseball cards, photographs, and even individual frames of films like *Star Wars* and *It's a Wonderful Life*.

Some mosaicists like to go beyond the inherent materials constraints. The domino mosaics of Ken Knowlton, Donald Knuth, and myself are not only made out of dominos, they are made out of *complete sets* of dominos. Knowlton's *Joseph Scala (Domino Player)* (from 1981) was made out of 24 complete sets of double-nine dominos, so it contains 24 dominos of each type: exactly 24 blank dominos, exactly 24 zero-one dominos, and so on. My domino portrait of President Obama, the 44th president of the United States, uses 44 complete sets. Knowlton's portrait of Helen Keller is composed of the 64 characters of the Braille writing system, and each of these characters appears 16 times. Chris Jordan's *Denali/Denial* mosaic arranges 24,000 (digitally altered) logos from the GMC Yukon Denali sports utility vehicle (six weeks of sales in 2004) into an image of Denali (also known as Mount McKinley). And a Robert Silvers photomosaic, commissioned by *Newsweek* for its 1997 pictures-of-the-year issue, portrays the late Princess Diana as a mosaic formed from thousands of photographs of flowers. All of these artists use com-puter software—usually computer programs that they have developed themselves—to design their mosaics.

In theory, you can design a photomosaic without software. You can take the senior portrait photos from your high-school yearbook, cut them out, and then arrange them in a rectangular grid so that from a distance, they will collectively resemble a photo of your favorite teacher. This is possible—some of the photos will be brighter and others will be darker. But you will need a good eye to assess the brightness of each

photo, and even then, you will have a tough time determining the best position for each photo. Likewise, you can make a domino mosaic without software—by printing the target image on a large piece of paper and then placing dominos on top of the print, saving the brightest dominos (the nine-nines) for the brightest sections and the darkest dominos (the zero-zeros or blanks) for the darkest sections. Here, though it is clear which dominos are brighter than others, it still will be difficult to determine where to place each domino.

With mathematical optimization it is quite easy to design photomosaics, and it isn't all that difficult to design domino mosaics. With mathematical optimization, the artist/mathematician (or mathematician/artist) can explore all manner of constraints systems. This book is an account of my explorations of this world.

CHAPTER 2

Truchet Tiles

Father Sébastien Truchet (1657–1729) entered the Carmelite order at age 17 and impressed his superiors with a genius for all things mechanical. Sent to Paris to further his education, the brilliant Truchet drew the attention of Louis XIV's men after Charles II of England had given the French king two watches and neither the Sun King nor his royal watchmaker could open them. The then-19-year-old Truchet was consulted, and he quickly discovered how to work the mechanism and repair the damage caused by the previous attempts at unlocking it.

For this success, Louis XIV awarded Truchet a sizable pension, which enabled him to throw himself completely into the study of "first the geometry necessary for the theory of mechanics and even anatomy and chemistry, neglecting nothing of what might be useful with respect to machines." And by the time of his death, Truchet was known both as France's foremost expert in hydraulics engineering and as a prodigious inventor. At the request of Louis XIV, he had worked on the aqueduct system of Versailles and had been involved in the construction of, or repair of, most of the French canals. One of his inventions was a machine that could transport whole trees without damaging them. Another, a team effort, was the infinitely scalable Romain du Roi typeface.

But today Truchet is not remembered for these great accomplishments. Instead he is known for a set of tiles, displayed in figure 2.1,

 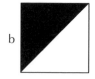 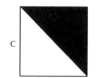 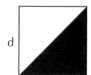

a b c d

Figure 2.1: Truchet tiles.

that caught his eye while he was in the city of Orleans inspecting canals.

At first glance it is surprising that these simple square tiles, each divided by a diagonal into a white half and a black half, not only captured the attention of Truchet's brilliant mind, but then held it long enough to inspire him to write an article, "Mémoire sur les combinaisons," and submit it for publication in the most prestigious academic journal of his time, *Memoires de l'Académie Royale de Sciences*, in 1704. But Truchet's article makes it clear that his fascination was less with the tiles themselves than with how they can be combined to form larger patterns. He devoted the bulk of the article to beautifully engraved plates that display "the fecundity of these combinations, the origin of which is nevertheless so very simple."

Figure 2.2 reproduces four of Truchet's patterns, along with the labels he gave them. Pattern A uses only tiles of type a, so we can say that pattern A is generated by tile a, and we can express this by writing $A = (a)$. Pattern C is a checkerboard formed from tiles of types a and c. Its odd numbered rows begin

$$a \quad c \quad a \quad c \quad \dots,$$

and its even numbered rows begin

$$c \quad a \quad c \quad a \quad \dots.$$

If we focus our attention on 2-by-2 blocks of tiles, starting at the top-left corner, we see that pattern C is generated by the 2-by-2 block $\left(\begin{smallmatrix} a & c \\ c & a \end{smallmatrix} \right)$. We can express this by writing $C = \left(\begin{smallmatrix} a & c \\ c & a \end{smallmatrix} \right)$. Like C, pattern D has a 2-by-2 generator, but unlike C it uses all four types of tiles. We can write pattern D as $D = \left(\begin{smallmatrix} b & a \\ c & d \end{smallmatrix} \right)$. Pattern E has a 4-by-4 generator.

Truchet's article displays 26 additional patterns, ordered by increasing complexity, and a 1722 book written by his Carmelite colleague Father Dominique Doüat shows many more. Doüat's pattern 72, reproduced in figure 2.3, is much busier than Truchet's patterns A, C, D, and E. Part of the reason is that it has a much larger generator, a 12-by-12 block of tiles.

Doüat was absolutely enthralled by Truchet's tiles. He titled his book *Methode pour fair une infinité de desseins différens, avec des carreaux mi-partis de deux couleurs par une ligne diagonale* (Method for making

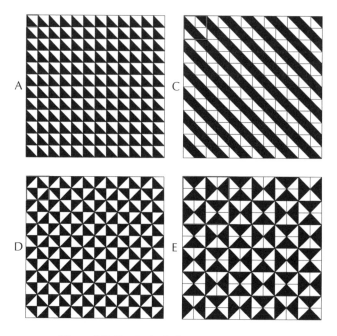

Figure 2.2: Truchet's designs *A*, *C*, *D*, and *E*.

Figure 2.3: Doüat's pattern 72.

an infinite number of different designs with squares divided into two colors by a diagonal line). In the preface he could not contain his excitement, exclaiming, "In this book you will find an inexhaustible source of designs for paving churches and other buildings, for tiling floors, and for making beautiful compartments. The painter will find inspiration. Marquetry workers, carpenters, marble cutters, and all other workers will find it very useful. Embroiderers, upholsterers, weavers—all those who work on canvas or use the needle—will learn to make beautiful works."

I completely agree with Doüat. Truchet's tiles are indeed wonderful for creating abstract patterns. I would be thrilled to have either of

Figure 2.4: A modified digital reproduction of a 1726 engraving by Henri-Simon Thomassin entitled *Portrait of Father Sébastien Truchet*, which was itself based on a painting by Elisabeth Cheron le Hay.

Truchet's patterns D and E on the floor of my kitchen, and I would be eager to patronize a hotel that was bold enough to install Doüat's pattern 72 in its lobby.

But at the same time I must mention that Truchet's tiles are not well suited for making figurative mosaics that resemble grayscale target images, an obsession of mine and one of the main topics of this book. By design, each Truchet tile is half white and half black, so any mosaic formed from the tiles will also be half white and half black. When viewed from a distance, any mosaic formed from Truchet tiles is likely to look like nothing other than a gray rectangle. If we want to make a mosaic that resembles Truchet himself (see figure 2.4)—and I certainly do!— we will need to use a different set of tiles, a set of tiles that has additional brightness values.

The Target Image

As shown in figure 2.5, for each pixel of a grayscale target image, there is an integer between 0 and 255 that indicates how bright the pixel is, with 0 corresponding to black, 255 to white, and intermediate values to various other shades of gray. (In base 2, the number 255 is written as 11111111_2, making it the largest integer that can be stored with one byte—eight bits—of computer memory.)

If we have enough space to make an enormous mosaic, we can select a tile for each individual pixel. Usually though, we downsample—we partition the pixels into $k \times k$ blocks (here, $k = 3$) and select a tile for each block.

We use ordered pairs to refer to the blocks. Block (i, j) is the block in row i and column j. To measure how bright block (i, j) is, we compute the average of its pixels' grayscale values and then divide the average by 255. This gives us a *block brightness* value $\beta_{i,j}$ that falls somewhere in the closed interval $[0, 1]$. As before, 0 corresponds to black, but now 1 corresponds to white.

For block $(32, 34)$, the block in the upper-left corner of the part of the image that corresponds to Truchet's left eye, the average grayscale value is 154.11, so $\beta_{32,34} = 154.11/255 = 0.60$. For block $(36, 39)$, in the opposite corner, the average grayscale value is 241.67, so $\beta_{36,39} = 241.67/255 = 0.95$. In other words, block $(32, 34)$ is somewhat brighter

	34	35	36	37	38	39
	154 159 197	196 211 230	229 245 253	253 249 250	244 229 227	211 192 192
32	144 147 175	176 179 183	182 195 201	201 211 215	213 207 207	201 194 194
	131 133 147	149 136 121	120 128 132	133 161 168	171 179 181	188 197 198
	131 133 148	149 135 118	117 125 130	131 161 168	171 182 183	192 201 203
33	125 124 111	112 104 94	93 94 93	94 118 124	124 125 124	135 145 146
	124 120 92	93 88 82	82 78 76	76 97 103	101 97 96	106 118 119
	125 122 93	94 88 82	82 77 76	76 96 101	99 96 95	106 118 119
34	178 173 132	132 120 104	105 85 76	75 72 72	72 73 71	98 125 127
	196 190 145	144 131 113	114 87 75	75 64 62	63 65 63	95 127 129
	198 193 148	148 132 111	112 90 80	80 70 68	72 81 80	114 149 152
35	209 204 160	161 138 110	110 98 94	94 86 82	94 122 125	167 213 216
	212 206 162	162 138 107	106 96 93	92 85 81	94 128 132	178 226 230
	212 208 178	179 160 135	134 137 139	139 134 131	141 168 170	203 240 243
36	212 210 198	199 184 166	165 182 189	190 188 186	193 213 215	235 253 254
	212 211 199	201 186 168	166 185 193	193 192 189	197 216 218	238 254 255

Figure 2.5: Grayscale values.

than the midrange half-black–half-white gray, and block $(36, 39)$ is quite bright—close to pure white.

Flexible Truchet Tiles

As mentioned before, each Truchet tile is half black and half white. Accordingly, and because we consider black to be 0 and white to be 1, we assign to each tile a *tile brightness* value of 0.5. By doing this, we are using area to define tile brightness, setting

$$tile\ brightness = 0 \cdot \text{AREA(black)} + 1 \cdot \text{AREA(white)},$$

which simplifies to

$$tile\ brightness = \text{AREA(white)},$$

where AREA(black) stands for the area of the black region and AREA(white) stands for the area of the white region. We use the \cdot symbol for multiplication, and we assume that the total area of the square tile is 1.

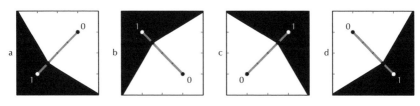

Figure 2.6: Flexible Truchet tiles with AREA(white) = 0.625.

To introduce a continuum of additional brightness values, some below 0.5 and others above 0.5, we allow ourselves to flex or bend the diagonal line that separates the black and white regions. By flexing the diagonal so that its midpoint moves into the black region, as shown in figure 2.6, we simultaneously increase AREA(white) and decrease AREA(black). This makes the tile as a whole appear brighter. If we were to move the midpoint into the white region, we would achieve the opposite effect.

We refer to these modified tiles as *flexible Truchet tiles*. In the diagrams, the light gray lines are sliders—they show the continuum of possible locations for the midpoint of the diagonal. In each tile, the slider's black endpoint shows the location that results in the tile being as dark as we allow, and the slider's white endpoint shows the location that results in the tiles being as bright as we allow. Note that we do not let the midpoint of the diagonal slide all the way to the corners. Our black and white endpoints lie halfway between the center of the square and its corners, ensuring that every tile, no matter how it is flexed, will have sizable black and white regions. We want the viewer to consider the flexed tile to be a modification of a Truchet tile, and we want them to be able to identify the flexed tile as an *a*, *b*, *c*, or *d*.

In each orientation we consider the black and white endpoints to be reference points for the midpoint of the diagonal. We think of the black endpoint as location 0 and the white endpoint as location 1. Having reference points enables us to specify the location of the midpoint with a single number t. In each of the figure 2.6 tiles, the midpoint is in location $t = 0.75$, three-quarters of the way toward the white endpoint of the slider, which results in AREA(white) = 0.625.

In figure 2.7 we see the effect of changing the location of the midpoint. When $t = 0$, the type *c* tile has been flexed into the darkest state we allow, with AREA(white) = 0.25. When $t = 0.25$, the tile is

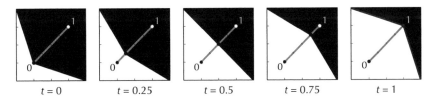

$t = 0$	$t = 0.25$	$t = 0.5$	$t = 0.75$	$t = 1$

Figure 2.7: Flexing the type c tile.

slightly brighter, and it turns out that AREA(white) = 0.375. When $t = 0.5$, the tile is in its unflexed position and has AREA(white) = 0.5. When $t = 0.75$, the tile is even brighter, and as was mentioned earlier, AREA(white) = 0.625. Finally, when $t = 1$, the tile is as bright as we allow, with AREA(white) = 0.75.

For each such diagram we can create an ordered pair (x, y) by setting x equal to the value of t and y equal to the corresponding AREA(white). If we plot y versus x (we won't do it here, but you can do it yourself, or you can treat it as a thought experiment), we find that the points lie on the line that has equation $y = 0.5x + 0.25$. So the relationship between AREA(white) and t, the location of the tile's midpoint, can be expressed as

$$\text{AREA(white)} = 0.25 + 0.5t.$$

This equation is extremely useful. It tells us that for any block with a midrange brightness value—any block (i, j) whose $\beta_{i,j}$ value lies in the interval $[0.25, 0.75]$—there is a flexible Truchet tile that is perfect for that block in terms of brightness. In fact, we can find this optimal t value—the best possible t value for the $\beta_{i,j}$ value—by solving the following equation for t:

$$0.25 + 0.5t = \beta_{i,j}.$$

This equation simply states what we've already said, but in a slightly different way. We know what the left-hand side is: it is just another way of writing AREA(white). So the equation is saying that we want AREA(white) to equal $\beta_{i,j}$. But now recall our tile brightness equation. The brightness of a tile equals the area of its white region. So we can interpret the equation as saying that the brightness of our flexible Truchet tile must equal $\beta_{i,j}$, the brightness of the block.

By performing the algebra (multiplying both sides of the equation by 2 and then subtracting 0.5 from each side), we find that for a midrange block, the optimal value of t is given by $t = 2\beta_{i,j} - 0.5$. For a dark block (one with $\beta_{i,j} < 0.25$), the algebra would yield a negative value for t (forbidden!), so the best we can do is to use $t = 0$, which corresponds to making the tile as dark as we allow. For a bright block (one with $\beta_{i,j} > 0.75$), the algebra would give a value greater than 1 (also forbidden!), so the best we can do is to use $t = 1$, which corresponds to making the tile as bright as we allow.

In summary, we obtain the optimal value of t (designated t^*) by setting

$$t^* = \begin{cases} 0 & \text{if} & \beta_{i,j} < 0.25, \\ 2\beta_{i,j} - 0.5 & \text{if} & 0.25 \leq \beta_{i,j} \leq 0.75, \\ 1 & \text{if} & 0.75 < \beta_{i,j}. \end{cases}$$

By following this procedure over and over again, block by block, it is easy to make a mosaic (figure 2.8) that blends together a grayscale target image and an orientation pattern.

From afar, viewers will be able to recognize the target image, but will be unable to see the individual tiles or to identify the pattern. Up close, viewers will be able to examine the individual tiles and spot the pattern, but will lose a sense of the target image. From an intermediate distance, they will be able to see both.

Figure 2.9 shows four more examples based on the same target image. Each mosaic has the same t values and consequently the same tile brightness values as the others. This means that given the constraints, each one is optimal—a best possible flexible-Truchet-tile mosaic—in terms of how closely it matches the brightness values of the Truchet target image.

Because the mosaics have identical brightness values, their differences in appearance are due to their orientation patterns. The size of the generator (highlighted in red) clearly has an impact on the mosaic's readability. Our visual systems have an easy time processing small generators. But larger generators require greater effort to make sense of, as do random or otherwise non-repeating generators. A pattern conflict arises, pitting a single comprehensible image against its individual pattern elements.

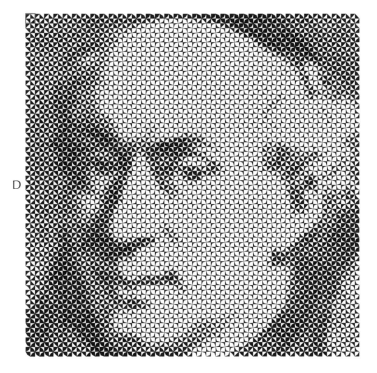

D

Figure 2.8: Truchet from flexible Truchet tiles.

Mathematical Modeling

For our introductory example, we needed only a little bit of optimization. For each block (i, j) of the target image, we had to determine how to bend the diagonal of the corresponding flexible Truchet tile. Our goal was to make the brightness of the tile as close as possible to the brightness of the block. We argued that if t denotes the location of the midpoint of the diagonal, then the optimal location t^* is given by

$$t^* = \begin{cases} 0 & \text{if} & \beta_{i,j} < 0.25, \\ 2\beta_{i,j} - 0.5 & \text{if} & 0.25 \leq \beta_{i,j} \leq 0.75, \\ 1 & \text{if} & 0.75 < \beta_{i,j}. \end{cases}$$

If you have taken a calculus course—and this is where the vast majority of us have our first encounter with mathematical optimization—you might be wondering how the above fits in with what you learned in that

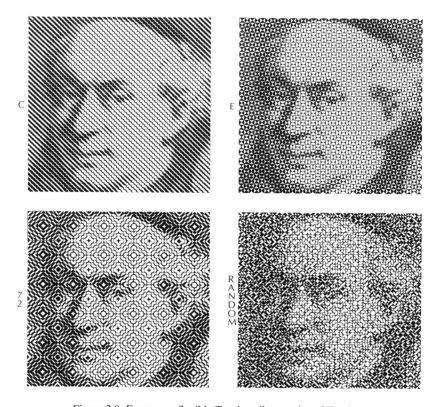

Figure 2.9: Four more flexible-Truchet-tile mosaics of Truchet.

class. To the student of calculus, optimization problems are phrased like this:

$$\text{minimize} \quad f(x)$$

$$\text{subject to} \quad a \leq x \leq b,$$

where f is a *function* of x, a "mathematical machine" that takes as input a real number x and produces as output a number denoted $f(x)$. For example, if $f(x) = (x - 0.95)^2$, then the function f takes as input a number x, subtracts the number 0.95 from it, and then squares the result. In this case, if we plug in $x = 0.25$ we get

$$f(x) = f(0.25) = (0.25 - 0.95)^2 = (-0.7)^2 = 0.49,$$

and if we plug in $x = 0.75$ we get

$$f(x) = f(0.75) = (0.75 - 0.95)^2 = (-0.2)^2 = 0.04.$$

In a calculus course, during the unit on optimization problems, students routinely come across "applied" problems like the following one:

The Guinea Pig Problem

Dima owns two guinea pigs, and he wants to build them an outdoor exercise pen. Dima's guinea pig guidebook says that each pig requires 8 square feet of space. Being thrifty, Dima wants to minimize the cost of building the 16-square-foot pen. If suitable fencing material costs $1 per linear foot and a town ordinance mandates rectangular guinea pig pens, what should Dima do?

We teach students to tackle the oft-dreaded "word problem" by rewriting it in mathematical notation, instructing them to coax the problem into either the "minimize $f(x)$ subject to $a \leq x \leq b$" template or the related maximization form. This can be difficult. There is no easy-to-follow step-by-step process for converting a real-world problem into a mathematical model, an abstract simplification of reality. Mathematical modeling requires deep thinking. It requires us to determine which features of the real-world problem are important and which can be safely ignored.

Usually in a calculus course (at least in a first-semester course), once we have managed to put the problem into the desired form, the hard work is done. The second step is to select an appropriate technique for finding a solution to the mathematical problem and then to execute the necessary steps in mechanical fashion, behaving as if we are computers. For example, we might begin by forming $f'(x)$, the derivative of $f(x)$, so that we can set $f'(x)$ equal to 0 and find all values of x that satisfy the equation $f'(x) = 0$, the so-called critical numbers.

There is a third step, although sometimes it is skipped or glossed over. Once we have obtained a solution to the mathematical problem, we should examine it and ask ourselves if it makes sense in the context of the original setting. If the solution seems odd, or even ridiculous, then either we made a mistake when finding the solution (maybe we found a "solution" that is not really a solution) or we made a mistake when constructing our model (maybe we made an assumption that we shouldn't have made or ignored some feature that we shouldn't have ignored).

In this book we will be doing a great deal of mathematical modeling, but we will focus on the first and third steps, the steps that must be performed by a human being.

Modeling the Guinea Pig Problem

Here the task is to build a rectangular pen. As there are two unknowns—the length and the width of the pen—we need two *variables*. We let x denote the length and y denote the width. We measure both of them in feet.

Dima wants to minimize the cost of the fencing. Because the fencing material is $1 per linear foot, the cost of the fencing in dollars will equal the perimeter of the pen in feet, which is twice the sum of its length and width. Thus, in terms of the variables, Dima wants to minimize $2x + 2y$.

Converting this into the desired format requires that we get rid of one of the variables. Fortunately, we know that the area of the pen must be 16 square feet. This allows us to write $xy = 16$ and then $y = 16/x$.

Expressing y in terms of x enables us to write the perimeter as a function of x. If the length of the pen is x, then the perimeter is $2x + 32/x$. So here the *objective function*, the function we want to minimize, is $f(x) = 2x + 32/x$.

Are there constraints? Is there any limit on how small x can be? Is there any limit on how large x can be? Well, if we care only about the mathematics, then we will end up deciding that we need to ensure only that x is positive. But if we also care about Dima's guinea pigs, we will realize that we cannot allow the length of the pen to get arbitrarily close to 0. Perhaps we should consult a guinea pig expert and ask how narrow we can make the pen. To proceed we will pretend that we have done this and that the answer we received was half a foot. If this is the case, then we must ensure that $0.5 \leq x \leq 32$. (We enforce $x \leq 32$ to keep $y \geq 0.5$.)

Putting all of this together gives us the following mathematical model for determining the best length for the pen:

$$\text{minimize} \quad 2x + 32/x$$
$$\text{subject to} \quad 0.5 \leq x \leq 32.$$

At this point, we have completed the first step of the mathematical modeling process, converting the real-world problem into a mathematical model.

The second step is to solve the model. If you want to solve it, you can use calculus or you can graph the objective function (for example, by plotting a bunch of ordered pairs (x, y) where $y = 2x + 32/x$). Regardless of what method you use, you will find that the optimal length is $x^* = 4$.

The third step is to examine the solution. Does it make sense? Would it be a good idea to have the length be 4 feet? Well, if the length were 4 feet, then the width would be 4 feet too. The area would be $4 \cdot 4 = 16$ square feet, as desired. The perimeter would be $2(4 + 4) = 16$ linear feet, so Dima would have to spend \$16 on the pen. Could he do better? It turns out that the answer is no. A square pen is a "happy medium" between the two extremes—a 0.5 by 32 foot pen and a 32 by 0.5 foot pen. These long narrow pens have a perimeter of 65 linear feet, so they would cost over four times more than the square pen.

Modeling the Tile Bending Problem

When we design a flexible-Truchet-tile mosaic, our task for block (i, j) is to determine how much to bend the diagonal of the tile that corresponds to block (i, j). We bend the diagonal by moving its midpoint along the slider that extends from the black endpoint (location 0) to the white endpoint (location 1), and we use t to specify the yet-to-be-determined location of the midpoint. So our task for block (i, j) can be converted into a single-variable optimization problem.

Here, there is just one constraint: to keep the midpoint of the diagonal on its slider, all we need to do is make sure that $0 \leq t \leq 1$. To enable ourselves to select the best possible value for t, we need an objective function.

We begin by calculating the difference between the brightness value of the tile (in our notation $0.25 + 0.5t$) and the brightness value of the block (in our notation $\beta_{i,j}$). A statistician might call this difference a brightness deviation, or a deviation for short. A positive deviation would tell us that our tile is too bright. A negative deviation would tell us that our tile is too dark. We would like the deviation to be zero, or if not zero, close to zero. In other words, our goal is to make the magnitude of the deviation as small as possible. We can accomplish this by minimizing the squared deviation—by charging ourselves a penalty whenever we have either a positive or negative deviation from the ideal brightness value.

Putting all of this together we can now write down our mathematical model for determining the best way to bend block (i, j)'s diagonal:

$$\text{minimize} \quad \left[(0.25 + 0.5t) - \beta_{i,j}\right]^2$$

$$\text{subject to} \quad 0 \le t \le 1.$$

As with the guinea pig problem, we can use calculus or graphing to obtain the optimal solution,

$$t^* = \begin{cases} 0 & \text{if} & \beta_{i,j} < 0.25, \\ 2\beta_{i,j} - 0.5 & \text{if} & 0.25 \le \beta_{i,j} \le 0.75, \\ 1 & \text{if} & 0.75 < \beta_{i,j}. \end{cases}$$

Is this reasonable? We have already argued that this scheme does give the best solution. And we have already demonstrated that it can be used to construct beautiful mosaics. So yes!

Another Mosaicking System: Flexible Star Tiles

Figure 2.10 displays a collection of *flexible star tiles*, each in its unflexed half-black–half-white "home-base" position. To make a flexible star tile brighter, we do exactly what we did with the flexible Truchet tiles: we slide the gray points along their tracks (drawn in light gray) toward the white points. To make a tile darker, we slide the gray points along their tracks toward the black points. When we perform the sliding, we make sure we preserve the tile's rotational symmetry; that is, when we slide a tile's gray points, we slide all of them by the same amount and in the same direction.

If we divide our target image into a grid of square blocks of pixels, we can use the four-pointed tiles to make a flexible-star-tile mosaic that resembles the target image. We simply follow the same strategy we used with the flexible Truchet tiles: for block (i, j), we flex a four-pointed tile into the best possible position for $\beta_{i,j}$, the block brightness value for block (i, j).

If we prefer to work with a grid of equilateral triangles, we partition our target image into triangular blocks of pixels, compute their

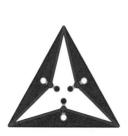 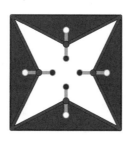

Figure 2.10: Three-pointed, four-pointed, and six-pointed flexible star tiles.

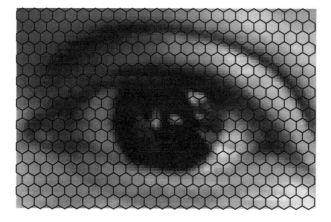

Figure 2.11: Imposing a hexagonal grid on a target image (a photo of my eye).

(triangular) block brightness values, and then, for each triangular block, flex a three-pointed tile into the best possible position for the block.

If we start with a grid of regular hexagons—a honeycomb tiling— we partition our target image into hexagonal blocks of pixels (as shown in figure 2.11), compute their block brightness values (as shown in figure 2.12), and then, for each hexagonal block, flex a six-pointed tile into the optimal position (as shown in figure 2.13).

And if we start with a semiregular (Archimedean) tiling, a tiling made up of several different types of regular polygons, we partition the target image into a variety of blocks—perhaps some of them triangles, some of them squares, and some of them hexagons—and then use a variety of flexible star tiles—some of them three pointed, some of them four pointed, and some of them six pointed.

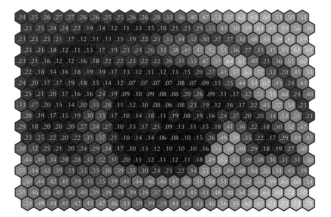

Figure 2.12: The resulting hexagonal block brightness values.

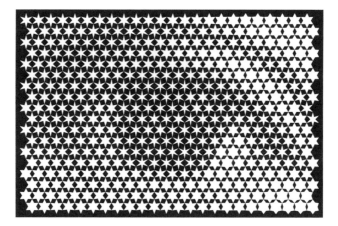

Figure 2.13: A hexagonal flexible-star-tile mosaic (*Starry Eyed*).

The left-hand side of figure 2.14 displays a flexible-star-tile mosaic based on a public-domain computer-generated image of the Milky Way galaxy. The right-hand side displays the underlying Archimedean tiling, the tiling known as "3.4.6.4" due to each vertex of the tiling being surrounded by a triangle, a square, a hexagon, and then another square in that order.

Figures 2.15 and 2.16 display two additional mosaics. Figure 2.15 is a portrait of Johannes Kepler (1571–1630). Though Kepler is best known for his work in astronomy, he also made important advances in geometry.

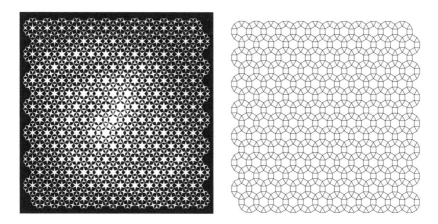

Figure 2.14: A flexible-star-tile mosaic and its underlying Archimedean tiling.

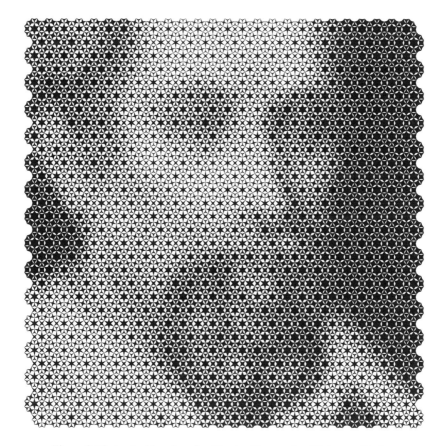

Figure 2.15: An Archimedean flexible-star-tile mosaic of Johannes Kepler.

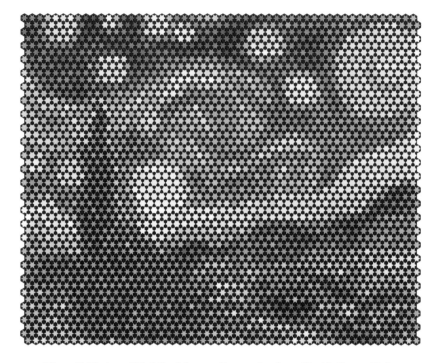

Figure 2.16: A modified-flexible-star-tile mosaic of van Gogh's *Starry Night*.

The small stellated dodecahedron and the great stellated dodecahedron are now known as *Kepler's star polyhedra*.

Like the Milky Way mosaic, the Kepler mosaic shown in figure 2.15 is based on the 3.4.6.4 Archimedean tiling. Here, though, the star tiles appear in inverted form, with black stars on a white background instead of white stars on a black background.

Figure 2.16 displays a modified-flexible-star-tile rendition of Vincent van Gogh's *Starry Night*. Here, all of the tiles are regular hexagons containing six-pointed stars, the points of the stars touch the midpoints of the edges of the hexagons (instead of the vertices), and the color of the star is obtained via averaging the RGB values of the underlying pixels of the target image. In a color image, each pixel is represented by an ordered triple (r, g, b), where r, g, and b are integers between 0 and 255 inclusive. The red value r measures how much red light the pixel emits, with 0 corresponding to none at all and 255 corresponding to the maximum possible. The green and blue values, g and b, have similar interpretations, but for green light and blue light. Consequently, $(255, 0, 0)$ stands for

red, $(0, 255, 0)$ for green, $(0, 0, 255)$ for blue, $(0, 0, 0)$ for black, and $(255, 255, 255)$ for white. Yellow, which emits the maximum amount of red and green light and no blue light whatsoever, is $(255, 255, 0)$.

Checkerboard Quadrilateral Tiles

Many additional "flextile" mosaicking systems are possible. In the previous examples—the flexible Truchet tiles and flexible star tiles—the amount of mathematical optimization required is minimal. For each block, whether it be square, triangular, or hexagonal, we need to solve a one-variable optimization problem to determine the best possible version of the tile for the block. None of these optimization problems depend on the others. Each can be done independently, in parallel if possible (or if desired).

Figure 2.17 displays output from a distinctly different system: a 2-by-2 arrangement of four *checkerboard quadrilateral tiles*. Each is formed by taking a square of one color (black or white) and placing within it a quadrilateral of the other color. Each quadrilateral has one vertex on each edge of its square. Each of these vertices can slide along its edge. The difficulty of using these tiles for mosaicking is that the right edge of a square is the left edge of the neighboring square on its right, and the bottom edge of a square is the top edge of the neighbor that lies beneath it. If we slide a tile's quadrilateral vertices to adjust the tile's brightness, we will end up making changes to the brightnesses of the neighboring tiles!

Still, with some more sophisticated mathematical optimization techniques, we can use checkerboard quadrilateral tiles to approximate target

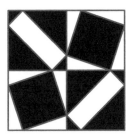

Figure 2.17: A 2-by-2 arrangement of four checkerboard quadrilateral tiles.

Figure 2.18: Two 10×10 checkerboard quadrilateral mosaics.

images. In chapter 10, we present one way of tackling this problem. For now, we provide the two example mosaics shown in figure 2.18. The one on the left is one of the darkest possible 10×10 checkerboard quadrilateral mosaics (given our self-imposed constraints that keep the sliders from getting too close to the corners), and the one on the right—its negative—is one of the brightest possible.

CHAPTER 3

Linear Optimization and the Lego Problem

A Danish furniture maker—we'll call him Lars—wants to do something different with his life. Although he is proud of his work, he has grown tired of spending so many hours in his workshop. He decides that now is the time to build one last batch of chairs and tables. He will then liquidate, buy a boat, and sail around the world.

Lars sells chairs for 8 kroner and tables for 11 kroner. To make them, he needs just two types of raw materials: SMALLS (two-by-two LEGO pieces) and LARGES (two-by-four LEGO pieces), as shown in figure 3.1. To make a chair, Lars uses a SMALL for the base, places a LARGE on top to form the seat, and then attaches one more SMALL to serve as the backrest. To make a table, Lars constructs a stack of two SMALLS to form a base. He then balances two LARGES on top of the base to form the tabletop.

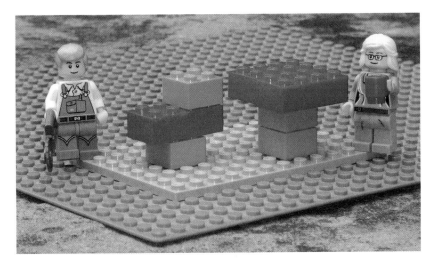

Figure 3.1: Lars, a chair, a table, and Luna.

The problem is this: If Lars has only 24 SMALLS and 18 LARGES on hand and does not want to purchase additional raw materials, how many chairs and tables should he make? (I have been using LEGO problems in my optimization classes for 20 years, ever since I came across an *ORMS Today* article on the subject by Norman Pendegraft.)

Lars's sister Luna, a mathematician, offers to help Lars in exchange for dinner at her favorite restaurant. During the main course, after pointing out that Lars's problem has two unknowns,

$$c = the\ number\ of\ chairs\ Lars\ should\ make$$

$$and\ \ t = the\ number\ of\ tables\ he\ should\ make,$$

Luna writes three equations on her napkin:

$$revenue = 8c + 11t, \qquad smalls = 2c + 2t, \qquad larges = c + 2t.$$

She then pauses to look at Lars. Lars nods. He recognizes that Luna's equations express the truth. Lars *knows* that Luna's equations are correct. He *knows* that if he makes c chairs and t tables, he will pull in $8c + 11t$ kroner, expend $2c + 2t$ of his SMALLS, and run through $c + 2t$ of his LARGES.

After dessert, Luna unveils her full mathematical model. She tells Lars that all they have to do is find the values of c and t that maximize the linear objective function

$$8c + 11t$$

subject to the linear constraints

$$2c + 2t \leq 24, \qquad c + 2t \leq 18, \qquad c \geq 0, \qquad t \geq 0.$$

Lars agrees that his sister's model captures all of the essential features of his problem. He does indeed want his revenue ($8c + 11t$) to be as large as possible, he definitely must ensure that his use of SMALLS ($2c + 2t$) and LARGES ($c + 2t$) does not exceed his supply (24 and 18 pieces, respectively), and he certainly cannot manufacture negative numbers of chairs and tables. His only question for Luna is this: How do we go about solving this mathematical model?

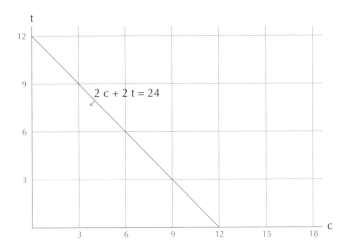

Figure 3.2: Luna's graph: axes and the SMALLS constraint.

While waiting for the waiter to bring coffee, Luna grabs Lars's napkin. She draws two axes. She labels the horizontal axis c and the vertical axis t, as shown in figure 3.2.

Stating that she's going to deal with the SMALLS constraint first, Luna sketches a line, labels it with the equation $2c + 2t = 24$, and attaches a small arrow to it. She says that a point (c, t) lies on the line if Lars would expend all 24 of his SMALLS in making c chairs and t tables. One such point is $(12, 0)$, which corresponds to Lars making 12 chairs and zero tables. Another one is $(0, 12)$, which corresponds to Lars making zero chairs and 12 tables.

And when the waiter finally brings the coffee, Luna ignores it in favor of continuing to work on her drawing.

Lars asks about the arrow, and Luna tells him that it points toward the feasible *half-space*, the region that corresponds to all options that are feasible with respect to the constraint. She asks him if it is possible, with what he has on hand, to make 6 chairs and 3 tables, and he immediately says yes, that doing so would use up only 18 of his 24 SMALLS and only 12 of his 18 LARGES. She mentions that we can see the first part of this from the drawing: the point $(6, 3)$ lies on the "good side" of the line, the half-space that includes the feasible solutions.

She includes a line for the LARGES constraint, labels it $c + 2t = 18$, and gives it an arrow that points toward its feasible half-space. She then

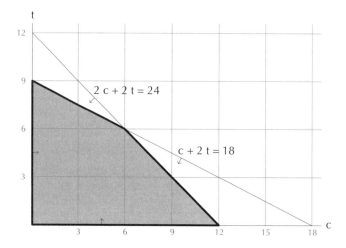

Figure 3.3: Luna's graph: the feasible region.

does the same for the two nonnegativity constraints, $c \geq 0$ and $t \geq 0$. Finally, she shades in the feasible region, the intersection of the four half-spaces. Figure 3.3 displays the current state of her drawing.

Reaching across the table, Lars yanks the pen out of Luna's hand. He smiles, tells her that her coffee is getting cold, and assures her that he's got it. Tracing the boundary, he states that the shaded polygon displays their options.

Luna beams. The final step, she says, is to plot the objective function, $8c + 11t$. This is done by picking any reasonable value and then setting the revenue equal to that value. For example, if we pick 66 (the revenue associated with making zero chairs and 6 tables), we get $8c + 11t = 66$.

Luna plots the lines corresponding to several of these revenue equations. She calls them contour lines. As shown in figure 3.4, they are parallel. As she draws more contour lines, she argues that *all* of the contour lines will be parallel. Because all of the revenue equations have the same c-coefficient (8) and the same t-coefficient (11), all of the corresponding revenue contour lines have the same slope ($-8/11$).

The waiter brings the check. Lars hands him his credit card and shoos him away. Turning toward Luna once again, Lars says that the drawing reminds him of a topographic map. The lines that form the boundary of the feasible region are like the borders of a national park. The revenue contour lines are like elevation lines. By following the contour lines, it is easy to locate the summit.

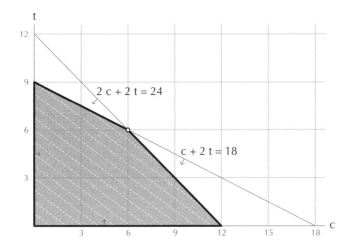

Figure 3.4: Luna's graph: some contour lines of the objective function.

Luna beams once more. She tells Lars that her branch of mathematics, optimization, is indeed very much like mountain climbing. Each problem can be thought of as a mountain. For Lars's problem, the summit is located at a vertex of the feasible region. This vertex, $(c^*, t^*) = (6, 6)$, specifies how many chairs and tables to make to bring in as much revenue as possible (here, 114 kroner).

Optimization is concerned with optimal performance—trying to perform a task as well as it can be performed. The task could be that of determining how many chairs and tables to make. It could be that of assigning employees to jobs (and as the chair of the local university's math department, Luna does need to decide which professors in her department will teach which courses). It could be that of finding the order in which a volunteer for a meals-on-wheels program should visit the houses on her list.

All of these problems can be modeled as linear optimization problems, problems that have a linear objective function and linear constraints.

More Products, More Variables

What if Lars makes not just chairs and tables but also *sofaborde* (Danish coffee tables)? If a sofabord sells for 15 kroner and requires two SMALLS placed side-by-side for the base and three LARGES arranged

side-by-side for the tabletop, then Luna's mathematical model can be written as

$$\text{maximize} \quad 8x_1 + 11x_2 + 15x_3$$
$$\text{subject to} \quad 2x_1 + 2x_2 + 2x_3 \leq 24,$$
$$x_1 + 2x_2 + 3x_3 \leq 18,$$
$$x_1, x_2, x_3 \geq 0.$$

Here, x_j stands for the number of units of product j that Lars should make; products 1, 2, and 3 are respectively chairs, tables, and sofaborde. We can solve this three-variable problem in the same way that Luna solved the two-variable problem. We begin by drawing three axes, one for each variable. Then we graph the constraints. The SMALLS constraint, $2x_1 + 2x_2 + 2x_3 \leq 24$, gives rise to a half-space—the plane that passes through the points $(12, 0, 0)$, $(0, 12, 0)$, and $(0, 0, 12)$, together with all points that lie beneath this plane. The LARGES constraint, $x_1 + 2x_2 + 3x_3 \leq 18$, gives rise to a second half-space, the plane through $(18, 0, 0)$, $(0, 9, 0)$, and $(0, 0, 6)$, as well as everything below it. The non-negativity constraints $x_1 \geq 0$, $x_2 \geq 0$, and $x_3 \geq 0$ yield three additional half-spaces. Figure 3.5 shows the graph.

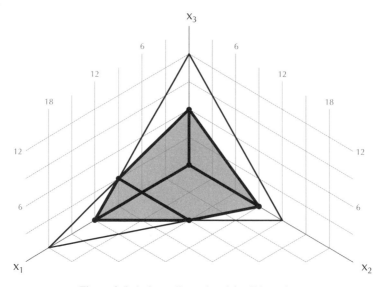

Figure 3.5: A three-dimensional feasible region.

As before, the feasible region is the intersection of the half-spaces, but here it is not a polygon but a polyhedron. This polyhedron has six vertices (corner points), nine edges (line segments that join adjacent vertices), and five faces (flat surfaces). Each face is a polygon. Consider the "bottom face" in figure 3.5, which consists of all of the points that satisfy $x_3 = 0$. This polygon happens to be—in fact, must be!—the feasible region for the two-product problem (the one with just chairs and tables).

As in the two-product case, the next step is to graph the contours of the revenue function, as in figure 3.6. Here, each contour $8x_1 + 11x_2 + 15x_3 = z$ is not a line but a plane that slices through the feasible region. As in the two-product two-variable example, all of the contours are parallel.

The origin $(0, 0, 0)$ is the trivial solution in which Lars does nothing and thus brings in $z = 0$ revenue. As z increases, the parallel contours corresponding to larger and larger revenue values lie farther and farther from the origin.

By following the contours outward, we discover the optimal solution, which happens to be the vertex $(x_1^*, x_2^*, x_3^*) = (9, 0, 3)$. So if Lars has the ability to make chairs, tables, and sofaborde, he will maximize his revenue by making 9 chairs, zero tables, and 3 sofaborde.

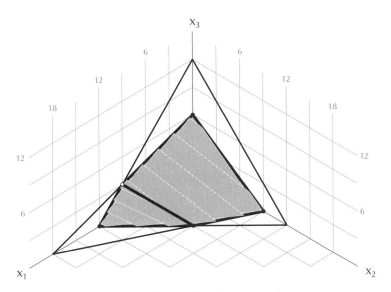

Figure 3.6: Objective function contour planes.

The Simplex Algorithm

We have seen that in a two-variable problem, each linear constraint gives rise to a line and a half-space, while in a three-variable problem, each linear constraint gives rise to a plane and a half-space. In each case, the feasible region is the intersection of the half-spaces. As shown in figure 3.7, in the two-dimensional case we get a polygon, a set bounded by line segments, while in the three-dimensional case we get a polyhedron, a set bounded by plane segments. In each case, the feasible region is *convex*—meaning that it has no indentations, and that every point in the set is in direct line of sight of every other point in the set.

We have also seen that in a two-variable problem, a linear revenue function produces parallel revenue contour lines, while in a three-variable problem, a linear revenue function gives rise to parallel revenue contour planes. See figure 3.8. In each case, we can follow the contours to an optimal solution. In both of our examples, the optimal solution was a vertex of the feasible region—a vertex of the polygon in the

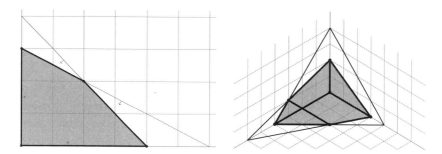

Figure 3.7: Two- and three-dimensional feasible regions.

Figure 3.8: Objective function contours for two- and three-dimensional problems.

two-variable case, and a vertex of the polyhedron in the three-variable case.

This is always the case; any linear optimization problem that has an optimal solution will have at least one vertex that is optimal. And we can exploit this to devise an alternate way of solving linear optimization problems.

We start at a vertex. We then examine the edges that are incident to our vertex. If one of these edges leads *uphill*—that is, if by following it, we would increase our revenue—we abandon our vertex and boldly go along the edge, moving uphill, increasing our revenue, until we reach the vertex at the opposite end of the edge.

From this new vertex, we repeat the process. We examine the incident edges, and if one of them leads uphill, we follow it to a better, higher revenue vertex. We keep doing this—going from our current vertex to an uphill neighbor—until it is no longer possible to go uphill. When no edges lead uphill, we stop. When this happens, our current vertex is optimal.

This algorithm is known as the *simplex algorithm*. It was invented by George Dantzig in 1947, and it is still the most widely used algorithm for solving linear optimization problems of this type.

The Mechanics of the Simplex Algorithm

Even though we just gave a geometric description of the simplex algorithm, all of its steps can be implemented algebraically. To demonstrate, we return to the three-product problem. For easy reference, here is Luna's model again:

$$\text{maximize} \quad 8x_1 + 11x_2 + 15x_3$$
$$\text{subject to} \quad 2x_1 + 2x_2 + 2x_3 \leq 24,$$
$$x_1 + 2x_2 + 3x_3 \leq 18,$$
$$x_1, x_2, x_3 \geq 0.$$

We initialize the algorithm by introducing three additional variables: s_1 and s_2 stand, respectively, for the numbers of units of resource 1 (SMALLS) and resource 2 (LARGES) that will remain after Lars makes

however many chairs, tables, and sofaborde he makes, and z stands for the revenue he will bring in. These three "auxiliary" variables depend on the original "decision" variables, and the dependencies can be expressed through the following three linear equations:

$$s_1 = 24 - 2x_1 - 2x_2 - 2x_3, \qquad (A_1)$$

$$s_2 = 18 - x_1 - 2x_2 - 3x_3, \qquad (A_2)$$

$$z = 8x_1 + 11x_2 + 15x_3. \qquad (A_z)$$

Equation (A_1) states that the number of SMALLS that are left over (s_1) must be equal to the number of SMALLS that Lars had at the start (24) minus the total number of SMALLS he used to make his chairs, tables, and sofaborde $(2x_1 + 2x_2 + 2x_3)$. Equation (A_2) plays a similar role, but for the LARGES. Equation (A_z) defines the revenue variable z.

Although equations (A_1), (A_2), and (A_z) are undeniably of interest to the furniture maker, providing information about resource usage and revenue, they play roles that are much more important. First, they specify a vertex of the polyhedron. Second, they enable us to examine the edges incident to the vertex and determine which ones, if any, lead uphill (toward higher revenue values). Finally, they can be converted into other equations that describe neighboring vertices.

In equations (A_1), (A_2), and (A_z), three variables appear on the right: x_1, x_2, and x_3. We set all of them equal to 0. From an algebraic standpoint, we are imposing three equations: $x_1 = 0$, $x_2 = 0$, and $x_3 = 0$. From a geometric standpoint, we are forcing (x_1, x_2, x_3) to be on three planes: the plane specified by the equation $x_1 = 0$ and the planes given by the equations $x_2 = 0$ and $x_3 = 0$. Each of these planes contains a face of our polyhedron, shown in figure 3.9, and the three of them intersect at a vertex, vertex A (the origin). In this way, equations (A_1), (A_2), and (A_z) can be thought of as pointing to vertex A.

From figure 3.9, we can see that the polyhedron has three edges that are incident to vertex A. One edge leads to vertex B, another to vertex C, and the third to vertex D. Each edge is composed of points that are on two faces of the polyhedron. For example, edge AB is on the face contained in the plane $x_2 = 0$ and on the face contained in the plane $x_3 = 0$. If we want to abandon vertex A and travel along edge AB, we should keep x_2 and x_3 fixed at their current values of 0. Increasing the value of x_1 from its current value of 0 will cause us to leave vertex A and move toward

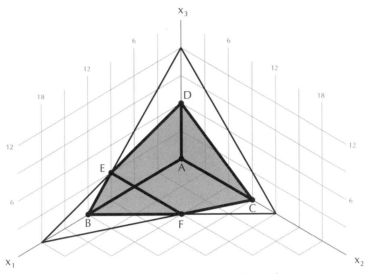

Figure 3.9: The vertices of the feasible region.

vertex B. If we want to leave vertex A via edge AC, we should keep x_1 and x_3 fixed at 0 and increase x_2. If we want to leave vertex A via edge AD, we should keep x_1 and x_2 fixed at 0 and increase x_3.

In summary, if we want to depart vertex A, we should keep two of the right-hand variables fixed at 0 and increase the third one. Keeping two of them fixed at 0 will keep us on an edge. Increasing the third one will move us along the edge.

To determine which edges lead uphill (toward higher revenue values), all we have to do is examine equation (A_z), the equation for z, the revenue. If a right-hand variable has a positive revenue coefficient, then by increasing that variable we will increase the revenue z. In (A_z), the revenue coefficients of x_1, x_2, and x_3 are 8, 11, and 15, respectively, so all three edges lead uphill in terms of revenue.

The coefficient of x_3 is the largest, so it seems reasonable to travel along the x_3 edge (edge AD), keeping x_1 and x_2 fixed at 0 and then increasing x_3. With $x_1 = 0$ and $x_2 = 0$, we can temporarily rewrite our equations:

$$s_1 = 24 - 2x_3, \qquad (A_1 \text{ with } x_1 = x_2 = 0)$$

$$s_2 = 18 - 3x_3, \qquad (A_2 \text{ with } x_1 = x_2 = 0)$$

$$z = 0 + 15x_3. \qquad (A_z \text{ with } x_1 = x_2 = 0)$$

By examining the new, simplified versions of equations (A_1), (A_2), and (A_z), we can determine the maximum amount by which we can increase x_3 while keeping x_1 and x_2 fixed at 0. The equation for s_1 limits x_3's increase to 12. If x_3 is 12, s_1 will be 0, and we will have used up all of our SMALL pieces. But the equation for s_2 limits x_3's increase even more. If x_3 is 6, s_2 will be 0, and we will have completely run through our supply of LARGE pieces. Consequently, we should increase x_3 from 0 to 6. When we do this, s_1 falls from 24 to 12 and s_2 drops from 18 to 0.

Our new solution has $x_1 = 0$, $x_2 = 0$, $x_3 = 6$, $s_1 = 12$, $s_2 = 0$, and $z = 90$. This solution is also a vertex—vertex D in figure 3.9. But we do not need to look at a graph to be sure of this. We know that our new solution is a vertex because it lies on three faces: faces contained in the planes specified by $x_1 = 0$, $x_2 = 0$, and $s_2 = 0$.

If we want to assess whether the new vertex is optimal, we need a set of equations that point to this vertex. We need a set of equations that play the same roles for vertex D that equations (A_1), (A_2), and (A_z) did for vertex A.

To obtain these equations, we rearrange equations (A_1), (A_2), and (A_z) so that the variables x_1, x_2, and s_2 (the variables that correspond to the faces that intersect at vertex D) appear on the right. In other words, we solve for x_3, s_1, and z in terms of x_1, x_2, and s_2. After performing the algebra, we obtain three equations that are both equivalent and analogous to equations (A_1), (A_2), and (A_z). These equations, as desired, point to vertex D:

$$x_3 = \ 6 - \frac{1}{3}x_1 - \frac{2}{3}x_2 - \frac{1}{3}s_2, \qquad (D_1)$$

$$s_1 = 12 - \frac{4}{3}x_1 - \frac{2}{3}x_2 + \frac{2}{3}s_2, \qquad (D_2)$$

$$z = 90 + 3x_1 + \ x_2 - 5s_2. \qquad (D_z)$$

These equations indicate that there are three edges incident to vertex D. The x_1 and x_2 edges lead uphill. If we increase x_1 from 0 while keeping x_2 and s_2 fixed at 0, we will increase z by 3 units per unit of x_1. If we increase x_2 from 0 while keeping x_1 and s_2 fixed at 0, we will increase z by 1 unit per unit of x_2. The s_2 edge leads downhill (back to vertex A). If we increase s_2 from 0 while keeping x_1 and x_2 fixed at 0, we will *decrease* z by 5 units per unit of s_2.

In the revenue equation (D_z), the coefficient of x_1 is the largest, so we will travel along the x_1 edge, keeping x_2 and s_2 fixed at 0 and then increasing x_1. With $x_2 = 0$ and $s_2 = 0$, we can temporarily rewrite our equations:

$$x_3 = 6 - \tfrac{1}{3}x_1, \qquad\qquad (D_1 \text{ with } x_2 = s_2 = 0)$$

$$s_1 = 12 - \tfrac{4}{3}x_1, \qquad\qquad (D_2 \text{ with } x_2 = s_2 = 0)$$

$$z = 90 + 3x_1. \qquad\qquad (D_z \text{ with } x_2 = s_2 = 0)$$

By examining the simplified versions of equations (D_1), (D_2), and (D_z), we can determine the maximum amount by which we can increase x_1 while keeping x_2 and s_2 fixed at 0. The equation for x_3 limits x_1's increase to 18, but the equation for s_1 limits x_3's increase even more. If x_1 is 9, s_1 will be 0, and we will have run out of SMALL pieces. Consequently, we should increase x_1 from 0 to 9. When we do this, x_3 falls from 6 to 3 and s_1 drops from 12 to 0.

Our new solution has $x_1 = 9$, $x_2 = 0$, $x_3 = 3$, $s_1 = 0$, $s_2 = 0$, and $z = 117$. This solution is also a vertex—vertex E in the graph. It is the intersection of three faces: the faces contained in the planes specified by $x_2 = 0$, $s_1 = 0$, and $s_2 = 0$.

At this point, we have performed two iterations of the simplex algorithm. On the first iteration, we moved from vertex A to vertex D. On the second iteration, we went from vertex D to vertex E. If we want to perform a third iteration, we need a set of equations that points to vertex E. To obtain these equations, we rearrange equations (D_1), (D_2), and (D_z) so that the variables x_2, s_1, and s_2 (the variables that correspond to the faces that intersect at vertex E) appear on the right. By performing the algebra, we obtain

$$x_1 = 9 - \tfrac{1}{2}x_2 - \tfrac{3}{4}s_1 + \tfrac{1}{2}s_2, \qquad\qquad (E_1)$$

$$x_3 = 3 - \tfrac{1}{2}x_2 + \tfrac{1}{4}s_1 - \tfrac{1}{2}s_2, \qquad\qquad (E_2)$$

$$z = 117 - \tfrac{1}{2}x_2 - \tfrac{9}{4}s_1 - \tfrac{7}{2}s_2. \qquad\qquad (E_z)$$

These equations indicate that there are three edges incident to vertex E and that all three of these edges lead downhill. If we increase x_2

from 0 while keeping s_1 and s_2 fixed at 0, we will decrease z by half a unit per unit of x_2. If we increase s_1 from 0 while keeping x_2 and s_2 fixed at 0, or if we increase s_2 from 0 while keeping x_2 and s_1 fixed at 0, we will decrease z by even more.

Since all edges that are incident to vertex E lead downhill, vertex E is optimal! This optimal solution is $(x_1^*, x_2^*, x_3^*) = (9, 0, 3)$ and has $s_1^* = 0$, $s_2^* = 0$, and $z^* = 117$.

Linear Optimization Software

What if Lars makes not just chairs and tables and sofaborde, but many more types of furniture as well, a total of n different types, made out of m different varieties of raw materials? In this case, Luna's model can be written as

$$
\begin{aligned}
\text{maximize} \quad & r_1 x_1 + r_2 x_2 + \cdots + r_n x_n \\
\text{subject to} \quad & a_{11} x_1 + a_{12} x_2 + \cdots + a_{1n} x_n \le b_1, \\
& a_{21} x_1 + a_{22} x_2 + \cdots + a_{2n} x_n \le b_2, \\
& \qquad\qquad\qquad \vdots \\
& a_{m1} x_1 + a_{m2} x_2 + \cdots + a_{mn} x_n \le b_m, \\
& x_1, x_2, \ldots, x_n \ge 0.
\end{aligned}
$$

The variable x_j stands for the number of units of product j that Lars should make. The remaining symbols—the r_j's, the a_{ij}'s, and the b_i's—all stand for data, numbers known by Lars or his employees. For example, r_j is the amount of revenue Lars will bring in if he makes and then sells one unit of product j, a_{ij} is the number of units of resource i that he needs to make one unit of product j, and b_i is the total number of units of resource i that he has in his warehouse.

If n is greater than 3, then the graphical method is out of the question, so Luna would use the simplex algorithm to obtain an optimal solution for Lars. As we've seen, hand-execution of the simplex algorithm is laborious and tedious, so a sensible person like Luna would use a computer. Fortunately, there are several excellent software packages for solving linear optimization problems. My favorite is the Gurobi Optimizer. The

name Gurobi comes from the names of the three optimization researchers who founded the company: Zonghao *Gu*, Edward *Ro*thberg, and Robert *Bi*xby.

To employ the Gurobi Optimizer's command line tool, we first use a text editor (or write a computer program) to create an *LP file*, a text file that contains a complete description of the linear optimization problem we want to solve. Figure 3.10 displays the contents of *lego.lp*, the LP file for the three-product version of Lars's problem.

Then, to instruct Gurobi to solve the problem, we can open up a terminal window on our computer and type in the following command:

```
gurobi_cl Resultfile = lego.sol
    Logfile = lego.log Method=0 lego.lp
```

Finally, we can examine the contents of the text files *lego.sol* (figure 3.11) and *lego.log* (figure 3.12) to retrieve the optimal solution and obtain a report on how much effort and time Gurobi expended to solve the problem. By reading the shaded part of figure 3.12, we can see that Gurobi needed only two iterations of the simplex algorithm and essentially no time whatsoever (only "0.00 seconds").

```
maximize
 8 X1 + 11 X2 + 15 X3
subject to
 2 X1 + 2 X2 + 2 X3 <= 24
   X1 + 2 X2 + 3 X3 <= 18
bounds
 0 <= X1
 0 <= X2
 0 <= X3
end
```

Figure 3.10: The contents of *lego.lp*.

```
# Objective value = 117
X1 9
X2 0
X3 3
```

Figure 3.11: The contents of *lego.sol*.

```
Gurobi 7.5.2 (mac64) logging started Wed Aug 15 15:51:53 2018

Academic license - for non-commercial use only
Set parameter Method to value 0

Gurobi Optimizer version 7.5.2 build v7.5.2rc1 (mac64)
Copyright (c) 2017, Gurobi Optimization, Inc.

Read LP format model from file lego.lp
Reading time = 0.00 seconds
: 2 rows, 3 columns, 6 nonzeros
Optimize a model with 2 rows, 3 columns and 6 nonzeros
Coefficient statistics:
  Matrix range      [1e+00, 3e+00]
  Objective range   [8e+00, 2e+01]
  Bounds range      [0e+00, 0e+00]
  RHS range         [2e+01, 2e+01]
Presolve time: 0.00s
Presolved: 2 rows, 3 columns, 6 nonzeros

Iteration    Objective       Primal Inf.    Dual Inf.      Time
       0   -0.0000000e+00   0.000000e+00   3.400000e+01     0s
       2    1.1700000e+02   0.000000e+00   0.000000e+00     0s

Solved in 2 iterations and 0.00 seconds
Optimal objective  1.170000000e+02

Wrote result file 'lego.sol'
```

Figure 3.12: The contents of *lego.log*.

Continuous versus Discrete Linear Optimization

Back to Lars and Luna. Let's imagine that after dinner, Lars rushes to his workshop. From what he learned from Luna, he knows that it would be optimal for him to make 6 chairs and 6 tables, and he is eager to put her plan into action. But when he gets back to the stockroom, he discovers that he had miscounted. He has 25 SMALLS, not 24. And he has 19 LARGES, not 18.

Lars realizes that he can still follow Luna's solution and make 6 chairs and 6 tables, which would bring in 114 kroner, but he also realizes that with the additional SMALL and the additional LARGE, he might be able to do even better. Wanting to impress his sister, Lars takes out his laptop, creates an LP file *lego2.lp*, downloads the Gurobi Optimizer (which Luna had been raving about), and uses it to obtain a file *lego2.sol* that contains the optimal solution of the new model. Figure 3.13 displays the contents of these files, but to save space, I

```
maximize
  8 X1 + 11 X2
subject to
  2 X1 + 2 X2 <= 25                  Z  119.5
    X1 + 2 X2 <= 19                  X1 6
bounds                               X2 6.5
  0 <= X1
  0 <= X2
end
```

Figure 3.13: The contents of *lego2.lp* and *lego2.sol*.

made one modification to Gurobi's solution file: I replaced the line "# Objective value = 119.5" (which actually appeared in the SOL file) with "Z 119.5".

When Lars examines the solution, he feels a mixture of disappointment, frustration, and anger. According to Gurobi, if he has 25 SMALLS and 19 LARGES, it would be optimal for him to make 6 chairs and 6.5 tables. But he can't make 6.5 tables! He could call Luna to complain and also to ask her what to do, but it's late and he wants to figure it out himself. He decides to bash on and call her in the morning to double-check his work.

Lars paces for a while. The problem is of course that $x_2 = 6.5$. Lars doesn't want x_2 to equal 6.5. He'd like to prevent x_2 from equaling 6.5, but he can't impose a constraint that asserts $x_2 \neq 6.5$ because this constraint wouldn't do enough. If x_2 were to equal 6.25 or 6.75 or some other number strictly between 6 and 7, the constraint would be satisfied even though he'd be in essentially the same situation he is in right now. He realizes that he needs to prevent x_2 from being any number that's strictly between 6 and 7. In other words, he needs to impose a constraint that guarantees that $x_2 \leq 6$ or $x_2 \geq 7$. And then, all of a sudden, a light-bulb goes off. Lars realizes that he can construct two slightly modified versions of the problem—one that includes the constraint $x_2 \leq 6$, and one that includes the constraint $x_2 \geq 7$. He can use Gurobi to solve both linear optimization problems, compare their optimal solutions, and keep the one that's best!

Because making more tables is better in terms of revenue than making fewer tables, Lars decides to pursue the $x_2 \geq 7$ option first. Figure 3.14 displays the contents of the resulting LP file and solution file.

```
maximize
    8 X1 + 11 X2
subject to
    2 X1 + 2 X2 <= 25        Z   117
       X1 + 2 X2 <= 19       X1 5
bounds                       X2 7
    0 <= X1
    7 <= X2
end
```

Figure 3.14: Imposing $x_2 \geq 7$.

```
maximize
    8 X1 + 11 X2
subject to
    2 X1 + 2 X2 <= 25        Z   118
       X1 + 2 X2 <= 19       X1 6.5
bounds                       X2 6
    0 <= X1
    0 <= X2 <= 6
end
```

Figure 3.15: Imposing $x_2 \leq 6$.

Now Lars is getting excited. The optimal solution to the $x_2 \geq 7$ problem makes sense: with the materials he has on hand, he can make 5 chairs and 7 tables, and the resulting revenue, 117 kroner, is higher (by 3 kroner) than that of Luna's solution!

But Lars knows that he has more work to do. He must also solve the other version of the problem, the one with $x_2 \leq 6$. With his new-found expertise, he quickly obtains the optimal solution with Gurobi. Figure 3.15 shows the results.

Here Lars feels some disappointment, but no anger or frustration. He knows how to deal with a non-integer-valued solution. This time, he needs to impose a constraint that guarantees $x_1 \leq 6$ or $x_1 \geq 7$ (in addition to $x_2 \leq 6$). So Lars constructs two versions of the $x_2 \leq 6$ problem—one that includes the constraints $x_1 \leq 6$ and $x_2 \leq 6$, and one that includes the constraints $x_1 \geq 7$ and $x_2 \leq 6$.

To keep consistent with his earlier action, and because making more chairs is better in terms of revenue than making fewer chairs, Lars decides to pursue the $x_1 \geq 7$, $x_2 \leq 6$ option first. With Gurobi he obtains the solution displayed in figure 3.16. When he sees that x_2 is not an integer, he curses at himself and Gurobi, but only briefly, because then a

```
maximize
  8 X1 + 11 X2
subject to
  2 X1 + 2 X2 <= 25        Z   116.5
     X1 + 2 X2 <= 19       X1  7
bounds                     X2  5.5
  7 <= X1
  0 <= X2 <= 6
end
```

Figure 3.16: Imposing $x_1 \geq 7$ and $x_2 \leq 6$.

```
maximize
  8 X1 + 11 X2
subject to
  2 X1 + 2 X2 <= 25        Z   114
     X1 + 2 X2 <= 19       X1  6
bounds                     X2  6
  0 <= X1 <= 6
  0 <= X2 <= 6
end
```

Figure 3.17: Imposing $x_1 \leq 6$ and $x_2 \leq 6$.

second lightbulb goes off. Lars realizes that he does not need to expend any more effort on the $x_1 \geq 7$, $x_2 \leq 6$ version of the problem. Each time that Lars has imposed an additional constraint or constraints, the revenue has dropped! Why? Because each additional constraint reduces the size of the feasible region. Here, the optimal solution to the $x_1 \geq 7$, $x_2 \leq 6$ version of the problem has revenue 116.5 kroner, so Lars knows that if he imposes additional constraints (like one that mandates that $x_2 \leq 5$ or $x_2 \geq 6$), he certainly won't do any better than 116.5 kroner. And he already has a solution that brings in 117 kroner!

Sensing that he's almost done, Lars addresses the $x_1 \leq 6$, $x_2 \leq 6$ version of the problem. With Gurobi, he confirms that Luna's solution— making 6 chairs and 6 tables, and bringing in 114 kroner—is optimal here. Figure 3.17 displays the contents of the LP and SOL files.

At this point, Lars turns in for the night, feeling the glow of having found the optimal product mix—7 chairs and 5 tables, with a revenue of 117 kroner—for when he has 25 SMALLS and 19 LARGES. With Gurobi handling the computations, Lars has solved a total of five *continuous* linear optimization problems (problems in which the variables are allowed

to take on non-integer values) in an effort to solve one *discrete* linear optimization problem (a problem in which all of the variables must take on integer values).

Branch and Bound

The next morning, Luna tells her brother that she is so very proud of him for independently discovering the *branch-and-bound algorithm* for discrete linear optimization problems. Branch and bound is an example of what computer scientists refer to as *divide and conquer*, a strategy that entails breaking a problem into cases and solving each case recursively.

Luna then takes Lars's computer output and arranges it into a *branch-and-bound tree* (figure 3.18) that summarizes his work. Each shaded rectangle is called a *node* and corresponds to one of the five continuous linear optimization problems that Lars solved with Gurobi. Each node contains the optimal values of the variables (in black) and states when the problem was solved—first, second, third, and so on (in gray).

The tree allows Lars, Luna, or anyone else to retrace Lars's steps. We can see that after solving the first problem, Lars dealt with x_2 being equal to 6.5 by *branching* on x_2—that is, by creating a *left-hand subproblem* that included the constraint $x_2 \leq 6$ and a *right-hand subproblem* that included the constraint $x_2 \geq 7$. We can also see that later on, after solving the third problem, Lars took care of x_1 being equal to 6.5 in a similar fashion, by branching on x_1.

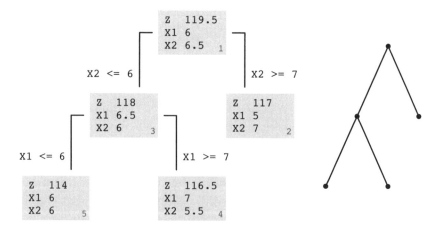

Figure 3.18: Lars's branch-and-bound tree.

On the other nodes/problems, he didn't need to branch. On the second and fifth problems, he obtained integer-valued solutions, so neither of these problems called for additional work. And in the optimal solution to the fourth problem, x_2 was equal to 5.5, but Lars was able to avoid branching by using a *bounding* argument—in which he compared the objective function value, 116.5, to the value of the best integer solution found thus far, 117—to convince himself that in this case branching would have been pointless.

A Graphical Examination of the Branch-and-Bound Algorithm

In figure 3.19, the shaded quadrilateral is the feasible region for the first problem Lars solved, which is known as the *root* problem due to its being at the topmost (starting) position of the tree. The black dots mark the feasible solutions that are integer valued, and the white dot marks the optimal solution, which is located at $(x_1, x_2) = (6, 6.5)$.

Figure 3.20 displays the feasible regions for the root's subproblems, which arose from branching on x_2 and imposing the constraints $x_2 \leq 6$ (on the left) and $x_2 \geq 7$ (on the right). Again, the white dots mark the optimal solutions.

The graphs show that branching on x_2 divided the root's feasible region into three disjoint sets: (1) the set of solutions that satisfy $x_2 \leq 6$, (2) the set of solutions that satisfy $6 < x_2 < 7$, and (3) the set of solutions that satisfy $x_2 \geq 7$. Because the second set cannot contain any integer-valued solutions, we discard it and focus on the other two sets.

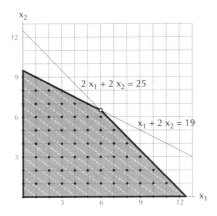

Figure 3.19: Lars's root problem.

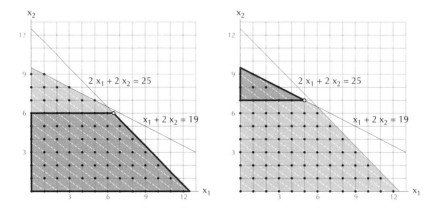

Figure 3.20: Branching on x_2 to create two subproblems.

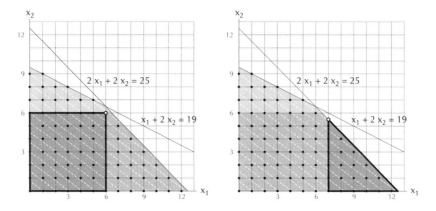

Figure 3.21: Branching on x_1 to create two more subproblems.

The optimal solution to the root's right-hand subproblem is integer valued, which means that we know the best action to take when $x_2 \geq 7$. By examining the graph, we see that if $x_2 \geq 7$, then it is best to set $(x_1, x_2) = (5, 7)$ and make 5 chairs and 7 tables.

The optimal solution to the root's left-hand subproblem is $(x_1, x_2) = (6.5, 6)$, which is not integer valued, so we treat it the same way we did the original. Here, with x_1 being equal to 6.5, we branch on x_1, creating an $x_1 \leq 6$ subproblem and an $x_1 \geq 7$ subproblem. Figure 3.21 displays their graphs.

Here, branching on x_1 divided the remaining portion of the feasible region into three disjoint sets: (1) the set of solutions that satisfy both $x_1 \leq 6$ and $x_2 \leq 6$, (2) the set of solutions that satisfy both $6 < x_1 < 7$ and

$x_2 \leq 6$, and (3) the set of solutions that satisfy both $x_1 \geq 7$ and $x_2 \leq 6$. As before, because the second set cannot contain any integer-valued solutions, we discard it and focus on the other two sets.

The optimal solution to the new right-hand subproblem is $(x_1, x_2) = (7, 5.5)$, which is not integer valued, but the revenue of this solution is less than the revenue of the best integer solution we've found thus far, $(x_1, x_2) = (5, 7)$, so there is no point in doing additional branching. By examining the graph, we see that if $x_2 \leq 6$ and $x_1 \geq 7$, then nothing we do will achieve the revenue of the solution $(x_1, x_2) = (5, 7)$, as the revenue contour line that $(5, 7)$ lies on does not intersect the right-hand subproblem's feasible region. (It just misses the shaded triangle.)

The optimal solution to the new left-hand subproblem is $(x_1, x_2) = (6, 6)$. By examining the graph, we see that if $x_2 \leq 6$ and $x_1 \leq 6$, then it is best to set $(x_1, x_2) = (6, 6)$ and make 6 chairs and 6 tables.

At this point, we can combine all five of these graphs into a single diagram, figure 3.22, that has the same structure as the branch-and-bound tree shown in figure 3.18. This branch-and-bound "tree of graphs" makes the divide-and-conquer aspects of branch and bound stand out. The diagram allows us to see that when we branch, moving downward in the tree from a node to its two *children nodes*, the branching divides the feasible region into two pieces, that the pieces contain all of the integer-valued solutions of the *parent node*, and that only *fractional* (non-integer-valued solutions) are discarded. At each node, we use the simplex algorithm to solve a continuous linear optimization problem. If the optimal solution is integer valued or if we can successfully employ a bounding argument, then we can rightfully say that we have "conquered" the node and its feasible region.

Also, if we focus on the *leaf nodes* (those that did not require branching), we can see that the union of their feasible regions is a set that contains all of the integer-valued solutions of the root problem. This means that if we conquer all of the leaf problems, we can be certain that we will find an optimal integer-valued solution to the root problem.

Branch and Bound with Gurobi

The Gurobi Optimizer can perform the branch-and-bound algorithm. We will demonstrate this on the discrete version of Lars's three-product (chairs, tables, and sofaborde) problem, assuming that he has 25 SMALLS and 19 LARGES. To inform Gurobi that certain variables

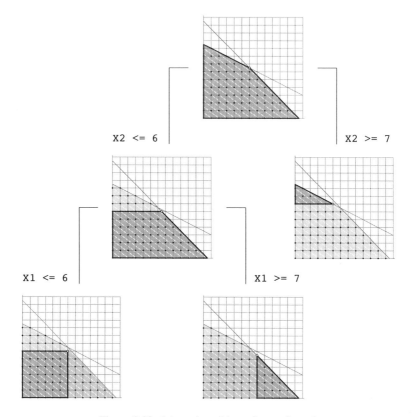

Figure 3.22: A branch-and-bound tree of graphs.

must be integer valued, we simply list these variables in an "integers" section of our LP file, *new_lego.lp*, as shown in figure 3.23.

Figure 3.24 displays the most interesting part of the log file *new_lego.log*. The top line tells us that when Gurobi solved the continuous version of the root problem, it obtained a solution with revenue 122.75 kroner, and that it performed three iterations of the simplex algorithm, which took "0.00 seconds."

The shaded section of the log file tells us that when Gurobi solved the discrete version of the problem, its branch-and-bound tree had 9 nodes, it performed a total of 13 iterations of the simplex algorithm, and that all of its work required "0.00 seconds."

Figure 3.25 displays the solution file, *new_lego.sol*. If Lars has the ability to make chairs, tables, and sofaborde and has 25 SMALLS and 19 LARGES on hand, it would be best for him to make 8 chairs, 1 table,

```
maximize
 8 X1 + 11 X2 + 15 X3
subject to
 2 X1 + 2 X2 + 2 X3 <= 25
   X1 + 2 X2 + 3 X3 <= 19
bounds
 0 <= X1
 0 <= X2
 0 <= X3
integers
 X1
 X2
 X3
end
```

Figure 3.23: The contents of *new_lego.lp*.

```
Root relaxation: objective 1.227500e+02, 3 iterations, 0.00 seconds

    Nodes    |    Current Node    |     Objective Bounds     |     Work
 Expl Unexpl |  Obj  Depth IntInf | Incumbent    BestBd   Gap | It/Node Time

     0     2  122.75000    0     2          -  122.75000     -      -    0s
     0     0  122.75000    0     2          -  122.75000     -      -    0s
*    2     2             1           116.0000000  122.25000  5.39%   1.5    0s
*    3     2             2           117.0000000  122.25000  4.49%   1.7    0s
*    5     2             3           120.0000000  121.50000  1.25%   1.6    0s

Explored 9 nodes (13 simplex iterations) in 0.00 seconds
Thread count was 8 (of 8 available processors)

Solution count 3: 120 117 116

Optimal solution found (tolerance 1.00e-04)
Best objective 1.200000000000e+02, best bound 1.200000000000e+02, gap 0.0000%

Wrote result file 'lego2.sol'
```

Figure 3.24: The contents of *new_lego.log*.

```
# Objective value = 120
X1 8
X2 1
X3 3
```

Figure 3.25: The contents of *new_lego.sol*.

and 3 sofaborde. If he adopts this mix of products, he will bring in 120 kroner.

Summary

We have covered a tremendous amount of ground in this chapter. We started with a version of Norman Pendegraft's LEGO problem, which is literally a "toy problem" version of a real-world problem known as the product-mix problem, and we described how to model it as a continuous linear optimization problem. We solved two-variable and three-variable versions of this problem via graphing, and then with the simplex algorithm (by hand), and then again with the Gurobi Optimizer software package's implementation of the simplex algorithm. Finally, we discussed the branch-and-bound algorithm for tackling the discrete version of the problem, where all of the variables have to be integer valued.

At this point, I should mention that continuous linear optimization problems are also known as *linear programming problems* or *linear programs*, and their discrete counterparts are often referred to as *integer programming problems* or *integer programs*. Up until 2010, the Mathematical Optimization Society—the premier international organization devoted to the study of mathematical optimization and its applications—was known as the Mathematical Programming Society, and its triennial meeting is still called the International Symposium on Mathematical Programming.

In every one of the subsequent chapters of this book, we will solve numerous discrete linear optimization problems. We will always use software, and for the most part, we will use the Gurobi Optimizer. (When we solve instances of the traveling salesman problem in chapter 6, we will use specialized software, the Concorde TSP Solver.)

The discrete linear optimization problems that come up in my visual art design work have many thousands—and sometimes hundreds of thousands—of variables. They have thousands—and sometimes many tens of thousands—of constraints. Yet on some of these problems, Gurobi is able to obtain optimal solutions extremely quickly—within seconds or even a fraction of a second. On others, it needs hours.

What explains the difference? The short answer is that the amount of time that Gurobi (or any similar software) needs to solve a problem

depends on how much branching it needs to perform. The more branching, the more nodes the branch-and-bound tree has. The more nodes, the greater the number of continuous linear optimization problems that must be solved. On the easiest discrete linear optimization problems Gurobi doesn't need to branch at all, because when it uses the simplex algorithm to solve the root problem, it is fortunate to obtain an integer-valued optimal solution. On other problems Gurobi needs to perform some branching, but not all that much. On the most difficult problems Gurobi has to branch and branch and branch. And on some problems its branch-and-bound tree can grow so large that it can no longer be stored on the computer!

CHAPTER 4

The Linear Assignment Problem and Cartoon Mosaics

In a small college there is a small department, and in this department there are five professors. We will refer to them by the first letter of their surnames: A, B, C, D, and V. These five professors are responsible for teaching a total of five courses, referred to by faculty and students alike simply as courses 1 through 5. The chair of the department is responsible for determining which professor will teach which course. This task is not a pleasant one and quite possibly the chair's least favorite task. For no matter what she does, no matter what professor-to-course pairings she comes up with, there will always be complaints.

This has been going on for years. It has gotten to the point where, going into the scheduling season, the chair will have a very good idea about how much complaining she will have to deal with during the semester—on a 1-to-5 scale measured in headache tablets—if she goes ahead and pairs a particular professor with a particular course, as detailed in table 4.1.

The chair's task is to produce an assignment that minimizes the total amount of complaining, as measured in headache tablets. She is constrained in that each professor has to teach exactly one course, and each course has to be taught by precisely one professor. No team teaching is allowed.

Table 4.1: The costs of pairing professors with courses

	1	2	3	4	5
A	2.5	3.5	4.0	4.0	3.5
B	2.5	1.5	2.5	1.5	4.0
C	4.0	3.0	3.5	2.0	3.5
D	3.5	4.0	3.5	2.5	4.0
V	4.0	3.5	3.5	4.0	1.5

Table 4.2: A possible assignment marked by underlined costs

	1	2	3	4	5
A	2.5	3.5	4.0	4.0	3.5
B	2.5	1.5	2.5	1.5	4.0
C	4.0	3.0	3.5	2.0	3.5
D	3.5	4.0	3.5	2.5	4.0
V	4.0	3.5	3.5	4.0	1.5

Table 4.3: The costs together with a binary table recording the pairings

	1	2	3	4	5
A	2.5	3.5	4.0	4.0	3.5
B	2.5	1.5	2.5	1.5	4.0
C	4.0	3.0	3.5	2.0	3.5
D	3.5	4.0	3.5	2.5	4.0
V	4.0	3.5	3.5	4.0	1.5

	1	2	3	4	5
A	1	0	0	0	0
B	0	1	0	0	0
C	0	0	1	0	0
D	0	0	0	1	0
V	0	0	0	0	1

One possible assignment, shown in table 4.2, has Professor A paired with course 1, Professor B with course 2, Professor C with course 3, and so on. Professor V, who would generate a considerable amount of complaining if paired with any of the first four courses (the V is for Voldemort, the chair's nickname for the professor she finds the most difficult to deal with), is paired with course 5. The total cost of the assignment—the total amount of complaining—is the sum of the under-lined entries, so with this assignment,

$$total\ cost = 2.5 + 1.5 + 3.5 + 2.5 + 1.5 = 11.5,$$

and the chair will end up taking a total of 11.5 headache tablets during the semester. Is this assignment optimal? Or can the chair do better?

The first step toward answering these questions is to observe that an assignment can be recorded as a 5×5 table of 0s and 1s, with the 1s marking the pairings, as shown in table 4.3. Note that the total cost can be obtained by smashing the two tables together, using the cost entries as the coefficients of the 0s and 1s:

$$total\ cost = \quad 2.5 \cdot 1 + 3.5 \cdot 0 + 4.0 \cdot 0 + 4.0 \cdot 0 + 3.5 \cdot 0$$
$$+ 2.5 \cdot 0 + 1.5 \cdot 1 + 2.5 \cdot 0 + 1.5 \cdot 0 + 4.0 \cdot 0$$

$$+4.0 \cdot 0 + 3.0 \cdot 0 + 3.5 \cdot 1 + 2.0 \cdot 0 + 3.5 \cdot 0$$
$$+3.5 \cdot 0 + 4.0 \cdot 0 + 3.5 \cdot 0 + 2.5 \cdot 1 + 4.0 \cdot 0$$
$$+4.0 \cdot 0 + 3.5 \cdot 0 + 3.5 \cdot 0 + 4.0 \cdot 0 + 1.5 \cdot 1 = 11.5.$$

The second step involves replacing the table of 0s and 1s that specifies the chair's assignment with a table of variables that stand for an unknown, yet-to-be-constructed assignment. There will be a binary variable for each of the 25 possible professor–course pairings. For example, as shown in table 4.4, the variable $x_{A,1}$ corresponds to pairing Professor A with course 1, and the variable $x_{V,1}$ corresponds to pairing Professor V with course 1. Should the chair pair Professor V (Voldemort) with course 1? Should she make this painful pairing? (Professor Voldemort is extremely difficult to deal with!) If the answer is yes, she sets the variable $x_{V,1}$ equal to 1. If the answer is no, she sets the variable $x_{V,1}$ equal to 0.

As before, the total cost can be obtained by smashing the two tables together, using the cost entries as the coefficients of the variables:

$$
\begin{aligned}
total\ cost = \quad & 2.5x_{A,1} + 3.5x_{A,2} + 4.0x_{A,3} + 4.0x_{A,4} + 3.5x_{A,5} \\
+ & 2.5x_{B,1} + 1.5x_{B,2} + 2.5x_{B,3} + 1.5x_{B,4} + 4.0x_{B,5} \\
+ & 4.0x_{C,1} + 3.0x_{C,2} + 3.5x_{C,3} + 2.0x_{C,4} + 3.5x_{C,5} \\
+ & 3.5x_{D,1} + 4.0x_{D,2} + 3.5x_{D,3} + 2.5x_{D,4} + 4.0x_{D,5} \\
+ & 4.0x_{V,1} + 3.5x_{V,2} + 3.5x_{V,3} + 4.0x_{V,4} + 1.5x_{V,5}.
\end{aligned}
$$

The chair would like to find values for the variables—0s and 1s—that will make this total cost expression as small as possible. Of course, the values she chooses must give rise to a feasible assignment.

Table 4.4: Binary variables for professor–course pairings

	1	2	3	4	5		1	2	3	4	5
A	2.5	3.5	4.0	4.0	3.5	A	$x_{A,1}$	$x_{A,2}$	$x_{A,3}$	$x_{A,4}$	$x_{A,5}$
B	2.5	1.5	2.5	1.5	4.0	B	$x_{B,1}$	$x_{B,2}$	$x_{B,3}$	$x_{B,4}$	$x_{B,5}$
C	4.0	3.0	3.5	2.0	3.5	C	$x_{C,1}$	$x_{C,2}$	$x_{C,3}$	$x_{C,4}$	$x_{C,5}$
D	3.5	4.0	3.5	2.5	4.0	D	$x_{D,1}$	$x_{D,2}$	$x_{D,3}$	$x_{D,4}$	$x_{D,5}$
V	4.0	3.5	3.5	4.0	1.5	V	$x_{V,1}$	$x_{V,2}$	$x_{V,3}$	$x_{V,4}$	$x_{V,5}$

When choosing values for the variables, the chair must keep in mind that *each professor is required to teach exactly one course*. To ensure that Professor Voldemort will teach exactly one course, the chair can require that the values for $x_{V,1}$, $x_{V,2}$, $x_{V,3}$, $x_{V,4}$, and $x_{V,5}$ satisfy what could be called the "Voldemort equation,"

$$x_{V,1} + x_{V,2} + x_{V,3} + x_{V,4} + x_{V,5} = 1,$$

which forces exactly one of the "Voldemort variables" to take on the value 1. To guarantee that each of the other professors will get exactly one course, the chair can impose similar equations for them:

$$x_{A,1} + x_{A,2} + x_{A,3} + x_{A,4} + x_{A,5} = 1,$$
$$x_{B,1} + x_{B,2} + x_{B,3} + x_{B,4} + x_{B,5} = 1,$$
$$x_{C,1} + x_{C,2} + x_{C,3} + x_{C,4} + x_{C,5} = 1,$$
$$x_{D,1} + x_{D,2} + x_{D,3} + x_{D,4} + x_{D,5} = 1.$$

Similarly, the chair must remember that *each course must be taught by precisely one professor*. To force herself to choose values that will actually result in course 1 being taught by precisely one professor, the chair can require that the values for $x_{A,1}$, $x_{B,1}$, $x_{C,1}$, $x_{D,1}$, and $x_{V,1}$ satisfy what could be called the "course-1 equation,"

$$x_{A,1} + x_{B,1} + x_{C,1} + x_{D,1} + x_{V,1} = 1,$$

which forces precisely one of the "course-1 variables" to take on the value 1. And again, to guarantee that each of the other courses will get precisely one professor, the chair can impose similar equations for the other courses:

$$x_{A,2} + x_{B,2} + x_{C,2} + x_{D,2} + x_{V,2} = 1,$$
$$x_{A,3} + x_{B,3} + x_{C,3} + x_{D,3} + x_{V,3} = 1,$$
$$x_{A,4} + x_{B,4} + x_{C,4} + x_{D,4} + x_{V,4} = 1,$$
$$x_{A,5} + x_{B,5} + x_{C,5} + x_{D,5} + x_{V,5} = 1.$$

As the objective function and all of the constraints are linear, the chair can find a best possible assignment by solving the following linear

optimization problem:

> minimize *total cost*
>
> subject to *the professor equations,*
>
> *the course equations,*
>
> *a binary restriction on each variable.*

The binary restrictions make this problem, the *linear assignment problem*, a *discrete* linear optimization problem. Although many discrete linear optimization problems are extremely difficult to solve, this one is extremely easy. Here we form what is called the *continuous relaxation* by replacing

$$x_{A,1} \in \{0, 1\} \quad \text{with } 0 \le x_{A,1} \le 1,$$
$$x_{A,2} \in \{0, 1\} \quad \text{with } 0 \le x_{A,2} \le 1,$$
$$x_{A,3} \in \{0, 1\} \quad \text{with } 0 \le x_{A,3} \le 1,$$
$$x_{A,4} \in \{0, 1\} \quad \text{with } 0 \le x_{A,4} \le 1,$$
$$x_{A,5} \in \{0, 1\} \quad \text{with } 0 \le x_{A,5} \le 1,$$

and making similar replacements for the other variables. Researchers have proved that in the case of the linear assignment problem, every vertex of the continuous relaxation's feasible region is integer valued. Consequently, if we use the simplex algorithm to solve the relaxation— by hand or with the Gurobi Optimizer—the optimal solution will definitely be integer valued. In other words, there is no need to use branching to force any of the variables to be 0 or 1, as it is a certainty that all of them will be 0 or 1 in the optimal solution to the root problem!

Figure 4.1 shows the contents of the problem's LP file, *prof.lp*, which was created with a text editor. If there had been a greater number of professors and courses, we would have benefited from writing a computer program that would load the problem data (the number of professors and courses and the table of cost values) and then construct the LP file for us.

In the optimal solution, the variables $x_{A,1}$, $x_{B,2}$, $x_{C,4}$, $x_{D,3}$, and $x_{V,5}$ equal 1, which means that the chair should pair Professor A with

```
minimize
   2.5 XA,1 + 3.5 XA,2 + 4.0 XA,3 + 4.0 XA,4 + 3.5 XA,5
 + 2.5 XB,1 + 1.5 XB,2 + 2.5 XB,3 + 1.5 XB,4 + 4.0 XB,5
 + 4.0 XC,1 + 3.0 XC,2 + 3.5 XC,3 + 2.0 XC,4 + 3.5 XC,5
 + 3.5 XD,1 + 4.0 XD,2 + 3.5 XD,3 + 2.5 XD,4 + 4.0 XD,5
 + 4.0 XV,1 + 3.5 XV,2 + 3.5 XV,3 + 4.0 XV,4 + 1.5 XV,5
subject to
   XA,1 + XA,2 + XA,3 + XA,4 + XA,5 = 1
   XB,1 + XB,2 + XB,3 + XB,4 + XB,5 = 1
   XC,1 + XC,2 + XC,3 + XC,4 + XC,5 = 1
   XD,1 + XD,2 + XD,3 + XD,4 + XD,5 = 1
   XV,1 + XV,2 + XV,3 + XV,4 + XV,5 = 1
   XA,1 + XB,1 + XC,1 + XD,1 + XV,1 = 1
   XA,2 + XB,2 + XC,2 + XD,2 + XV,2 = 1
   XA,3 + XB,3 + XC,3 + XD,3 + XV,3 = 1
   XA,4 + XB,4 + XC,4 + XD,4 + XV,4 = 1
   XA,5 + XB,5 + XC,5 + XD,5 + XV,5 = 1
bounds
  0 <= XA,1 <= 1
  0 <= XA,2 <= 1
  0 <= XA,3 <= 1
  0 <= XA,4 <= 1
  0 <= XA,5 <= 1
  0 <= XB,1 <= 1
  0 <= XB,2 <= 1
  0 <= XB,3 <= 1
  0 <= XB,4 <= 1
  0 <= XB,5 <= 1
  0 <= XC,1 <= 1
  0 <= XC,2 <= 1
  0 <= XC,3 <= 1
  0 <= XC,4 <= 1
  0 <= XC,5 <= 1
  0 <= XD,1 <= 1
  0 <= XD,2 <= 1
  0 <= XD,3 <= 1
  0 <= XD,4 <= 1
  0 <= XD,5 <= 1
  0 <= XV,1 <= 1
  0 <= XV,2 <= 1
  0 <= XV,3 <= 1
  0 <= XV,4 <= 1
  0 <= XV,5 <= 1
end
```

Figure 4.1: The contents of *prof.lp*.

course 1, Professor B with course 2, Professor C with course 4, Professor D with course 3, and the notorious Professor V with course 5. If she does this, she'll have to take 11 headache tablets to handle the complaining. In obtaining this optimal solution, the Gurobi Optimizer performed 9 iterations of the simplex algorithm, which took only "0.00 seconds" on my laptop.

Cartoon Mosaics

Years ago, while teaching myself the PostScript programming language, I made the series of cartoon portraits shown in figure 4.2. Cartoon 0 (the one of the guy wearing the Devo hat and shades) is the darkest, followed by cartoon 1 (Cher), cartoon 2 (Jesus), and cartoon 3 (Frankenstein's monster). Cartoon 9 (Martha Washington) is the brightest.

If we print multiple copies of this sheet of cartoons, we could cut them up, use the individual cartoons as tiles, and form a cartoon mosaic of our favorite target image, a public-domain publicity photo of Boris Karloff as Frankenstein's monster (figure 4.3, left). As we did with the Truchet tiles, we would begin by partitioning the target image into $k \times k$ blocks of pixels. In the Truchet tile example, we measured both the block brightness and tile brightness values on a 0-to-1, black-to-white scale. Here, though, we have 10 cartoons—cartoons 0 through 9—arranged in order of increasing brightness, so it is much more convenient to set the tile brightness value of cartoon c to c and, for consistency, to scale and round the block brightness values to integers ranging from 0 to 9 (figure 4.3, right).

Here, each block is 10×10, and the final mosaic will be 15 blocks wide by 22 blocks high. The top-left and top-right blocks, $(1, 1)$ and $(1, 15)$, are both somewhat brighter than midrange gray, so it shouldn't be a surprise to learn that their block brightness values are $\beta_{1,1} = \beta_{1,15} = 6$. The bottom-left block, $(22, 1)$, is a bit brighter, and its block brightness value is $\beta_{22,1} = 8$. The bottom-right block, $(22, 15)$, is considerably

Figure 4.2: Cartoon portraits.

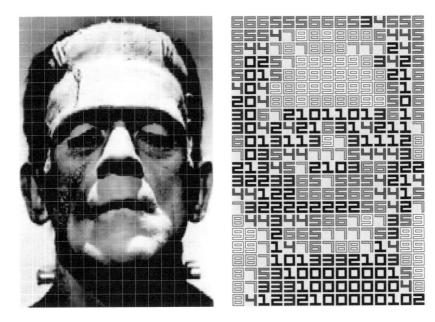

Figure 4.3: Boris Karloff as Frankenstein's monster.

darker, but it is not the darkest block in the image. Its block brightness value is only $\beta_{22,15} = 2$.

We can use the array of block brightnesses as the plans for our cartoon mosaic, placing a Devo wherever we find a 0, a Cher wherever we see a 1, and so on, but if we do this, we will need to print out 36 sheets of the cartoons. The reason is that the number 9 appears 36 times in the array, the most of any number. So if we use the array as plans for our mosaic, we will need 36 Martha Washingtons. But then we will end up with 6 leftover copies of cartoon 3, the Frankenstein's monster cartoon, as the number 3 appears only 30 times in the array, the least of any number.

To avoid being wasteful we impose constraints that force us to use each type of cartoon the same number of times. As there are $22 \cdot 15 = 330$ blocks and 10 types of cartoons, the desired number is 33.

With these constraints, determining which type of cartoon should be placed in each block is much more challenging, but it turns out that this task is essentially the same as assigning professors to courses. It has the same mathematical structure and can be tackled with the same optimization model.

When we were assigning professors to courses, we used a binary variable $x_{i,j}$ to model the yes/no decision we face when we are considering whether to pair professor i with course j. When designing a cartoon mosaic, we need a binary variable $x_{c,i,j}$ that equals 1 if we place a copy of the type-c cartoon in block (i, j) and 0 if we do not. As we have 10 types of cartoons and there are 22 rows and 15 columns of blocks, we end up with $10 \cdot 22 \cdot 15 = 3300$ $x_{c,i,j}$ variables!

When we were assigning professors to courses, we needed to impose two types of constraints: the professor constraints that ensure each professor teaches exactly one course, and the course constraints that make sure each course receives precisely one professor. When designing a cartoon mosaic, we must impose analogous constraints.

To force ourselves to place exactly one cartoon in block (i, j), we impose the "block (i, j)" constraint

$$x_{0,i,j} + x_{1,i,j} + x_{2,i,j} + x_{3,i,j} + \cdots + x_{9,i,j} = 1.$$

We can use summation notation to express this constraint more concisely:

$$\sum_c x_{c,i,j} = 1.$$

The summation is over all possible values of c, the index that specifies the type of cartoon. The row index i and column index j are fixed, as this constraint is for block (i, j). We need one of these constraints for each of the $22 \cdot 15 = 330$ blocks.

To force ourselves to use exactly 33 copies of the type-c cartoon, we impose a similar constraint, the "type-c cartoon" constraint

$$
\begin{aligned}
& x_{c,1,1} + x_{c,1,2} + \cdots + x_{c,1,15} \\
+\ & x_{c,2,1} + x_{c,2,2} + \cdots + x_{c,2,15} \\
& \vdots \\
+\ & x_{c,22,1} + x_{c,22,2} + \cdots + x_{c,22,15} = 33,
\end{aligned}
$$

which in summation notation can be written as

$$\sum_i \sum_j x_{c,i,j} = 33.$$

Figure 4.4: A cartoon mosaic of Frankenstein's monster.

Figure 4.5: Frankenstein's monster in 10 shades of gray.

This time, we are summing over all blocks (i, j)—in other words, all possible ways of selecting both a row i from 1 to 22 and a column j from 1 to 15—and we are keeping the index c fixed. We need 10 of these constraints, one for each type of cartoon.

Our goal is to design a cartoon mosaic that resembles the target image. Suppose we place a copy of cartoon c in block (i, j). Cartoon c has brightness c, and block (i, j) has brightness $\beta_{i,j}$. So we can define the cost for placing a copy of cartoon c in block (i, j) to be the squared error, $(c - \beta_{i,j})^2$, and the total cost to be

$$total\ cost = \sum_c \sum_i \sum_j (c - \beta_{i,j})^2 x_{c,i,j}.$$

The full optimization model has the same structure as the model used for the professor–course assignment problem:

minimize *total cost*

subject to *the cartoon equations,*

the block equations,

a binary restriction on each variable.

In other words, the cartoon-mosaic design problem is another example of a linear assignment problem.

Consequently, if we solve this problem with the Gurobi Optimizer, we will find that no branching is needed. When Gurobi uses the simplex algorithm to solve the continuous relaxation of the root problem of a linear assignment problem, all of the variables will end up being 0 or 1.

Here, the LP file is much too large to display. It was generated by the same computer program that converts target images into the $\beta_{i,j}$ block brightness values. In solving this problem, the Gurobi Optimizer performed 828 iterations of the simplex algorithm, and this took only 0.01 seconds on my laptop.

The resulting cartoon mosaic is shown in figure 4.4, and a mosaic formed from the 10 corresponding shades of gray is shown in figure 4.5.

Domino Mosaics

Just a month before my high-school graduation, I opened the May 1981 issue of *Omni* magazine. As was my custom, I turned first to Scot Morris's Games column. This one was titled "A word is worth one thousandth of a picture" and was focused on the artwork of Ken Knowlton. Most of the second page was devoted to a photo of a five-foot-tall portrait of Knowlton's friend and former student Joseph Scala. Knowlton's portrait—made out of 24 complete sets of double-nine dominos—closely resembles a photo that shows Scala, a lover of the game, holding up one of its pieces to the photographer.

Almost four years later, two months before my college graduation, I opened the March 1985 issue of *Omni*, and once again I quickly found my way to the Games column. In this installment, Morris gave updates on previous columns, including the one from May 1981 on Knowlton. In his update, Morris mentioned that Knowlton had patented his process and was selling plans for building portraits of famous figures like Marilyn Monroe and Albert Einstein out of four complete sets of double-nine dominos.

And finally, about 15 years later, while browsing the stacks at Oberlin's Mudd Library during my tenth year of teaching at Oberlin, I came across the book *The Mathemagician and Pied Puzzler: A Collection in Tribute to Martin Gardner*. Gardner was loved and respected for, among many other things, having written a long running and extremely influential mathematical games column for *Scientific American*. On the back cover of the tribute book, I found a photo of a Ken Knowlton portrait of Martin Gardner made out of six complete sets of double-nine dominos.

Seeing the photo brought me back to the first two times I had been exposed to Knowlton's domino mosaics. Back then, I had marveled at them. Though I knew he had designed them with his own software, I

had no idea how his software worked, and I couldn't even imagine how it worked. But this third time, with all of the training I had received in mathematical optimization in graduate school, I could see a way of using what I had learned—and what I was currently teaching to my students— to emulate Knowlton and solve instances of the *domino mosaic design problem*: given a grayscale target image and a fixed number of complete sets of double-nine dominos, find an arrangement of the dominos that most closely resembles the target image.

Double-Nine Dominos

As shown in figure 5.1, there are 55 dominos in a complete set of double-nine dominos, one domino of each type. We can use ordered pairs to refer to the dominos, or we can refer to them by their index numbers, which are shown in gray. When we use ordered pairs, we will always write them with the smaller number as the first coordinate. So if someone hands us a domino that has 3 dots on one of its halves and 8 dots on the other, we can thank them for handing us a $(3, 8)$ domino or thank them for giving us a type-33 domino.

Figure 5.1: One complete set of double-nine dominos.

Figure 5.1 also shows that we can arrange one complete set of double-nine dominos into a 10×11 rectangle, which has an aspect ratio of 10:11. By rotating, we can get an 11×10 rectangle, which has an aspect ratio of 11:10. Because we can factor the number 10 into $2 \cdot 5$, we can obtain additional rectangles (for example, 2×55 and 5×22 rectangles) and additional aspect ratios.

If we use more than one set of double-nine dominos, we can produce even more rectangles and aspect ratios. When we get around to constructing our first domino mosaics—of Frankenstein's monster, naturally!—we will use three complete sets of double-nine dominos and arrange them into a 22×15 rectangle, which has an aspect ratio of 22:15.

The Target Image

The first step in converting a grayscale target image into a domino mosaic is to decide how many complete sets of double-nine dominos we will use and how we will arrange them into a rectangle. If the rectangle's aspect ratio is not the same as that of our target image, we will need to crop the image. After we crop it, we downsample, computing a block brightness value $\beta_{i,j}$ for each block (i, j) of pixels (as we did in chapter 2). Because double-nine dominos have between 0 and 9 white dots on each of their halves, it makes sense to scale the $\beta_{i,j}$ values so that they fall between 0 and 9 inclusive, as shown in figure 5.2.

The second step is the one that involves optimization: finding the best way of assigning dominos to *slots*, pairs of adjacent blocks. At first it might seem that this is no different from assigning professors to courses when forming a schedule or assigning cartoons to blocks when designing a cartoon mosaic. In the professor–course assignment problem, there were 5 professors and 5 courses, each professor had to teach 1 course, and each course had to be taught by 1 professor. In the cartoon-mosaic design problem, there were 10 different types of cartoons and 330 blocks, each type of cartoon had to be used 33 times, and each block had to be given 1 cartoon. Here, if we have decided to use 3 complete sets of double-nine dominos and arrange them into a 22×15 rectangle, there are 55 different types of dominos and 330 blocks, each type of domino has to be used 3 times, and each block has to be covered by just 1 domino. Not each slot, but each block. A corner block belongs to 2 slots. A non-corner block on

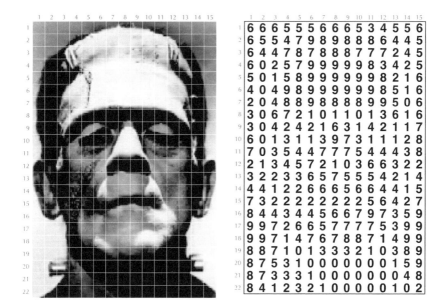

Figure 5.2: Downsampling.

the edge of the rectangle belongs to 3 slots. An interior (not-edge) block belongs to 4 slots.

Easier Versions of the Problem

If we restrict ourselves to vertical slots, as shown in figure 5.3, the domino placement problem becomes much easier, as it is an instance of the linear assignment problem. For this vertical-slot version of the problem, we introduce, for each domino d and each vertical slot s, a binary variable $x_{d,s}$ that equals 1 if we place a copy of domino d in slot s and 0 if we do not make this placement.

Figure 5.3 shows two domino placements. The one on the left involves setting $x_{33,5} = 1$, as it places a copy of domino 33—the $(3, 8)$ domino—into vertical slot 5, which covers blocks $(1, 5)$ and $(2, 5)$. The one on the right corresponds to setting $x_{26,27} = 1$, as it places a copy of domino 26—the $(2, 8)$ domino—into vertical slot 27, which covers blocks $(3, 12)$ and $(4, 12)$.

To ensure that each vertical slot s receives exactly 1 domino, we impose a *vertical-slot constraint*,

Figure 5.3: Partitioning the rectangle into vertical slots.

$$\sum_d x_{d,s} = 1,$$

for each vertical slot s. In each of these equations, the summation is over all possible values of the domino index d, and the slot index s is fixed. Similarly, to guarantee that each domino d is used 3 times, we impose a *domino constraint*,

$$\sum_s x_{d,s} = 3,$$

for each domino d. In each of these equations, the summation is over all values of the slot index s, and the domino index d is fixed.

Figure 5.4: The two options associated with setting $x_{33,5} = 1$.

When considering whether to make a domino placement, we need to be able to determine whether it is a good one. Suppose we are thinking of setting $x_{33,5} = 1$. We know that domino 33 is the $(3, 8)$ domino, that vertical slot 5 covers blocks $(1, 5)$ and $(2, 5)$, that block $(1, 5)$ has a brightness value of $\beta_{1,5} = 5$, and that block $(2, 5)$ has a brightness value of $\beta_{2,5} = 7$. As shown in figure 5.4, we have two choices: we could orient the domino with its smaller number up top—pairing the 3 with the 5 and the 8 with the 7—or we could rotate the domino 180° and pair the 8 with the 5 and 3 with the 7. If we decide to go with the first option, our cost will be the sum of two squared errors $(3 - 5)^2 + (8 - 7)^2 = 5$, and if we decide to go with the second, our cost will be the sum of two squared errors $(8 - 5)^2 + (3 - 7)^2 = 25$. Consequently, we can say that $c_{33,5}$, the cost of placing domino 33 into vertical slot 5, is $\min\{5, 25\} = 5$ (the smaller of these two values).

We need to compute a cost term $c_{d,s}$ for each way of placing a domino d into a vertical slot s. Assuming that each domino d could also be referred to as an (m, n) domino, with $m \leq n$, and that each vertical slot s covers the two blocks (i, j) and $(i + 1, j)$, where i is odd, we end up with

$$c_{d,s} = \min\left\{ (m - \beta_{i,j})^2 + (n - \beta_{i+1,j})^2, (n - \beta_{i,j})^2 + (m - \beta_{i+1,j})^2 \right\}.$$

This formula looks intimidating, but it does exactly what we did before—it computes the sum of the squared errors associated with each option and then takes the smaller of these two values.

With these $c_{d,s}$ cost terms, we can write the total cost of our entire domino arrangement as

$$total\ cost = \sum_{d} \sum_{s} c_{d,s}\, x_{d,s}.$$

Consequently, to find a best arrangement of dominos into vertical slots—an arrangement that has the lowest possible total cost—we can solve the following discrete linear optimization problem:

> minimize *total cost*
>
> subject to *the domino constraints,*
>
> *the vertical-slot constraints,*
>
> *a binary restriction on each variable.*

If instead we want to use nothing but horizontal slots, then all we have to do is replace the vertical-slot constraints with horizontal-slot constraints, make a minor adjustment to the formula for computing the $c_{d,s}$ cost terms, and solve the following modification of the problem:

> minimize *total cost*
>
> subject to *the domino constraints,*
>
> *the horizontal-slot constraints,*
>
> *a binary restriction on each variable.*

As both versions are instances of a linear assignment problem, no branching will be needed.

In fact, if someone gives us their favorite slot pattern—some specific way of partitioning the rectangle that will hold the dominos into vertical and horizontal slots—and tells us that we must use these slots, we will be able to handle the problem of finding the best way of assigning our dominos to this demanding person's favorite collection of slots in virtually the same way that we handled the other two versions of the problem. For this demanding person's vertical slots, we will use vertical-slot constraints. For their horizontal slots, we will use horizontal-slot constraints. To compute the $c_{d,s}$ cost terms, we will use the original formula whenever s is a vertical slot and the horizontal version of the formula whenever s is a horizontal slot. No matter what the demanding person's slot pattern is, we will end up with yet another instance of the linear assignment problem, so no branching will be needed.

Figure 5.5 displays two domino mosaics of Frankenstein's monster, each one made out of 3 complete sets of double-nine dominos. In the

left-hand mosaic, only vertical slots were allowed. In the right mosaic, aside from the rightmost column, only horizontal slots were allowed. (Due to the rectangle having an odd number of columns, it is impossible to use only horizontal slots.)

Neither mosaic is a particularly good likeness of the subject, but the total cost of the "vertical-slot" mosaic shown on the left is about 16% lower than that of the "mostly horizontal" mosaic shown on the right (305 versus 365). In the vertical-slot mosaic, 130 of the 330 blocks had no error, 165 of the blocks were off by ±1, and 35 of the blocks were off by ±2. In the mostly horizontal mosaic, 121 of the 330 blocks had no error, 162 of them were off by ±1, 44 were off by ±2, and 3 were off by ±3.

And neither version of the problem proved to be difficult for Gurobi. Each version has 9075 variables, 55 domino constraints, and 155 slot constraints. To obtain the left-hand mosaic, Gurobi performed 1826 iterations of the simplex algorithm, and this required less than a fifth of a second on my laptop. For the right-hand mosaic, Gurobi performed 2302 iterations of the simplex algorithm and needed approximately the same amount of time.

Finding High-Quality Slot Patterns

We have seen that the quality of a domino mosaic can depend on the slot pattern. The total cost of the vertical-slot mosaic shown in the left-hand side of figure 5.5 is about 16% lower than the total cost of the mostly horizontal mosaic shown on the right-hand side, and I think that the vertical one does look a bit better. (Both look better if you squint and hold this book at arms length!)

To find the best possible domino mosaic, we could—in theory— consider each possible slot pattern in turn. For the first slot pattern, we would use the Gurobi Optimizer to find the best possible assignment of dominos to its slots. At this point, we would refer to the first slot pattern as the "best" slot pattern, because it would have been the best one we'd seen. For each subsequent slot pattern, we would use the Gurobi Optimizer to find the best possible assignment of dominos to its slots. If the total cost of the current slot pattern were better than that of the "best" slot pattern, we would update the "best" slot pattern, replacing it with the current slot pattern. We wouldn't stop until we had evaluated all of

Figure 5.5: Two domino mosaics of Frankenstein's monster made out of 3 complete sets of double-nine dominos. In the left-hand mosaic, all slots are vertical. In the right-hand mosaic, most of the slots are horizontal.

the slot patterns. At this point, our "best" slot pattern would truly be the best slot pattern.

The difficulty with this exhaustive brute-force approach is that the number of possible slot patterns is truly enormous. Figure 5.6 shows a template for constructing all slot patterns that belong to just one particular family of slot patterns. The template partitions the 22×15 rectangle into 11 rows and 7 columns of 2×2 squares, as well as a single column of vertical slots on the rectangle's right edge. Each square (marked with a question mark) can hold either two vertical slots or two horizontal slots. Because there are two options per square and a total of 77 squares, there is a total of $2^{77} \approx 1.51 \times 10^{23}$ possible slot patterns in this family alone!

The Knowlton–Knuth Method

Knowlton realized that not all slots are equal. The slots that enclose widely different block brightness values are the most important, as they represent high-contrast domino-sized segments of the target image.

Figure 5.6: A template for constructing one family of slot patterns.

Figure 5.7 overlays the slot patterns used for the figure 5.5 domino mosaics on top of the block brightness values. For each vertical slot s that covers blocks (i, j) and $(i + 1, j)$, we can compute the block's *contrast score* k_s by setting $k_s = |\beta_{i,j} - \beta_{i+1,j}|$. If s is a horizontal slot that covers blocks (i, j) and $(i, j + 1)$, we set $k_s = |\beta_{i,j} - \beta_{i,j+1}|$.

The vertical-slot mosaic has a total contrast score of 304 (and a total cost of 305). The mostly-horizontal-slot mosaic has a total contrast score of 277 (and a total cost of 365). Knowlton's approach is to divide the domino mosaic design problem into two stages. In the first stage his software searches for a high-contrast slot pattern, and in the second stage it finds a low-cost assignment of dominos to slots.

The preeminent computer scientist Donald Knuth realized that *both* stages of Knowlton's method are instances of the linear assignment problem! In the first stage, though, it might not be obvious what is being assigned to what. To resolve this, it is helpful to try to make analogies between the slot-formation problem and the professor–course assignment problem. Doing this entails asking ourselves two questions: What in the slot-formation problem could play the role of the professors? What could play the role of the courses? The key to answering these questions

	1	2	3	4	5	6	7	8	9	10	11	12	13	14	15
1	6	6	6	5	5	5	6	6	6	5	3	4	5	5	6
2	6	5	5	4	7	9	8	9	8	8	8	6	4	4	5
3	6	4	4	7	8	7	8	8	8	7	7	7	2	4	5
4	6	0	2	5	7	9	9	9	9	9	8	3	4	2	5
5	5	0	1	5	8	9	9	9	9	9	9	8	2	1	6
6	4	0	4	9	8	9	9	9	9	9	9	8	5	1	6
7	2	0	4	8	8	9	8	8	8	8	9	9	5	0	6
8	3	0	6	7	2	1	0	1	1	0	1	3	6	1	6
9	3	0	4	2	4	2	1	6	3	1	4	2	1	1	7
10	6	0	1	3	1	1	3	9	7	3	1	1	1	2	8
11	7	0	3	5	4	4	7	7	7	5	4	4	4	3	8
12	2	1	3	4	5	7	2	1	0	3	6	6	3	2	2
13	3	2	2	3	3	6	5	7	5	5	5	4	2	1	4
14	4	4	1	2	2	6	6	6	5	6	6	4	4	1	5
15	7	3	2	2	2	2	2	2	2	5	6	4	2	7	
16	8	4	4	3	4	4	5	6	6	7	9	7	3	5	9
17	9	9	7	2	6	6	5	7	7	7	7	5	3	9	9
18	9	9	7	1	4	7	6	7	8	8	7	1	4	9	9
19	8	8	7	1	0	1	3	3	3	2	1	0	3	8	9
20	8	7	5	3	1	0	0	0	0	0	0	0	1	5	9
21	8	7	3	3	3	1	0	0	0	0	0	0	0	4	8
22	8	4	1	2	3	2	1	0	0	0	0	0	1	0	2

	1	2	3	4	5	6	7	8	9	10	11	12	13	14	15
1	6	6	6	5	5	5	6	6	6	5	3	4	5	5	6
2	6	5	5	4	7	9	8	9	8	8	8	6	4	4	5
3	6	4	4	7	8	7	8	8	8	7	7	7	2	4	5
4	6	0	2	5	7	9	9	9	9	9	8	3	4	2	5
5	5	0	1	5	8	9	9	9	9	9	9	8	2	1	6
6	4	0	4	9	8	9	9	9	9	9	9	8	5	1	6
7	2	0	4	8	8	9	8	8	8	8	9	9	5	0	6
8	3	0	6	7	2	1	0	1	1	0	1	3	6	1	6
9	3	0	4	2	4	2	1	6	3	1	4	2	1	1	7
10	6	0	1	3	1	1	3	9	7	3	1	1	1	2	8
11	7	0	3	5	4	4	7	7	7	5	4	4	4	3	8
12	2	1	3	4	5	7	2	1	0	3	6	6	3	2	2
13	3	2	2	3	3	6	5	7	5	5	5	4	2	1	4
14	4	4	1	2	2	6	6	6	5	6	6	4	4	1	5
15	7	3	2	2	2	2	2	2	2	5	6	4	2	7	
16	8	4	4	3	4	4	5	6	6	7	9	7	3	5	9
17	9	9	7	2	6	6	5	7	7	7	7	5	3	9	9
18	9	9	7	1	4	7	6	7	8	8	7	1	4	9	9
19	8	8	7	1	0	1	3	3	3	2	1	0	3	8	9
20	8	7	5	3	1	0	0	0	0	0	0	0	1	5	9
21	8	7	3	3	3	1	0	0	0	0	0	0	0	4	8
22	8	4	1	2	3	2	1	0	0	0	0	0	1	0	2

Figure 5.7: The slot patterns of the vertical-slot and mostly-horizontal-slot mosaics.

is contained in the left-hand side of figure 5.8, which is the same array of block brightnesses that we've seen before, but with checkerboard shading.

The key observation is that each slot pairs a shaded block with an unshaded block. Consequently, we can think of the shaded blocks as professors, and the unshaded blocks as courses (or vice versa). By maximizing the total contrast associated with the assignment—the sum of all of the resulting k_s terms—we obtain the slot pattern displayed on the right-hand side of figure 5.8. To solve this instance of the linear assignment problem, Gurobi required 257 iterations of the simplex algorithm and approximately one-hundredth of a second of computer time. The total contrast score, 482, is substantially higher than those of the vertical-slot and mostly-horizontal-slot patterns.

When we assign dominos to this slot pattern—by solving yet another instance of the linear assignment problem—we obtain the domino mosaic shown in figure 5.9. This one has a total cost of 97, which is about 68% lower than that of the vertical-slot mosaic. To my eye, it more closely resembles the target image than the previous two do. In this mosaic, 233 of the 330 blocks had no error, and 97 were

```
6 6 6 5 5 5 6 6 6 5 3 4 5 5 6        6 6 6 5 5 5 6 6 6 5 3 4 5 5 6
6 5 5 4 7 9 8 9 8 8 8 6 4 4 5        6 5 5 4 7 9 8 9 8 8 8 6 4 4 5
6 4 4 7 8 7 8 8 8 7 7 7 2 4 5        6 4 4 7 8 7 8 8 8 7 7 7 2 4 5
6 0 2 5 7 9 9 9 9 9 8 3 4 2 5        6 0 2 5 7 9 9 9 9 9 8 3 4 2 5
5 0 1 5 8 9 9 9 9 9 9 8 2 1 6        5 0 1 5 8 9 9 9 9 9 9 8 2 1 6
4 0 4 9 8 9 9 9 9 9 9 8 5 1 6        4 0 4 9 8 9 9 9 9 9 9 8 5 1 6
2 0 4 8 8 9 8 8 8 8 9 9 5 0 6        2 0 4 8 8 9 8 8 8 8 9 9 5 0 6
3 0 6 7 2 1 0 1 1 0 1 3 6 1 6        3 0 6 7 2 1 0 1 1 0 1 3 6 1 6
3 0 4 2 4 2 1 6 3 1 4 2 1 1 7        3 0 4 2 4 2 1 6 3 1 4 2 1 1 7
6 0 1 3 1 1 3 9 7 3 1 1 1 2 8        6 0 1 3 1 1 3 9 7 3 1 1 1 2 8
7 0 3 5 4 4 7 7 7 5 4 4 4 3 8        7 0 3 5 4 4 7 7 7 5 4 4 4 3 8
2 1 3 4 5 7 2 1 0 3 6 6 3 2 2        2 1 3 4 5 7 2 1 0 3 6 6 3 2 2
3 2 2 3 3 6 5 7 5 5 5 4 2 1 4        3 2 2 3 3 6 5 7 5 5 5 4 2 1 4
4 4 1 2 2 6 6 6 5 6 6 4 4 1 5        4 4 1 2 2 6 6 6 5 6 6 4 4 1 5
7 3 2 2 2 2 2 2 2 2 5 6 4 2 7        7 3 2 2 2 2 2 2 2 2 5 6 4 2 7
8 4 4 3 4 4 5 6 6 7 9 7 3 5 9        8 4 4 3 4 4 5 6 6 7 9 7 3 5 9
9 9 7 2 6 6 5 7 7 7 7 5 3 9 9        9 9 7 2 6 6 5 7 7 7 7 5 3 9 9
9 9 7 1 4 7 6 7 8 8 7 1 4 9 9        9 9 7 1 4 7 6 7 8 8 7 1 4 9 9
8 8 7 1 0 1 3 3 3 2 1 0 3 8 9        8 8 7 1 0 1 3 3 3 2 1 0 3 8 9
8 7 5 3 1 0 0 0 0 0 0 0 1 5 9        8 7 5 3 1 0 0 0 0 0 0 0 1 5 9
8 7 3 3 3 1 0 0 0 0 0 0 0 4 8        8 7 3 3 3 1 0 0 0 0 0 0 0 4 8
8 4 1 2 3 2 1 0 0 0 0 0 1 0 2        8 4 1 2 3 2 1 0 0 0 0 0 1 0 2
```

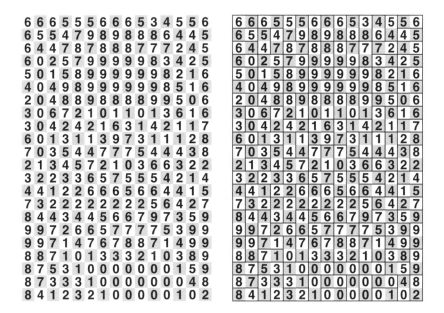

Figure 5.8: Checkerboard shading applied to the block brightness array, and a maximum total contrast slot pattern.

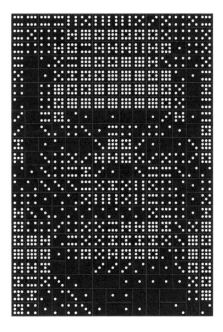

Figure 5.9: Another domino mosaic of Frankenstein's monster made out of 3 complete sets of double-nine dominos. This one was produced by the two-stage Knowlton–Knuth method.

off by ±1. To obtain this mosaic, Gurobi performed a total of 1910 iterations of the simplex algorithm, and this required less than a tenth of a second.

A Single-Stage Method

To do even better than the Knowlton–Knuth method, we need to simultaneously select the slots and place the dominos within them.

The variables for our single-stage model look the same and behave the same as those in our fixed-slot-pattern models, but there are more of them. Here we form a set S of all possible slots, vertical and horizontal. In addition, for each block (i, j), we form a subset $S_{i,j}$ of S that contains all of the slots that cover block (i, j). Note that if (i, j) is a corner block, then $S_{i,j}$ will have just two slots in it. If (i, j) is a non-corner block that lies on the edge of the rectangle, then $S_{i,j}$ will contain three slots. Otherwise, block (i, j) will be an "interior" block, and $S_{i,j}$ will contain four slots—two vertical and two horizontal—as shown in figure 5.10.

The single-stage model has a binary domino-placement variable $x_{d,s}$ for each domino d and each slot $s \in S$. As before, we set $x_{d,s}$ equal to 1 if we place domino d in slot s and 0 if we don't do this. And as before, each variable $x_{d,s}$ has a cost term $c_{d,s}$ that measures the cost of the best way of placing domino d into slot s. The total cost formula is now written as

$$total\ cost = \sum_{d} \sum_{s \in S} c_{d,s}\, x_{d,s}.$$

To guarantee that each domino d is used 3 times, we still impose a *domino constraint*,

$$\sum_{s \in S} x_{d,s} = 3,$$

Figure 5.10: The four slots that belong to the set $S_{i,j}$ for an interior block (i, j) (marked with an asterisk).

for each domino d. In these equations, we sum over all slots s that belong to S, keeping the domino d fixed. But in this single-stage model, to ensure that each block is covered by just 1 domino, we impose a *block constraint*,

$$\sum_{d} \sum_{s \in S_{i,j}} x_{d,s} = 1,$$

for each block (i, j). In the block equation for block (i, j), the sum is a double sum and is over all dominos d and all slots s that belong to $S_{i,j}$, the set of slots that cover block (i, j).

We then use the Gurobi Optimizer to solve the following discrete linear optimization problem:

> minimize *total cost*
>
> subject to *the domino constraints,*
>
> *the block constraints,*
>
> *a binary restriction on each variable.*

The single-stage problem is not an instance of the linear assignment problem, and it is often the case that when Gurobi solves the continuous relaxation of the root problem, it obtains a non-integer-valued optimal solution. Usually, though, the branch-and-bound tree is quite small.

Figure 5.11 displays two domino mosaics made with the single-stage method. The left-hand side displays the best mosaic of Frankenstein's monster that can be made with 3 complete sets of double-nine dominos, and the right-hand side shows the best one that can be made with 48 complete sets.

The optimal 3-set mosaic has a total cost of 59, which is about 39% lower than that of the 3-set Knowlton–Knuth mosaic (and about 81% lower than the total cost of the 3-set vertical-slot mosaic). In the optimal 3-set mosaic, 271 of the 330 blocks have no error, and the remaining 59 are off by ± 1.

The 3-set single-stage problem has 34,265 variables, 55 domino constraints, and 330 block constraints. Gurobi did need to branch, but there were only 7 nodes in its branch-and-bound tree. To explore the tree, Gurobi performed a total of 29,242 iterations of the simplex algorithm, completing all of its work in slightly less than 2 seconds.

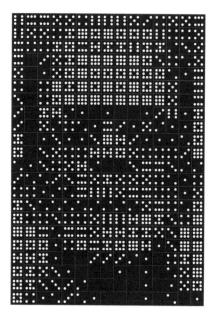
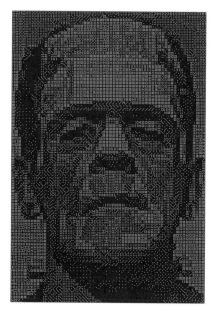

Figure 5.11: Domino mosaics of Frankenstein's monster made out of 3 (left) and 48 (right) complete sets of double-nine dominos.

The 48-set single-stage problem has 572,660 variables, 55 domino constraints, and 5280 block constraints. On this much larger problem, Gurobi performed a surprisingly small amount of branching, as there were only 15 nodes in its branch-and-bound tree! To explore the tree, Gurobi executed a total of 30,861 iterations of the simplex algorithm, completing all of its work in just under 1 minute.

Examples

Figure 5.12 shows two of my favorite 12-set designs: domino mosaics of the Statue of Liberty and Martin Luther King Jr. Free plans and instructions are available at www.dominoartwork.com.

During the past 16 years, numerous groups of schoolchildren have assembled these mosaics out of real dominos. (My son Dima's class at Oberlin's Eastwood Elementary, taught by Sharon Blecher and Gail Burton, was the first to build the MLK mosaic.) Two groups, to my

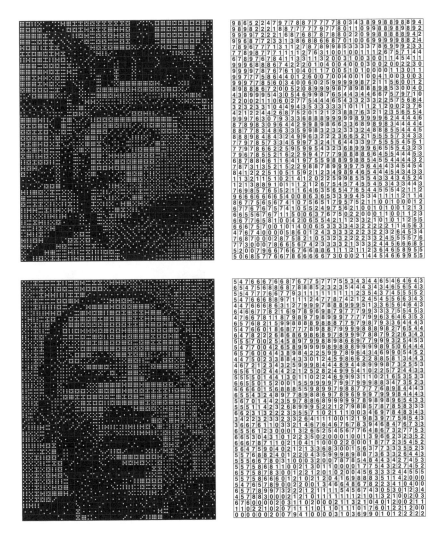

Figure 5.12: The Statue of Liberty and Martin Luther King Jr., each done in 12 complete sets of double-nine dominos.

knowledge, have constructed the 44-set domino portrait of Barack Obama shown in figure 5.13. One group was made up of all K-5 students at Franklin Elementary School in Westfield, MA. This team was led by Julian Fleron, professor of mathematics at Westfield State University. The other group was made up of children who were receiving treatment for HIV at the Detroit Children's Hospital.

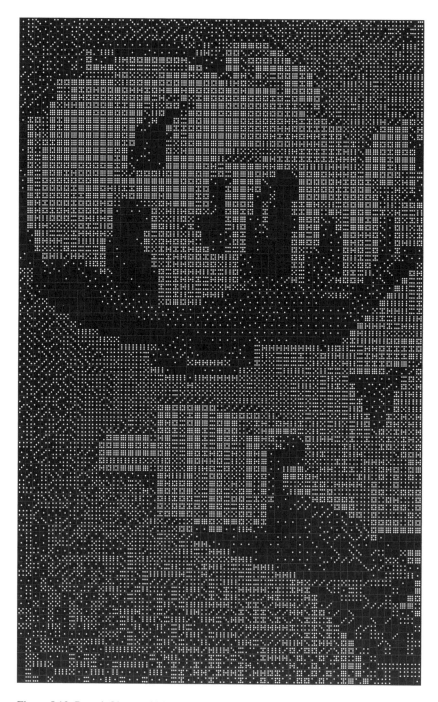

Figure 5.13: Barack Obama, 44th president of the United States of America (44 complete sets of double-nine dominos).

From the TSP to Continuous Line Drawings

Once a week, a meals-on-wheels volunteer bikes to headquarters (location 1 in figure 6.1) to pick up 19 meals and a list of 19 names and addresses (locations 2 through 20). She then gets in a van, delivers the meals, and returns to headquarters. Her goal is to drop off the meals in an order that will minimize the number of kilometers she will travel, as this will also minimize fuel consumption, pollutant emissions, and time spent on the job.

A computer-circuit-board manufacturer must drill 20 holes on each board. A blank board is carefully positioned on a drill press so that the drill bit will drill the first hole precisely where it is supposed to be. After the first hole is drilled, the board is repositioned so that a second hole can be drilled in its proper location. And after the second hole is drilled, the board is repositioned once more so that a third hole can be drilled. These two steps—reposition and drill—are repeated over and over again until all the holes have been drilled. At this point, the finished board is removed from the drill press and another blank board takes its place. Determining an optimal drilling order is prudent. The less movement there is, the faster that the holes can be drilled.

Both of these problems are instances of the traveling salesman problem (TSP), which is usually phrased in terms of a salesperson, based in one of the cities, who must devise a tour that visits each of the other cities exactly once and then returns home.

Solving TSPs with Linear Optimization

When we are designing a tour, whether it be for a meals-on-wheels volunteer, a circuit board, or an actual traveling salesperson, we face a binary (yes–no) decision for each *edge e* = $\{u, v\}$ (that is, each unordered

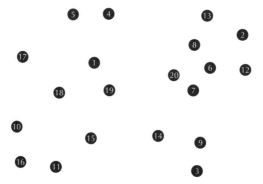

Figure 6.1: A 20-location instance of the TSP.

Figure 6.2: All edges of the 20-location TSP.

pair of locations $\{u, v\}$). Should we design the tour so that it visits locations u and v consecutively? In other words, when we connect the dots, should we join together dots u and v with a straight-line segment?

We let E denote the set of all possible edges. If n is the number of locations, then there is a total of $n(n-1)/2$ possible edges. When $n = 20$, there are 190 such edges. If we draw them all, we get the graph shown in figure 6.2, which looks like something we'd find in the back of an airline's in-flight magazine (if the airline offers direct flights from any city it serves to any other city it serves).

Because each tour returns to its starting location, each tour of an n-location TSP uses n edges. To determine which edges we will select, we introduce a binary decision variable x_e for each possible edge e. If e stands for an unordered pair of locations $\{u, v\}$ and we set x_e equal to 1, then we will include edge e in the tour, we will draw a straight-line

segment that joins locations u and v in our graph, and we will tell the meals-on-wheels volunteer or the drill press operator or the traveling salesperson to visit locations u and v consecutively. If we set x_e equal to 0, then we won't include edge e in the tour, and we won't connect locations u and v in our drawing.

In the 20-location TSP, would we want to select edge $\{2, 16\}$? Probably not, as its endpoint locations 2 and 16 are the two that are the farthest apart. So we are probably safe in setting $x_{2,16}$ equal to 0. Would we want to select edge $\{2, 13\}$, the edge drawn in black in figure 6.2? Maybe, as it is much shorter. If we decide to select it, we will set $x_{2,13}$ equal to 1.

We want the tour to have as low a total cost as possible. Each edge has a cost. We let c_e denote the cost of edge e. In the case of the meals-on-wheels volunteer, c_e would be the distance by car (to the nearest kilometer) from location u to location v. This distance should be the same as the distance from v to u, provided that there are no oneway streets. In the case of the circuit boards on the drill press, c_e would be the straight-line distance (to the nearest millimeter, perhaps) from hole location u to hole location v or vice versa, which is roughly proportional to the length of the line segment that represents edge e in the graph.

If we select edge e, we should charge ourselves its cost, c_e. If we don't select it, we should charge ourselves nothing for it. Regardless, the correct cost term for edge e is $c_e x_e$ (as $c_e \cdot 1 = c_e$ and $c_e \cdot 0 = 0$). And the total cost for the tour is the sum of all of these terms,

$$total\ cost = \sum_{e \in E} c_e x_e = \sum (c_e x_e : e \in E).$$

All that's left for us to do is to devise constraints that ensure that when we assign values to the x_e's, we obtain a tour. Figure 6.3 shows all of the edges that are incident to location 6. We denote this set of edges as $\delta(\{6\})$. If S is a subset of locations, then we will let $\delta(S)$ denote the set of edges that have one and only one endpoint in S.

To provide both a way in and a way out of location 6, we must select exactly two of the edges of $\delta(\{6\})$. To force ourselves to do this, we impose the constraint

$$\sum (x_e : e \in \delta(\{6\})) = 2,$$

Figure 6.3: Any tour uses exactly two of the edges in the set $\delta(\{6\})$.

which sums all the variables that correspond to edges that touch location 6. In expanded form, this equation can be written as

$$(x_{1,6} + x_{2,6} + x_{3,6} + x_{4,6} + x_{5,6}) + (x_{6,7} + x_{6,8} + x_{6,9} + \cdots + x_{6,20}) = 2.$$

We do the same thing for the other locations. In general, for location v, we impose the equation

$$\sum(x_e : e \in \delta(\{v\})) = 2.$$

Each of these equations is called a *degree constraint*. In the branch of mathematics known as graph theory, the *degree* of a vertex—what we've been calling a location—is defined to be the number of edges that touch that vertex.

Unfortunately, while the degree constraints are necessary, they are not sufficient to produce a tour. Let's see what happens when we solve the following linear optimization model:

> minimize *total cost*
>
> subject to *the degree constraints,*
>
> *a binary restriction for each variable.*

If we relax each binary restriction $x_{u,v} \in \{0, 1\}$ with the lower and upper bounds $0 \le x_{u,v} \le 1$, we can use the simplex algorithm (implemented in the Gurobi Optimizer software package) to solve this

Figure 6.4: Stage 1 of the 20-location TSP (cost = 67,301).

"stage-1" model. The optimal solution found by Gurobi is shown in figure 6.4. The solution has a total cost of 67,301 distance units, and 23 iterations of the simplex algorithm were needed to obtain it.

Unfortunately, even though all of the variables are 0 or 1, the stage-1 solution does not give us a tour. Each location is adjacent to two others, as mandated by the degree equations, but there are three sets of locations that form *subtours*:

$$S_1 = \{1, 4, 5, 10, 11, 15, 16, 17, 18, 19\},$$
$$S_2 = \{2, 6, 7, 8, 12, 13, 20\},$$
$$S_3 = \{3, 9, 14\}.$$

Fortunately we can deal with these subtours. To "break" the subtour associated with $S_1 = \{1, 4, 5, 10, 11, 15, 16, 17, 18, 19\}$, we can impose the *subtour-elimination constraint*

$$\sum \left(x_e : e \in \delta(S_1) \right) \geq 2.$$

This constraint requires that the solution include at least 2 of the edges that belong to $\delta(S_1)$. These edges have one endpoint in S_1 and one endpoint outside S_1. Accordingly, these edges cross the "chasm" that cuts off S_1 from the rest of the graph, as shown in figure 6.5. Any tour must have at least two such edges (that cross the chasm) in order to have both a way into and a way out of S_1.

Figure 6.5: A tour must include at least two edges of $\delta(S_1)$.

To break the subtours S_2 and S_3, we could impose similar constraints. In fact, if we want to eliminate *all* possible subtours, we could impose a constraint

$$\sum \left(x_e : e \in \delta(S) \right) \geq 2$$

for each subset S of locations having more than 2 and fewer than $n-2$ locations. (With the degree equations, subtours of 1, 2, $n-2$, or $n-1$ locations are impossible.) But the number of possible subsets—and subtours, and subtour-elimination constraints—grows exponentially. The exact number of possible subsets of locations is $2^n - (n^2 + n + 2)$. When $n = 20$, there are 1,048,154. When $n = 50$, there are more than 10^{15}.

A much better strategy is to play whack-a-mole with the subtours. We tell ourselves not to worry about subtours until they pop up. When we do see one, we eliminate it. Whack! And then we keep on eliminating them, a few at a time—Whack! Whack! Whack!—until no more rear their heads.

If we incorporate the subtour-elimination constraints for S_1, S_2, and S_3 along with the degree constraints into a new stage-2 model, relaxing the variables, the simplex algorithm yields an optimal solution after 33 iterations. As before, all of the variables are 0 or 1, even though we didn't force them to be binary. The total cost is higher, 71,985 distance units, but this is to be expected. Imposing additional constraints cannot improve the value of the objective function and will usually worsen it.

Figure 6.6: Stage 2 of the 20-location TSP (cost = 71,985).

Figure 6.7: Stage 3 of the 20-location TSP (cost = 72,993).

The stage-2 solution, shown in figure 6.6, has two subtours:

$$S_4 = \{1, 3, 4, 5, 7, 9, 10, 11, 14, 15, 16, 17, 18, 19, 20\} \quad \text{and}$$
$$S_5 = \{2, 6, 8, 12, 13\}.$$

If we now incorporate the subtour-elimination constraints for S_1, S_2, S_3, S_4, and S_5 into a new stage-3 model, once again relaxing the variables, the simplex algorithm yields an optimal solution after 34 iterations. And again, all of the variables are 0 or 1. The total cost is even higher, 72,993 distance units, but we are done. The stage-3 solution, shown in figure 6.7, gives us a tour!

But is this dog-shaped tour really optimal? Well, suppose it isn't. In other words, suppose that there exists a tour that has a lower total cost. This hypothetical lower-cost tour would certainly be feasible for all of

the optimization models we solved. But it would also have a lower total cost than the stage-3 model, the model that produced the dog-shaped tour. This implies that either we goofed on our final attempt—and we didn't!—or that the hypothetical lower-cost tour cannot exist!

Branch and Cut

Our whack-a-mole strategy worked beautifully. We knew that there were 1,048,154 possible sets of locations that could give rise to subtours, but we needed to impose only 5 subtour-elimination constraints! And on each stage, all of the variables ended up being either 0 or 1, as desired, but not explicitly required. This isn't always the case. Consider a second TSP, one with the 21 locations shown in figure 6.8.

Figure 6.8: A 21-location instance of the TSP.

Again we begin by minimizing the total cost, subject to the degree equations, and again we relax the variables (replacing each discrete constraint $x_e \in \{0, 1\}$ with a pair of continuous constraints $0 \le x_e \le 1$). In this initial stage-1 model, the simplex algorithm yields an optimal solution, shown in figure 6.9, which has a total cost of 88,190 distance units after 34 iterations.

The black line segments correspond to the variables x_e that have value 1, which in turn correspond to the edges that have been selected for the tour. The gray line segments correspond to variables $x_{u,v}$ that have value $\frac{1}{2}$. It is difficult to interpret these fractional values. If $x_{u,v} = \frac{1}{2}$, does it

Figure 6.9: Stage 1 of the 21-location TSP, cost = 88,190.

mean that one-half of edge $e = \{u, v\}$ has been selected? Does it mean that half a salesperson travels between locations u and v?

This disturbing solution satisfies the degree equations. After all, at each location the relevant edge variables sum to 2. And at first glance, it appears that the solution has no subtours. After all, the graph is connected.

But if we carefully examine the light gray blobs, we can see that the solution actually does violate 2 subtour-elimination constraints. Within the left blob, we find something very similar to a 3-location subtour. In fact, the subtour-elimination constraint for $S_1 = \{8, 10, 14\}$,

$$\sum \left(x_e : e \in \delta(S_1)\right) \geq 2,$$

will prohibit what appears there, as its left-hand side, the sum of all of the variables that connect locations in the left blob to locations in the outside world, evaluates to $\frac{1}{2} + \frac{1}{2} = 1$. We can handle the right blob in the same way.

After incorporating 2 subtour-elimination constraints into our model, the whack-a-subtour strategy runs smoothly, at least for a while. On stage 2, we obtain the solution shown in figure 6.10.

For stage 3, we throw in 3 more subtour-elimination constraints, and we quickly obtain the solution shown in figure 6.11.

For stage 4, we impose 3 additional subtour-elimination constraints. And then, for a moment, we throw our hands up in the air. Because the stage-4 solution, shown in figure 6.12, is truly disturbing! It

Figure 6.10: Stage 2 of the 21-location TSP (cost = 89,006).

Figure 6.11: Stage 3 of the 21-location TSP (cost = 89,059).

Figure 6.12: Stage 4 of the 21-location TSP (cost = 89,721).

Figure 6.13: Stage 5 of the 21-location TSP (cost = 89,746).

has numerous half-used edges, but it does not violate any subtour-elimination constraints.

There are two ways to proceed. The most elegant way is to devise a linear inequality that prohibits the current solution but does not remove any legitimate tours from consideration. These inequalities are called *cuts* or *cutting planes*: when they are incorporated into an optimization model, they cut off an unwanted (fractional) portion of the feasible region.

Another is to use the branch-and-bound divide-and-conquer strategy discussed in chapter 3. We select any fractional variable—I picked $x_{4,5} = \frac{1}{2}$, marking edge $\{4, 5\}$ with an asterisk—and then construct two *subproblems*. In one of them, we force the selected variable to equal 0. In the other, we force it to equal 1. Recall that this is called branching.

We can solve these subproblems in either order. I decided to solve the $x_{4,5} = 0$ branch first, making it the stage-5 model. This model includes all of the degree constraints, all of the subtour-elimination constraints that we have previously imposed, and finally, the constraint that fixes $x_{4,5}$ to 0. Using the simplex algorithm yet again, we obtain a solution, shown in figure 6.13, that has no fractional variables, but does contain two subtours.

On stage 6 we break these subtours, and we finally—joy of joys!—obtain the tour shown in figure 6.14.

We could stop here, with the somewhat crab-shaped tour that has total cost 89,887, but we cannot be certain that it is optimal. This tour came from our exploration of the $x_{4,5} = 0$ branch of stage 4. We have

Figure 6.14: Stage 6 of the 21-location TSP (cost = 89,887).

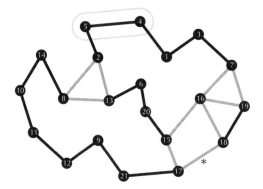

Figure 6.15: Stage 7 of the 21-location TSP (cost = 89,885.5).

yet to explore the $x_{4,5} = 1$ branch. For stage 7 we do just that. Starting from the stage-4 problem, we use all of the degree constraints, and all of the previous subtour-elimination constraints. But this time, we impose the constraint that fixes $x_{4,5}$ at 1, and the simplex algorithm delivers the disturbing fractional solution shown in figure 6.15.

To move beyond this solution, we apply the divide-and-conquer idea a second time. We select any fractional variable—I picked $x_{17,18} = \frac{1}{2}$— and then branch on it, constructing two subproblems: one with the variable fixed at 0, and the other with it fixed at 1.

I decided to tackle the $x_{17,18} = 0$ branch first. The stage-8 problem is identical to the stage-7 problem, but with $x_{17,18}$ fixed at 0. Using the simplex algorithm, we obtain the disturbing fractional solution shown in figure 6.16.

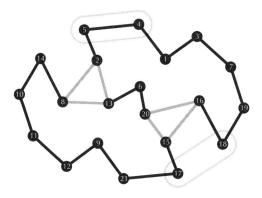

Figure 6.16: Stage 8 of the 21-location TSP (cost = 89,993.5).

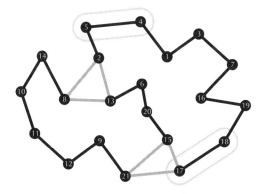

Figure 6.17: Stage 9 of the 21-location TSP (cost = 89,915).

We could continue to use the divide-and-conquer idea, select a third fractional variable, and then branch on it. But if we compare the current solution's total cost, 89,993.5, with that of the crab-shaped tour, 89,887 (found on stage 6), we can conclude that additional branching would be a waste of time and effort. If we perform additional branching or impose additional constraints, the total cost will either stay at 89,993.5 or it will increase. Additional constraints cannot lower the cost. This bounding argument enables us to conclude that when $x_{4,5} = 1$ and $x_{17,18} = 0$, there is no tour with cost lower than 89,887, the cost of the crab-shaped tour.

The last (it turns out) piece of work is to explore the remaining branch. Stage 9 is identical to stage 7, but with $x_{17,18}$ fixed at 1. Using the simplex algorithm one last time, we obtain the disturbing fractional solution shown in figure 6.17.

Here too, by comparing the current solution's total cost, 89,915, with that of the crab-shaped tour, 89,887, we can see that additional branching is not needed. The extra effort would either keep the total cost at 89,915 or would increase it. This bounding argument enables us to conclude that when $x_{4,5} = 1$ and $x_{17,18} = 1$, there is no tour better than the crab-shaped tour.

We can summarize our extensive work in graphical form with the *branch-and-cut tree* shown in figure 6.18. The tree has a node for each stage of the solution process. The top node, the root, corresponds to the stage-1 problem. At each node of the tree, we give the cost of the solution to that stage. In parentheses, we indicate what action we executed after examining the solution. When faced with subtours, we imposed subtour-elimination constraints (cuts). To handle fractional solutions in which no subtours were present, we turned to branching.

A glance at the tree reveals that to find an optimal tour for the 21-location TSP, we solved a total of 9 linear optimization problems. We employed branching twice (after stages 4 and 7). We also invoked a bounding argument twice (after stages 8 and 9). In other words, our branch-and-cut tree had two branch-and-bound nodes. A more careful

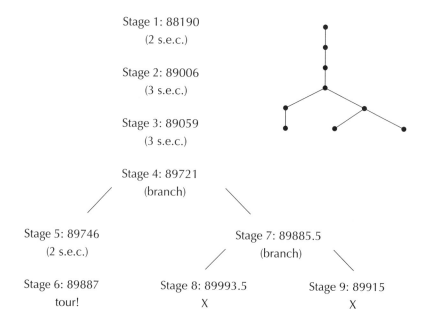

Stage 1: 88190
(2 s.e.c.)

Stage 2: 89006
(3 s.e.c.)

Stage 3: 89059
(3 s.e.c.)

Stage 4: 89721
(branch)

Stage 5: 89746
(2 s.e.c.)

Stage 7: 89885.5
(branch)

Stage 6: 89887
tour!

Stage 8: 89993.5
X

Stage 9: 89915
X

Figure 6.18: The branch-and-cut tree for the 21-location TSP with subtour-elimination constraints (s.e.c.'s) as indicated.

examination of the tree shows that as we add constraints, whether they be subtour-elimination constraints or branching constraints, the total cost of the solution does not decrease. As mentioned before, imposing additional constraints cannot lower the total cost.

Continuous Line Drawings

The optimal tour for the 20-location TSP resembles a dog, and the optimal tour for the 21-location TSP looks somewhat like a crab. If we use considerably more locations, carefully positioning them so that they collectively resemble a well-known target image, then the optimal tour will be a *continuous line drawing* of the target image, something that an artist could produce without lifting pen from paper.

We could, for example, construct the point sets shown in figure 6.19—each of the four with $2^{10} = 1024$ points—that resemble emojis for being cool, happy, nervous, and in love.

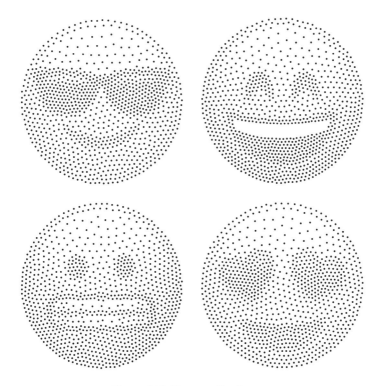

Figure 6.19: Four emoji point sets.

In each case we could think of the 1024 points as the cities of some country that just so happens to resemble an emoji (Being-Cool-Emoji-Land, Being-Happy-Emoji-Land, and so on). We could say that in this country, the cost of traveling directly from one city to another is the length of the straight-line segment that connects the two corresponding points (measured in suitable units and then rounded to an integer). And finally, we could imagine that there is a salesperson who lives in the country's northernmost city and whose job entails taking road trips that visit each of the other 1023 cities once and only once and then returning home. Such a salesperson would certainly want to solve a TSP. Such a salesperson's optimal tour should end up resembling their emoji.

To determine optimal tours for the Being-Cool-Emoji-Land, Being-Happy-Emoji-Land, Being-Nervous-Emoji-Land, and Being-In-Love-Emoji-Land TSPs, I used Concorde, a state-of-the-art TSP solver that was developed by a team led by William Cook, now a member of the Department of Combinatorics and Optimization at the University of Waterloo. The Concorde TSP solver is an extremely sophisticated and greatly enhanced implementation of the linear-optimization-based method we employed earlier in this chapter to solve the 20-location and 21-location TSPs. On each of these emoji TSPs, Concorde needed between 6 and 11 minutes to obtain an optimal tour, and its branch-and-bound trees had between 115 and 211 branch-and-bound nodes.

The optimal tours, shown in figure 6.20, do indeed look like their respective emojis, perhaps so much so that we can feel comfortable calling them *opt-emojis*! But they certainly look less like the emojis than do the point sets. The reason is that in each case, no matter how we join the points together to form a tour, we will inevitably introduce some amount of visual noise. The question is how much noise. By minimizing the cost of the tour—the total length of its edges—we will produce a tour that contains as little visual noise as possible.

If we use even more locations, positioning them extremely carefully, we can even produce pieces of TSP Art that closely resemble well-known works of fine art. Figure 6.21 displays an optimal tour for a 3072-location point set that was derived from a section of Michelangelo's *The Creation of Adam*. Here, Concorde needed 1045 minutes and 2773 branch-and-bound nodes.

In theory, we could put this tour into physical form if we were to join together the two ends of a long piece of black string, place the black loop

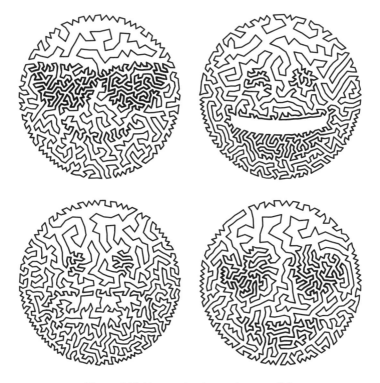

Figure 6.20: Four optimal tours (opt-emojis).

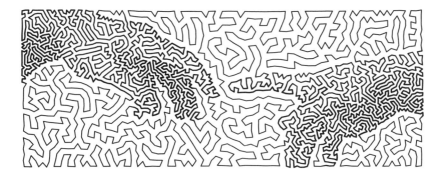

Figure 6.21: *Hands, Version One* (an optimal tour).

on a large sheet of white paper in such a way that it forms an enormous circle, and then—with steady hands and great patience—manipulate the loop until it looks just like this optimal tour of the 3072 points. When we do this manipulation, we can be certain that we will never have to lift up some section of the loop and place it on top of some other section, nor will we have to perform the opposite operation. We will be able to achieve our goal by pushing around the loop of string, sliding one section one way and another section another way. The reason is that the optimal tour, like the circle, is a *simple closed curve*. Like the circle, it does not intersect itself (which is why we say that it is simple). And like the circle, it is closed (meaning that when you draw it, no matter where you start, you will end up precisely where you started).

The artistic consequences can be unexpectedly profound. If we trace the optimal tour shown above, starting near the top of God's index finger—God's hand is the one on the right—moving "upward" (initially) around the distorted circle of the tour, we will eventually find ourselves near the tip of Adam's forefinger, and we will realize that we can interpret the tour as an assertion that God and Adam are connected, even though a casual examination seems to suggest that they are not.

Another tour, shown in figure 6.22, is much less subtle about making this point and therefore may be more appealing to "those of little faith." This close-to-optimal tour is only about 0.02% longer than the optimal tour, but is much more efficient at asserting divine connectedness (for those inclined to read it that way).

But what about artwork for those who believe that God and Adam are most definitely *not* connected (believing, perhaps, that the Creator set

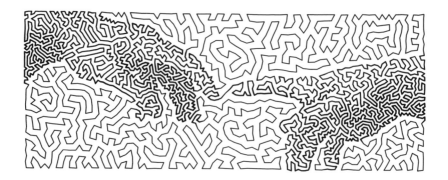

Figure 6.22: *Hands, Version Two* (0.02% longer than optimal).

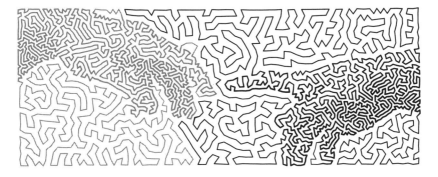

Figure 6.23: *Hands, Version Three* (not a tour, but rather two subtours).

the universe in motion and since that moment of activity has not cared one iota for it or its inhabitants)? For these folks, we have figure 6.23, a drawing composed of two subtours: an "Adam subtour" drawn in gray, and a "God subtour" drawn in black.

Stippling

To make TSP Art, we need to be able to convert target images into point sets. This is called *stippling*. We can imagine enlarging the image—large enough to make it so the individual pixels are visible as squares—and then printing it on an enormous piece of paper mounted on cork. If we did this, we could throw darts at the target. Our goal would be to hit the dark sections and miss the bright sections. In reality we simulate the dart throwing on a computer, arranging it so that the probability that a pixel is hit is equal to its darkness value (255 minus its grayscale value) divided by the sum of all of the pixel darkness values. As a consequence, the darker a pixel is, the greater the chance that it is hit. And each time a pixel is hit, we randomly place a point in the corresponding square, as shown in figure 6.24, which displays a target image that reads "dots" together with a point-set rendition made out of 200 dots.

Here, the dart-throwing algorithm failed. Many of the points are too close to other points, and some sections of the target image have no points at all. To remedy this, we can turn to MacQueen's "tractor beam" algorithm to reposition the points:

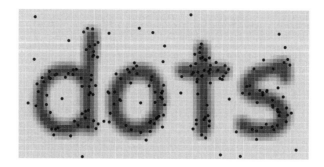

Figure 6.24: An attempt at rendering the word "dots" with 200 dots.

0. Use the dart-throwing algorithm to position a total of k points. Let \mathbf{p}_i denote the current location of point i, and let n_i equal the number of times that point i has been the target of the tractor beam. Initially, set $n_i := 0$ for $i = 1, 2, \ldots, k$.

1. Use the same dart-throwing algorithm that was used to position the k points to select the location of one more point, the new location \mathbf{w} of the tractor beam.

2. Find the point i whose current location \mathbf{p}_i is closest to \mathbf{w}.

3. Add 1 to i's counter (setting $n_i := n_i + 1$). Then aim the tractor beam at point i's current location \mathbf{p}_i and use the tractor beam to pull the target point to its new location, $\frac{1}{n_i+1}\mathbf{w} + \frac{n_i}{n_i+1}\mathbf{p}_i$.

4. If dissatisfied with the new point locations, go back to step 1.

In figure 6.25, a gray line segment connects \mathbf{w} to \mathbf{p}_i, \mathbf{w} is drawn as a large gray dot, and the target point's new location is drawn as a white dot. It is worth mentioning that the new location for point i, $\frac{1}{n_i+1}\mathbf{w} + \frac{n_i}{n_i+1}\mathbf{p}_i$, is a weighted average of \mathbf{w} and \mathbf{p}_i. The weights are such that the first time that point i is targeted by the tractor beam, its new location will be $\frac{1}{2}\mathbf{w} + \frac{1}{2}\mathbf{p}_i$, which means that it will be pulled halfway toward the tractor beam, as shown in figure 6.25.

The second time that point i is targeted, its new location will be $\frac{1}{3}\mathbf{w} + \frac{2}{3}\mathbf{p}_i$, which means that it will be pulled less, only one-third of the way toward the tractor beam. The third time, it will be pulled even less—one-quarter of the way. What this means is that MacQueen's algorithm provides for the points to build up resistance to the tractor beam. Figure 6.26 displays the result of 10,000 iterations of MacQueen's algorithm.

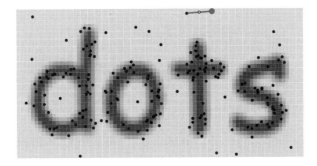

Figure 6.25: After 1 iteration of MacQueen's algorithm.

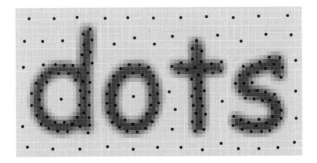

Figure 6.26: The result of 10,000 iterations of MacQueen's algorithm.

Due to the stochastic nature of MacQueen's algorithm (the random selection of the dart-throwing algorithm that gave the initial positions of the points, and the repeated random selection of the location of the tractor beam), if we run the algorithm a second time, we will obtain a different stipple pattern, as shown in figure 6.27. Up close, it is clear that figures 6.26 and 6.27 are different. From a distance, they look the same. Both closely resemble the target image.

If my goal for a piece of TSP Art is to capture the tones of the target image (its lightnesses and darknesses) and nothing more—the emoji examples, for example—then a single run of MacQueen's algorithm usually suffices to produce a decent point set. But if I am striving for more, I might need to do multiple runs—and solve a TSP for each run—in order to get a result that pleases me. For the pieces based on Michelangelo's *The Creation of Adam*, for example, I performed numerous runs of the stippling algorithm and solved numerous TSPs. Figure 6.28 displays four of these point sets, each with 3072 points. From

Figure 6.27: An alternate final stipple pattern.

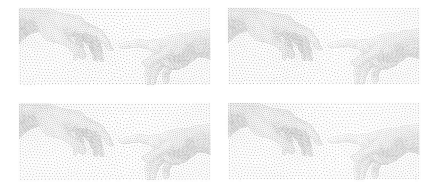

Figure 6.28: Four point sets based on Michelangelo's *The Creation of Adam*.

a distance, the point sets appear to be identical. Figure 6.29 displays an optimal tour for each one, and these tours are quite different from one another. My favorite is the one in the lower right, as it contains a path that extends from one of the knuckles of God's index finger to the tip of Adam's index finger. For the other three (and the many others that are not displayed), I was unhappy with the way in which the tour connected the "God side" and the "Adam side" of the image.

A Gallery of Examples

I designed *Connecting the Dots*, shown in figure 6.30, to honor M. C. Escher. Here I intentionally omitted some of the edges of the optimal tour of the 1640 locations. My hope was that the missing edges would pull the viewer into the piece and induce them to try to connect the remaining

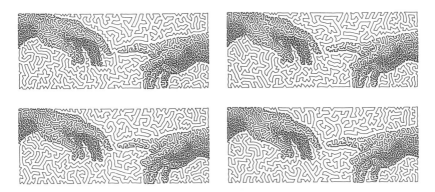

Figure 6.29: An optimal tour for each point set.

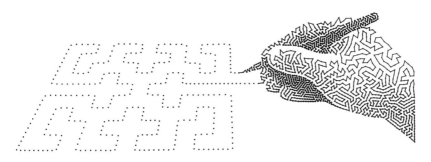

Figure 6.30: *Connecting the Dots.*

dots with their eyes, leading them to discover that the completed piece is a large number of dots joined together to form a simple closed curve.

I have found that if I keep the number of points small (under two or three thousand), then I can count on the Concorde TSP Solver to find an optimal tour in what I consider to be an entirely reasonable amount of time: typically less than a day on my laptop computer, and often much more quickly than that.

The three pieces shown in figure 6.31, each one formed from an optimal tour of $64^2 = 4096$ points, are the largest TSPs I've solved to optimality (thanks to Concorde once again!). Collectively they form one of the most computationally intensive puns ever made! Mathematicians refer to tours as *Hamiltonian cycles* in honor of the great Irish mathematician William Rowan Hamilton. In the triptych of Hamiltonian cycle portraits shown above, we have William Rowan Hamilton himself on the

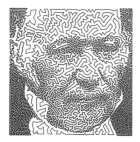 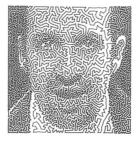 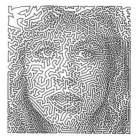

Figure 6.31: Three Hamiltonian cycles of the complete graph on 4096 vertices.

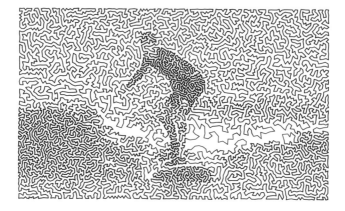

Figure 6.32: *The Surfer Is Connected to the Wave.*

left. In the center and on the right, we have two other famous Hamiltons: Lin-Manuel Miranda (of the Tony-award- and Pulitzer-prize-winning musical *Hamilton*) and Linda Hamilton (of the 1984 movie *The Terminator*, which was selected for preservation by the Library of Congress in 2008). On each of these TSPs, Concorde needed several thousand minutes to obtain an optimal tour, and its branch-and-bound trees had thousands of branch-and-bound nodes. The Linda Hamilton problem was the most difficult for Concorde, requiring 3156 minutes and 6199 branch-and-bound nodes.

If resolution demands more points, then I need to let Concorde run for much longer or give up on optimality. For *The Surfer Is Connected to the Wave*, which is shown in figure 6.32 and is based on an 8192-location TSP derived from a photo of Dima Bosch (not Bethany Hamilton!), I made no attempt to find an optimal tour.

Figure 6.33: *Father and Son* (based on my mother Charlotte Woebcke Bosch's 1968 photo of my father Robert Krauss Bosch and me).

Instead, I employed Concorde's implementation of what is known as the *Lin–Kernighan TSP heuristic*, which tends to produce high-quality tours quite quickly. I also used Lin–Kernighan for the piece *Father and Son*, shown in figure 6.33, which was based on a 10,000-location TSP derived from an old family photo (taken in the last year of my father's life).

The Mona Lisa TSP Challenge

In 2009, TSP guru William Cook asked me to design several large TSP Art instances to challenge TSP researchers. I made six of them— using famous works by Leonardo da Vinci, Vincent van Gogh, Sandro Botticelli, Diego Velázquez, Gustave Courbet, and Johannes Vermeer as target images—with the smallest being a 100,000-point rendition of a section of Leonardo's *Mona Lisa*.

Figure 6.34 displays the best known tour (as of March 3, 2019) for what is known as the *Mona Lisa TSP Challenge*. This tour has length 5,757,191 and was found by Yuichi Nagata on March 17, 2009.

On the website devoted to the challenge, Bill Cook wrote, "An optimal solution to the 100,000-city Mona Lisa instance would set a new world record for the TSP." And in an email dated August 23, 2018, Bill

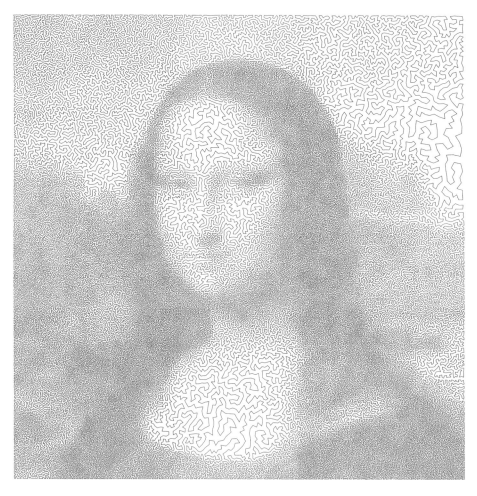

Figure 6.34: The best tour (as of March 3, 2019) for the Mona Lisa TSP Challenge.

informed me that his most recent Concorde run explored 11,479 nodes of the branch-and-cut tree, producing a lower bound of 5,757,092, which is only 99 units below the length of Nagata's tour!

It is possible that Nagata's tour is optimal. During the past nine years, no one has found a better one. But if Nagata's tour isn't optimal, the lower bound obtained with Concorde tells us that the optimal tour cannot be more than 99 distance units shorter (that is, 0.001720% shorter) than Nagata's tour!

TSP Art with Side Constraints

From a distance, a viewer will see *Knot?* (displayed in figure 7.1) as a black Celtic knot drawn on a white background. Moving closer, they will notice that it is actually a single white loop—an *unknot*—drawn on a black background. The viewer may ask, "Where did the knot go?"

Figure 7.1: *Knot?*

If the viewer happens to be a mathematician, they will undoubtedly make some additional observations. From a distance, they will notice that the black knot is an *alternating knot*; if they follow the knot, tracing it with their mind, they will find that the crossings alternate between overpasses and underpasses. And from up close, they will notice that the white loop is a simple closed curve. (Recall that a curve is simple if it does not intersect itself, and closed if it ends up where it began.) There is a famous mathematical result called the *Jordan curve theorem* which states that any simple closed curve in the plane is like a cookie cutter in that it divides the plane into two regions: the part that lies inside the curve (the cookie), and the part that lies outside it (the sheet of extra dough). So when a mathematician sees figure 7.1 they may ask, "For this curve, what do the inside and outside regions look like?"

To answer this question, we can shade in the interior and leave the exterior black, as in figure 7.2. Note that from up close, the coloring helps the viewer realize that the white curve is a simple closed curve. It enables the viewer to quickly identify what's inside the curve (red) and what's outside it (black). But from a distance, the coloring will confuse the inquisitive viewer. If they follow the colored version of the knot, tracing it with their mind, they will notice that sometimes it changes color when it goes through an underpass, and other times it doesn't. They may try to understand why this happens or try to figure out the (here, nonexistent) pattern. They may reason (here, incorrectly) that the artist used the coloring to point out something important or interesting about the Celtic knot.

The left-hand side of figure 7.3 displays a simple-closed-curve rendition of a two-component link—each component resembles a fidget spinner—while the right-hand side draws the same curve and in addition colors in the interior region defined by the curve. In this case the coloring is entirely beneficial: the viewer who sees the uncolored version could mistakenly think that the subject is a knot, but the viewer who sees the colored version will immediately notice that the subject is a two-component link. Each component—each fidget spinner—has its own color.

Images like the colored version of figure 7.3 give viewers a fairly good idea of what the Jordan curve theorem is saying. To give them an even better *feel* for the theorem (in a completely literal sense), we can convert simple closed curves into two-piece simple-closed-curve sculptures. To create the sculpture *Embrace* displayed in figure 7.4,

Figure 7.2: *Knot?* (with colored interior).

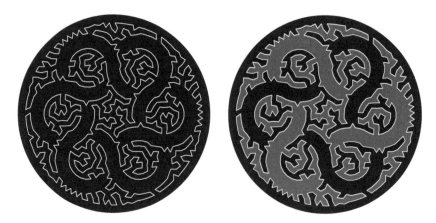

Figure 7.3: A simple-closed-curve rendition of a two-component link, and the same simple closed curve with colored interior.

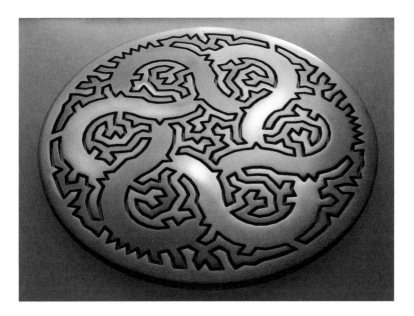

Figure 7.4: *Embrace* (2010 Mathematical Art Exhibition, First Prize).

I copied the figure 7.3 design onto two quarter-inch-thick, eight-inch-diameter disks—one stainless steel, one brass. Then I hired someone to use a water jet cutter to cut along the curve, dividing each disk into two pieces. Finally, I swapped the inside pieces. This yielded two sculptures based on the curve. In the version shown in figure 7.4, the inside piece (the cookie) is stainless steel and the outside piece (the extra dough) is brass.

Controlling the In and Out of the Tour

Figure 7.5 displays a 50-city TSP together with an optimal tour. The point set can be thought of as a circle that was split into regions—labeled *A* and *B*—by a vertical bisector. The optimal tour winds its way through the points in such a way that *A* and *B* lie on the same side of the tour.

There are essentially two formal ways of determining whether two point-free regions *A* and *B* lie on the same side of a non-self-intersecting TSP tour. In the *path method*, we attempt to draw a path from *A* to *B* that doesn't cross any edges of the tour. In effect, we try to find a path through

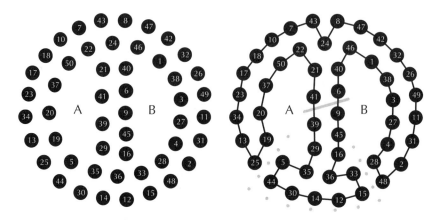

Figure 7.5: A 50-location TSP and an optimal tour.

a maze formed by the tour, a maze that might not have a solution. In our example, there is indeed a path from A to B, marked by the light gray dots in figure 7.5. For a larger, more complicated tour, it may be difficult to find such a path, but if we find one, we will be able to use it to convince anyone that A and B lie on the same side of the tour. Note that if no such path exists, it might be an extremely difficult task to convince ourselves or anyone else that this is the case!

In the *crossing number method*, we draw any line segment $\ell_{A,B}$ that starts in region A, ends in region B, and does not pass through any of the points in the point set (the light gray line in figure 7.5, for example). Next, we count the number of edges of the tour that cross $\ell_{A,B}$. We call this number the *crossing number* for $\ell_{A,B}$, and we denote it $\#(\ell_{A,B})$. For any two point-free regions A and B, there are infinitely many line segments that can serve as $\ell_{A,B}$. The value of $\#(\ell_{A,B})$ may not be the same for each of these line segments, but the parity of $\#(\ell_{A,B})$ will not vary. It will be the same—either odd or even—for all line segments that have one endpoint in A and the other in B.

The crossing number method works as follows: if $\#(\ell_{A,B})$ is even, then A and B lie on the same side of the tour; if $\#(\ell_{A,B})$ is odd, then A and B lie on opposite sides. If the crossing number is even, it gives us a short and convincing proof that A and B lie on the same side of the tour. If it is odd, it provides us with a short and convincing proof that A and B lie on opposite sides. In our example, $\ell_{A,B}$ crosses exactly 2 edges of the tour—edge $\{6, 9\}$ and edge $\{39, 41\}$—so the crossing

number $\#(\ell_{A,B})$ is even, telling us that A and B lie on the same side of the tour.

We need one more piece of notation to be able to incorporate the crossing number into a linear optimization formulation of the TSP. We let $\chi(\ell_{A,B})$ stand for the set of all possible edges $e = \{u, v\}$ that cross $\ell_{A,B}$. This notation enables us to express the crossing number in terms of the x_e variables we use when solving TSP instances:

$$\#\left(\ell_{A,B}\right) = \sum \left(x_e : e \in \chi\left(\ell_{A,B}\right)\right).$$

To force the tour to visit the points in such a way that A and B end up on the same side of the tour, as shown on the right-hand side of figure 7.5, we can introduce a nonnegative integer variable $y_{\ell_{A,B}}$ and impose the following linear equation:

$$\sum \left(x_e : e \in \chi\left(\ell_{A,B}\right)\right) = 2y_{\ell_{A,B}}.$$

To force the tour to separate A and B—so that they end up on opposite sides, as shown on the left-hand side of figure 7.6—we impose a slightly modified version:

$$\sum \left(x_e : e \in \chi\left(\ell_{A,B}\right)\right) = 2y_{\ell_{A,B}} + 1.$$

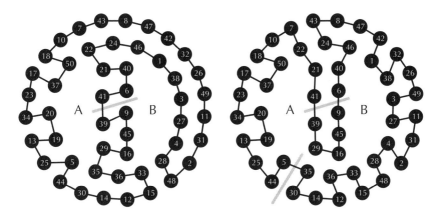

Figure 7.6: Two alternate tours.

The variable $y_{\ell_{A,B}}$ controls the parity of the crossing number (whether it is an even number or an odd number). In the first case, it forces the crossing number to be even (as 2 times an integer is most certainly an even number). In the second, it forces it to be odd (an even number plus 1).

To produce the tour shown on the right-hand side of figure 7.6, we imposed two of these two-region *side constraints*: one to ensure that A and B are on the same side of the tour, and the other to ensure that A ends up in the tour's interior.

Examples

The left-hand side of figure 7.7 shows a 500-location point set that resembles *King Solomon's knot*, which is not a knot but a two-component link (the simplest two-component link). The 500 points define four point-free regions. Regions A and C constitute one component of the link (one of the two pointy ovals), and regions B and D the other. The middle portion of figure 7.7 displays an optimal tour of the points, whereas the right-hand side displays an alternate slightly-longer-than-optimal tour. Both tours look like King Solomon's knot. At a distance, it is difficult to tell one from the other.

In figure 7.8, the interiors are shaded. The shading demonstrates that though the optimal tour may be best in terms of length, it is most definitely *not* best at displaying King Solomon's knot. The optimal tour places regions A and B, which correspond to different components, on one side of the tour and C and D on the other. The alternate tour winds its way through the points in such a way that B and D are in the interior and A and C are in the exterior.

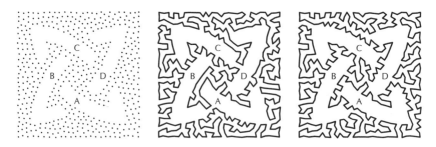

Figure 7.7: A 500-point stipple pattern, an optimal tour, and an alternate tour.

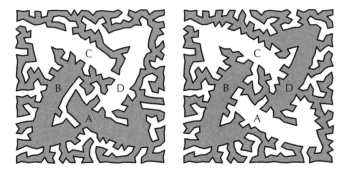

Figure 7.8: The interiors of the tours: optimal (left) and alternate (right).

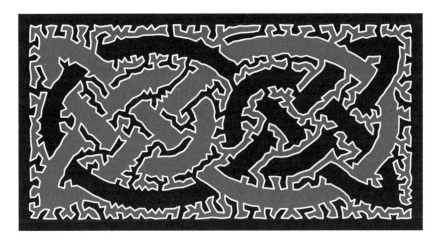

Figure 7.9: *One Fish, Two Fish, Red Fish, Black Fish.*

To find the optimal tour, we used the Concorde TSP Solver. To find the alternate tour, we couldn't rely on Concorde, as it does not allow for side constraints. To find the alternate tour, we used the Gurobi Optimizer's simplex-algorithm-based branch-and-bound capabilities. Figures 7.9 through 7.11 display three additional examples of artwork produced with Gurobi.

In figures 7.9 and 7.10, the tour is white, the exterior is black, and the interior is red. The pieces of the black ring in the center of figure 7.10 (*Outside Ring*) are actually—perhaps surprisingly, at first glance—portions of the tour's exterior.

For figure 7.11 (*The Jordan Curve Theorem*), the tour was drawn on sheets of two different types of plywood—light and dark—and then my

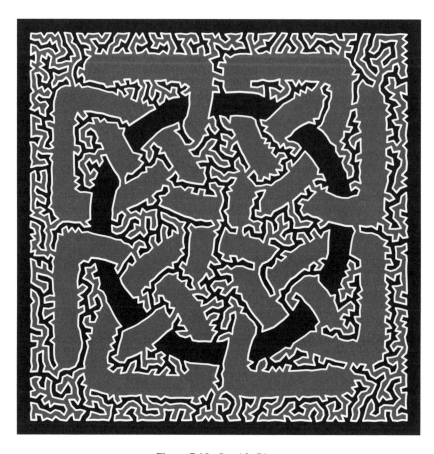

Figure 7.10: *Outside Ring*.

Figure 7.11: *The Jordan Curve Theorem*.

friend James Gyre used a laser cutter to cut through them. If you look closely, you can see the burn marks that were left by the laser as it cut along the edges of the tour. The cut plywood pieces were then stacked in such a way that the interior of the tour would be darker and also, more importantly, inset. The inset portion is a single connected piece and reads "IN". The non-sunken part is a single connected piece and reads "OUT".

Symmetric Tours

Suppose we've been hired to design a TSP Art fidget spinner that's based on the target image displayed on the left-hand side of figure 7.12. If we use MacQueen's algorithm to construct a stipple pattern, we will obtain something like the right-hand side of figure 7.12. The target image has 10-fold rotational symmetry, but the stipple pattern does not. The wedges are similar but not identical.

Symmetric Stippling

To create a stipple pattern that has 10-fold rotational symmetry, we run a two-phase algorithm based on MacQueen's tractor beam algorithm. In phase 1, we run the standard version of MacQueen's tractor beam algorithm, exactly as described in chapter 6 (and ending up with something like the right-hand side of figure 7.12). We then find all of the points that lie in the "first wedge" (the 0°-to-36° white wedge) of a circle centered

Figure 7.12: A target image with 10-fold rotational symmetry and a stipple pattern constructed with MacQueen's algorithm.

Figure 7.13: A rotationally symmetric version of MacQueen's tractor beam algorithm at the end of (a) phase 1 and (b) phase 2.

at the center of the target image, and we discard all of the points that lie in the other 9 wedges (the gray ones). By rotating the points in the white wedge 36° about the center of the drawing, then another 36°, then another 36°, and so on, we produce symmetric "replacement points" for the other 9 wedges. The resulting stipple pattern (shown on the left-hand side of figure 7.13) will definitely have 10-fold rotational symmetry, but near the wedge boundaries we are likely to find points in each wedge that are too close to points in a neighboring wedge.

In phase 2, we fix the "too closeness" by running a modified version of MacQueen's algorithm. Here, when we select the location **w** of the tractor beam, we rotate it 9 times by 36° in order to position a total of 10 rotationally symmetric tractor beams, one in each wedge. We aim each tractor beam at the point that's closest to it in the point set. With 10 tractor beams, there will be 10 target points, one in each wedge. The target points will have 10-fold rotational symmetry, so when the tractor beams pull them, the 10-fold rotational symmetry of the stipple pattern will be preserved. If we perform many iterations of the algorithm, we will end up with something like the right-hand side of figure 7.13.

Symmetric Tours

To force the tour to be symmetric, we impose additional side constraints, and these side constraints are quite simple. Our side constraints set $x_e = x_{e'}$ whenever edges $e = \{u, v\}$ and $e' = \{u', v'\}$ are rotational counterparts (rotated copies of each other).

Figure 7.14: Eight possible designs for a TSP Art fidget spinner.

If our stipple pattern has 10-fold rotational symmetry, but we force the tour to have 5-fold rotational symmetry instead of the expected 10-fold, then when we shade the interior of the tour, we will find that certain "motifs" appear in both shaded and unshaded forms. In the top-left design of figure 7.14, for example, I see 10 snakes, each of them staring into the center of the design. Observe that 5 of the snakes are white on a gray background, and 5 of them are gray on a white background. They alternate white, gray, white, gray, and so on. Due to the 5-fold symmetry of the tour, if we rotate the design 72° it will look exactly the same. Due to the 10-fold symmetry of the points, if we rotate it 36°, much of it will look the same, but with the colors swapped. All eight of the designs share some of this color symmetry—alternating white and gray leaves in the top-right design, alternating white and gray robotic claws in the bottom left, alternating white and gray light sabers in the bottom right.

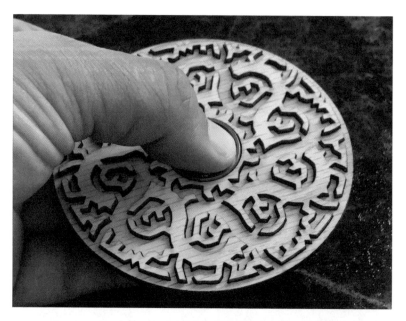

Figure 7.15: A bespoke laser-cut hardwood TSP Art fidget spinner.

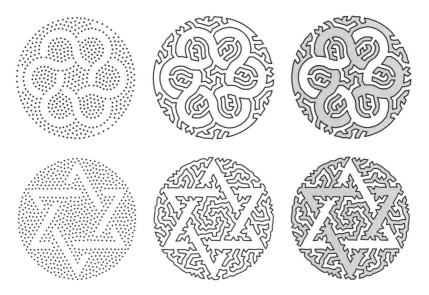

Figure 7.16: Interlocking triangles (curvy and straight).

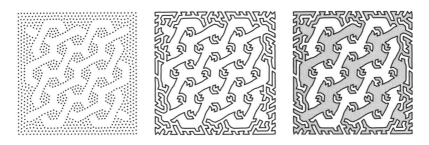

Figure 7.17: *Interwoven*.

The bottom-left design was my favorite, so I put in an order for it to be laser cut in oak. Figure 7.15 shows two photos of the final product. The inside piece is twice as thick as the outside piece.

Figures 7.16 through 7.18 display several more of my favorite symmetric designs. The two examples shown in figure 7.16 have 6-fold rotationally symmetric point sets and 3-fold rotationally symmetric tours.

In figure 7.17's *Interwoven*, which was inspired by the work of the great mathematical artist Rinus Roelofs, both the point set and the tour have 2-fold rotational symmetry, but there is additional symmetry: the

Figure 7.18: *Square Knot.*

Figure 7.19: Smoothing two segments of the tour with a cubic Bezier curve.

open-mouthed-head motif appears in both gray and white and in various rotations and reflections.

In figure 7.18, the point set has horizontal mirror symmetry, but the tour does not.

Smoothing the Tour

If we'd prefer a smooth curve to the usual piecewise linear tour, which may be too crinkly for some target images, we can follow a process familiar to many graphic designers. In the left part of figure 7.19, we see two adjacent segments of a tour. In the first step of our smoothing process, we find the midpoint of each tour segment. In the second step, we find the midpoint of each subsegment. In the final step, we use the two tour-segment midpoints and two of the subsegment midpoints as the *control points* (marked in black in the right-hand part of figure 7.19) for a *cubic Bezier curve*. The Bezier curve is guaranteed to connect the two tour-segment midpoints, to be tangent to the two tour segments, and to lie within the convex quadrilateral (drawn in light gray) formed by the four control points.

Figure 7.20: Smoothed symmetric designs.

If we perform these operations for every pair of adjacent tour segments, we transform the tour into a smooth simple closed curve. Figure 7.20 displays six examples—simple-closed-curve "portraits" of five links and one knot. The top-left piece is a smoothed version of the design from the top row of figure 7.16.

CHAPTER 8
Knight's Tours

We can also use optimization to design *knight's tours*. As shown in figure 8.1, we start with a standard 8×8 chessboard, place a dot (a vertex) in each square, and then draw a line segment (an edge) for each pair of squares that can be connected by a single move of a chess knight, who is allowed to move only by going two squares in one direction and then one in an orthogonal direction. A knight's tour can be thought of as a TSP tour of the chessboard. The knight starts in any one square, the bottom-right square for example, and then, through a sequence of 63 knight's moves, visits each of the remaining squares once and only once. On the 64th and final move, the knight returns to the starting square.

Thanks to the work of an Australian computer scientist named Brendan McKay, we know that there are 13,267,364,410,532 undirected knight's tours of a standard 8×8 chessboard, far too many for anyone to examine one at a time. Even if we had a superpower that gave us the ability to view knight's tours at a rate of 100 tours per second, we would need 4207 years to see them all!

Also thanks to McKay, we know that 608,233 of the 8×8 knight's tours have twofold rotational symmetry. A *twofold tour* is unchanged when rotated by 180°, which means that it looks the same when viewed from opposite sides of the board. With our superpower, it would take us much less time to view all the twofold tours: slightly less than 1.69 solid days at 100 tours per second.

If each square of the chessboard is 1 unit wide, then each knight's move has length $\sqrt{5}$ and each 8×8 knight's tour has exactly the same tour length, $64\sqrt{5}$. This means that minimizing the length of a knight's tour is pointless. If we want to optimize the tour, we need a different objective function, a different measure of tour quality.

First I decided to search for 8×8 knight's tours that are as close as possible to having fourfold rotational symmetry, as it is known that no

Figure 8.1: A chessboard (top left), with vertices (top right), with both vertices and edges (bottom left), and with a knight's tour of the board (bottom right).

8×8 knight's tour possesses this symmetry. That is, no 8×8 knight's tour is unchanged when rotated by 90°. No 8×8 knight's tour looks the same when viewed from all four sides of the board.

The two knight's tours shown in figure 8.2 are twofold tours, but they are not fourfold tours. They have twofold rotational symmetry, but they do not have fourfold rotational symmetry. They look the same from opposite sides of the board, but they do not look precisely the same from all four sides. But given that they are quite close to having fourfold rotational symmetry—as close as possible, it turns out—we can call them *nearly fourfold* tours.

If we remove from these nearly fourfold tours all nonsymmetric edges—all edges that are missing one or more of their rotated

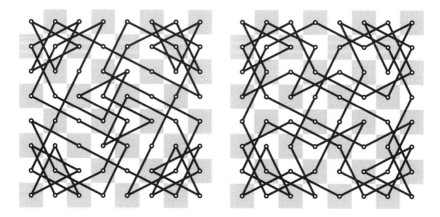

Figure 8.2: Two nearly fourfold knight's tours.

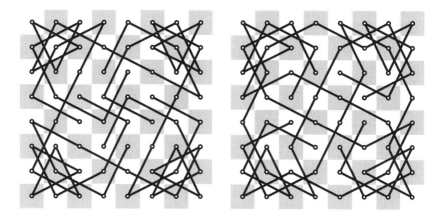

Figure 8.3: Nearly fourfold tours with nonsymmetric edges removed.

counterparts—we obtain tour fragments that do have fourfold symmetry, as shown in figure 8.3. In each case, 60 of the original 64 edges remain. All 60 of these fully symmetric edges have all of their rotated counterpart edges present in the tour, the largest number possible.

To find a nearly fourfold tour, we introduce additional binary variables. In addition to what we did for the TSP—having a binary edge-usage variable x_e that equals 1 if we select the knight's-move edge e to be in the tour and 0 if we don't—we include a binary symmetry-detection variable r_e that equals 1 if edge e is fully symmetric in the tour (that is, is accompanied by all of its rotated counterpart edges).

Here are the details: Let E denote the set of all possible knight's moves on the standard 8×8 chessboard. For each possible knight's-move edge e in E, we let e', e'', e''' stand for the other three knight's-move edges that are the $90°$-, $180°$-, and $270°$-counterclockwise-rotated counterparts of edge e. We want to ensure that all four edges e, e', e'', and e''' appear in the tour when r_e equals 1. To enforce this, we impose four linear inequalities:

$$r_e \leq x_e, \qquad r_e \leq x_{e'}, \qquad r_e \leq x_{e''}, \qquad \text{and} \qquad r_e \leq x_{e'''}.$$

Even though they are linear inequalities, we think of them as logical implications. The first one states that if r_e equals 1, then x_e equals 1. The second inequality states that if r_e equals 1, then $x_{e'}$ equals 1. And so on. Together they tell us what we must do if we set the symmetry-detection variable r_e equal to 1: we must also set the edge-usage variables x_e, $x_{e'}$, $x_{e''}$, and $x_{e'''}$ equal to 1.

With the r_e symmetry-detection variables and the linear inequalities that link them to the x_e edge-usage variables, we can maximize the number of fully symmetric edges in the tour by solving the following linear optimization problem:

maximize $\displaystyle\sum_e r_e$

subject to $\quad r_e \leq x_e, r_e \leq x_{e'}, r_e \leq x_{e''}, r_e \leq x_{e'''}$ *for all e in E*,

the usual TSP constraints (degree and subtour elimination).

It was by solving this model (with Gurobi) that I obtained the nearly fourfold knight's tour shown on the left-hand side of figure 8.2. Then, after imposing two additional linear constraints—one to prohibit this first tour and one to prohibit its mirror image—I solved the updated model (again with Gurobi) and obtained the nearly fourfold knight's tour shown on the right-hand side of figure 8.2. By repeating this process many times, I found many additional nearly fourfold knight's tours, including the two displayed in figure 8.4.

Figures 8.5 through 8.8 show 3D-printed sculptural versions of the nearly fourfold tours (photographed on a light board). When viewed from the focal point (about one meter away, straight on), they look flat, just like the standard drawings displayed in figures 8.2 and 8.4.

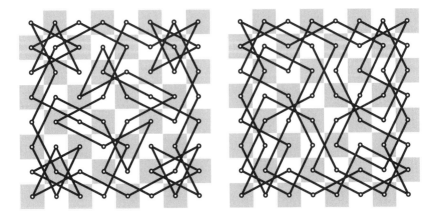

Figure 8.4: Two more nearly fourfold knight's tours.

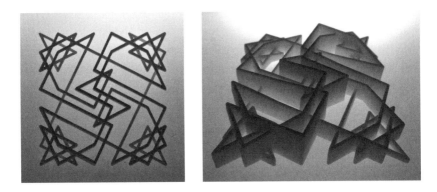

Figure 8.5: A 3D-printed nearly fourfold knight's tour.

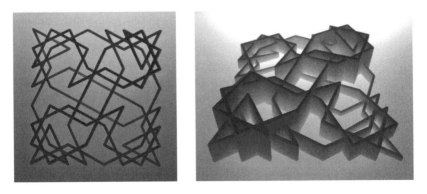

Figure 8.6: A second 3D-printed nearly fourfold knight's tour.

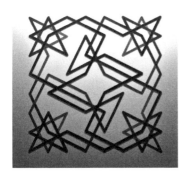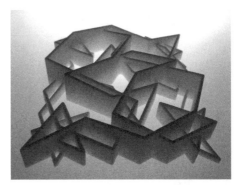

Figure 8.7: A third 3D-printed nearly fourfold knight's tour.

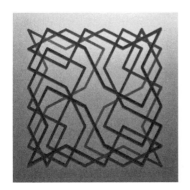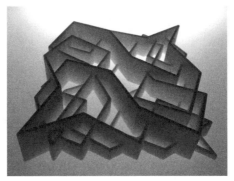

Figure 8.8: One more 3D-printed nearly fourfold knight's tour.

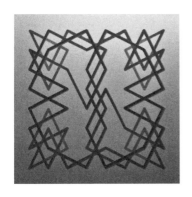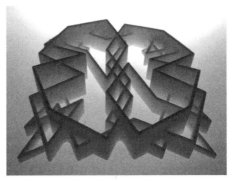

Figure 8.9: Two views of a 3D-printed nearly mirror knight's tour.

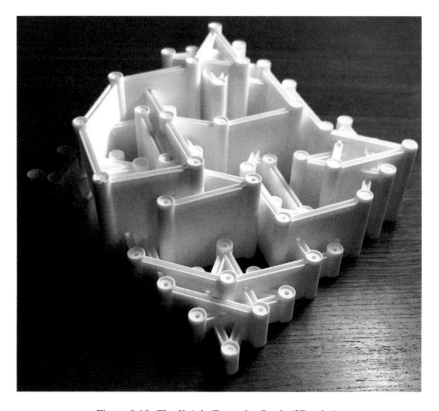

Figure 8.10: *The Knight Tours the Castle* (3D print).

From other viewpoints, the 3D-printed knight's tours resemble architectural models. When we view them from the side, we see that in each case the elevation of the tour is not uniform (due to the intentional variations in the amount of extrusion in the 3D print). We can imagine the knight starting in the bottom right corner. As he moves from vertex to vertex, his altitude increases. When he is 16 moves in, at the quarter point of his tour, he is at maximum altitude. He starts to descend. By 32 moves in, at the halfway point (the top-left corner, which is hidden from view in the right-hand photos), he is back to his starting altitude. During the second half of the tour, he repeats the elevation pattern.

The 3D-printed sculptural versions make it easier for viewers to follow a knight's tour. When I try to follow the knight's path in a standard drawing of a knight's tour, my eyes tend to jump from one tour segment to other nearby parallel tour segments, and I end up having to start over again. I don't have this problem when I try to trace the 3D-printed

Figure 8.11: *The Knight Tours the Castle* (with Sage Jenson).

versions. In addition, I believe that the sculptural versions are more likely to engage viewers and pull them into the artwork. I believe that by varying the elevation, I induce viewers to spend more time with the tour, following it upward, downward, upward, downward.

I used a similar discrete linear optimization model to search for 8×8 knight's tours that are as close as possible to having mirror symmetry, as it is known that no knight's tour of an 8×8 board has this symmetry. Figure 8.9 displays a sculptural version of a *nearly mirror* tour found using this method. At a quick glance, it appears to have vertical mirror symmetry, but only 56 of its 64 edges are accompanied by their mirror-symmetric counterparts in the tour.

Figures 8.10 and 8.11 display two versions of a piece called *The Knight Tours the Castle*. Both are based on the knight's tour shown in

figure 8.7, but with a different elevation pattern. Figure 8.10 shows a photo of a 3D-printed sculptural version. The sculpture is functional in the sense that a tiny knight could "tour the castle" by walking along its walkways and passing through its turrets.

Figure 8.11 is digital artwork of the same structure. This piece was done in collaboration with my former student Sage Jenson, who did the rendering (the texturing, lighting, and shading).

CHAPTER 9

Labyrinth Design with Tiling and Pattern Matching

If Theseus were to venture into one of the 13×13 labyrinths shown in figure 9.1, he would easily make his way to its center, unspooling out Ariadne's thread as he navigated the dimly lit passageways. Of course, he would know that when he reached the center, he would have to fight the Minotaur, and that the battle would bring him to the brink of exhaustion. So our hero would be well aware that Ariadne's gift is truly a treasure, even though the labyrinth is unicursal—a most trivial maze that consists of nothing but a single path that connects the center to the outside world. For without Ariadne's thread, what would happen if, after the fight, a punch drunk Theseus were to experience a sudden bout of dizziness? When his head and body finally stopped spinning, would he still be on his way out? Or would he be headed back toward the center?

In either labyrinth, Theseus would visit each of the $13^2 = 169$ grid points on both his inward and his outward journeys. And in either labyrinth, Theseus's path would cover the same total distance: $13^2 - 1 = 168$ distance units (the distance from any grid point to a closest neighbor). But certainly Theseus would experience the two labyrinths differently. If he could see their floor plans beforehand, he'd undoubtedly have a strong preference for the one on the left. The labyrinth on the left has only 28 turns. Because of its long straightaways, Theseus would be able to make the inward trip quickly and arrive at the center fresh for the fight. The labyrinth on the right has a whopping 154 turns. In this labyrinth, Theseus might arrive at the center in a state of great agitation, having had to deal with the stress of "What's around this particular corner?" much more frequently than he would have liked.

If you were hoping to be hired by King Minos to design a labyrinth, you would want to be able to control the number of turns in your labyrinth, to be able to make your labyrinth more bendy, or less bendy,

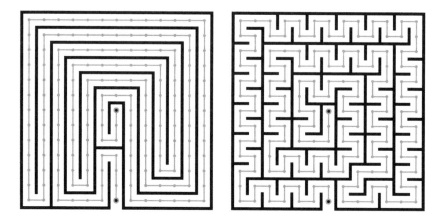

Figure 9.1: Two labyrinths on a 13×13 grid.

or exactly as bendy as King Minos desired. You would also want to be able to specify both the location of the entrance and the location of the Minotaur in accordance with his wishes. Finally, you would want to be able to design a labyrinth that would catch his eye, or in other words, have an aesthetically pleasing floor plan. Figure 9.2 displays two additional 13×13 labyrinths. Neither is perfectly symmetric in any way—none can be—but without question the labyrinth on the right is much closer to being "maximally symmetric" (which would require having rotational symmetry and vertical and horizontal mirror symmetry) than the one on the left. In fact, the labyrinth on the right is reminiscent of some labyrinths found on the floors of medieval cathedrals (Chartres, for example, where it is possible—if you show up on the right day— to join the pilgrims who walk the labyrinth and meditate, reflect, and contemplate the progress they've made on their ongoing journey to the afterlife).

Figure 9.3 displays two of the many 13×13 labyrinths that can be called *nearly fourfold*, by virtue of being as close as possible (in a sense similar to that defined in the previous chapter) to having fourfold rotational symmetry.

One approach to labyrinth design involves making minor modifications to the TSP-based linear optimization model for finding close-to-symmetric knight's tours. In addition to the binary edge-selection variables and symmetry-detection variables, we could include a bend-detection variable $b_{e,f}$ for every unordered pair of edges e and f that

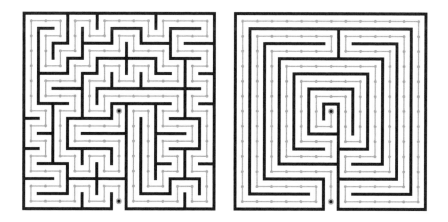

Figure 9.2: Two additional labyrinths on a 13×13 grid.

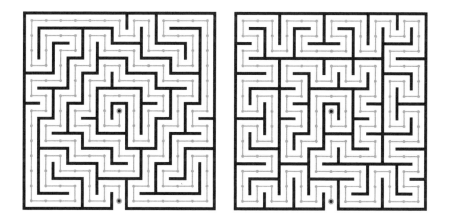

Figure 9.3: Two nearly fourfold labyrinths on a 13×13 grid.

intersect at a right angle, forming a bend. To detect this particular bend, we could impose the following linear constraints:

$$b_{e,f} \leq x_e, \qquad b_{e,f} \leq x_f, \qquad x_e + x_f \leq 1 + b_{e,f}.$$

The first two inequalities force x_e and x_f to equal 1 when $b_{e,f}$ equals 1, and the third one forces $b_{e,f}$ to equal 1 when both x_e and x_f equal 1. Together they model the logical equivalence $b_{e,f} = 1$ if and only if $x_e = 1$ and $x_f = 1$.

Labyrinth Tiles

A second approach requires thinking of a labyrinth as being composed of copies of the eight different *labyrinth tiles* shown on the right-hand side of figure 9.4. Tiles *A* through *D* are the bendy ones (that have turns), and tiles *E*, *F*, *T*, and *M* are the straight ones. In any unicursal labyrinth, tile *T* and tile *M* will appear just once, as they mark the starting position of Theseus and the location of the Minotaur, respectively. We are making two assumptions: first, that King Minos requires the path to begin by heading straight toward the center of the labyrinth, and second, that he wants the entrance to the Minotaur's lair to be oriented in the same direction as the entrance.

Designing a labyrinth, then, requires determining which tiles we place in the various square cells. To model this, we once again use binary variables, setting $x_{t,i,j}$ equal to 1 if we place a copy of tile t in the row-i–column-j square. If we follow Theseus into the labyrinth displayed on the left-hand side of figure 9.4, we see that $x_{T,9,5} = 1$, $x_{F,8,5} = 1$, and $x_{B,7,5} = 1$.

With these binary tile-placement variables, we can compute the total number of bends via the linear equation

$$bends = \sum_i \sum_j \left(x_{A,i,j} + x_{B,i,j} + x_{C,i,j} + x_{D,i,j} \right),$$

and we can use this expression as our objective function if we want to maximize or minimize the total number of 90° turns that Theseus will take on his journey to the Minotaur.

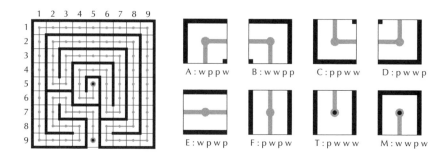

Figure 9.4: A grid superimposed on a 9×9 labyrinth, revealing it to be composed of copies of the eight different labyrinth tiles.

Now we turn to the constraints. If King Minos wants the entrance to the labyrinth to be in the center of the bottom row, we would impose $x_{T,9,5} = 1$ when designing a 9×9 labyrinth and $x_{T,n,(n+1)/2} = 1$ for the general case, an $n \times n$ labyrinth. If King Minos wants the Minotaur to hang out in the center, we would impose $x_{M,5,5} = 1$ for a 9×9 labyrinth and $x_{M,(n+1)/2,(n+1)/2}$ for the general case. And for each cell (i, j) that doesn't contain Theseus or the Minotaur, we would impose the linear equation

$$x_{A,i,j} + x_{B,i,j} + x_{C,i,j} + x_{D,i,j} + x_{E,i,j} + x_{F,i,j} = 1$$

to ensure that the cell receives one and only one tile.

Pattern-Matching Constraints

What we have yet to do is to make sure that when we lay down the tiles, they form a single path that connects Theseus to the Minotaur. We need to devise the tile-placement analogues of a TSP model's degree constraints and subtour-elimination constraints.

We handle the degree constraints through what we call *pattern-matching constraints*. Each labyrinth tile has four sides, and each side is either part of the path or a wall. On the right-hand side of figure 9.4, just below the drawing of each tile, we see its *path–wall sequence*, a sequence of p's and w's presented in clockwise order starting at the top. We write a generic tile t's path–wall sequence as TOP(t), RIGHT(t), BOTTOM(t), LEFT(t). So for tile A, we have

$$\text{TOP}(A) = w, \quad \text{RIGHT}(A) = p, \quad \text{BOTTOM}(A) = p,$$
$$\text{LEFT}(A) = w,$$

as the path passes through the right and bottom sides of tile A.

Now let's consider two neighboring cells that are horizontal neighbors. We must make sure that the right-hand side of the tile placed in cell (i, j) has the same pattern value—a p or a w—as the left-hand side of the tile placed in cell $(i, j + 1)$. Perhaps surprisingly, all we need is the following linear equation:

$$x_{A,i,j} + x_{C,i,j} + x_{E,i,j} = x_{B,i,j+1} + x_{D,i,j+1} + x_{E,i,j+1}.$$

The left-hand side counts the total number of tiles t with $\text{RIGHT}(t) = p$ that are placed in cell (i, j), and the right-hand side counts the total number of tiles t with $\text{LEFT}(t) = p$ that are placed in cell $(i, j + 1)$. By virtue of the one-tile-per-cell constraints presented earlier, each of these counts can only be 0 or 1. If the left-hand side evaluates to 1, then the right-hand side must evaluate to 1. If the left-hand side is 0, then the right-hand side must be 0. And vice versa.

And for vertical neighbors we must make sure that the bottom side of the tile placed in cell (i, j) has the same pattern value as the top side of the tile placed in the cell just below it, cell $(i + 1, j)$. Again, all we need is a single linear equation:

$$x_{A,i,j} + x_{B,i,j} + x_{F,i,j} = x_{C,i+1,j} + x_{D,i+1,j} + x_{F,i+1,j}.$$

Here, the left-hand side counts the total number of tiles t with $\text{BOTTOM}(t) = p$ that are placed in cell (i, j), and the right-hand side counts the total number of tiles t with $\text{TOP}(t) = p$ that are placed just below in cell $(i + 1, j)$.

If we choose to maximize the total number of bends, then we don't need to impose any additional constraints. For each grid there are multiple optimal solutions—a greater and greater number as the size of the grid increases. For the 9×9 case, the Gurobi Optimizer found 2 optimal solutions, while for each of the 13×13, 17×17, 21×21, and 25×25 cases, the number was twice the number for the previous case. For the 9×9 and 13×13 cases, Gurobi needed only a fraction of a second to find all optimal solutions, while for the 25×25 case, it needed about 70 seconds to find them all. Figure 9.5 displays three maximally bendy

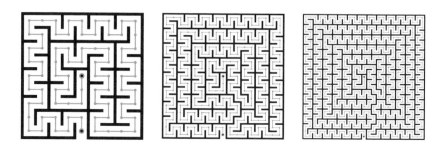

Figure 9.5: Bendiest labyrinths for 9×9, 17×17, and 25×25 grids.

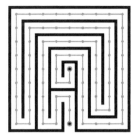 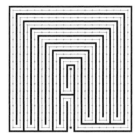 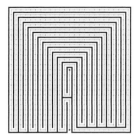

Figure 9.6: Least bendy labyrinths for 9×9, 17×17, and 25×25 grids.

labyrinths that force Theseus to alternate between making clockwise and counterclockwise circuits.

If instead we choose to minimize the number of bends, then we do need to implement the analogue of TSP subtour-elimination constraints—constraints that eliminate loops. We don't want loops! We want to lay down the tiles so that the path segments on them join together to form a single path that connects Theseus to the Minotaur and visits every other square cell along the way. As we did when tackling the TSP, we follow a whack-a-mole strategy, imposing loop-elimination constraints just for the loops we come across. Again, for each grid there are multiple optimal solutions. But here there are many more, and the number grows much more quickly as the size of the grid increases.

For the 9×9 case, Gurobi found all 8 minimally bendy solutions in less than 0.1 seconds, imposing just 2 loop-elimination constraints in the process. For the 13×13 case, there are 606 optimal solutions, and Gurobi found all of them in just under 12 minutes, imposing a total of 388 loop-elimination constraints. For larger cases, I made no effort to find all optimal solutions, terminating the search after finding 100 optimal solutions. Figure 9.6 displays three examples from the same infinite family of labyrinths.

Different Objective Functions

We can also attempt to design labyrinths that have a desired pattern of bendy tiles and straight tiles. For the three labyrinths shown in figure 9.7, the desired pattern was a diamond set within a square, with the diamond packed with bendy tiles and the straight tiles banished to the corners.

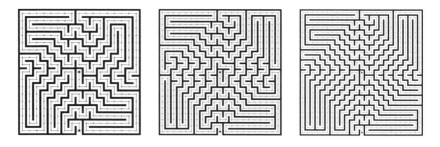

Figure 9.7: Labyrinths (17×17, 21×21, and 25×25) that look like diamonds.

The idea was to minimize the total number of "misplaced" tiles—the number of straight tiles inside the diamond, plus the number of bendy tiles outside it. Gurobi had no trouble executing this task. For the 25×25 labyrinth on the right, it took less than 1 minute, imposing a total of 89 loop-elimination constraints.

Interestingly, the inverted pattern—the one with the straight tiles inside the diamond and the bendy tiles in the corners—was more of a challenge for Gurobi, requiring approximately 12 minutes and 226 loop-elimination constraints for the 13×13 case (not shown). This demonstrates that the objective function can have a big impact on how long it takes to solve a linear optimization problem.

Other objective functions can be formed with symmetry-detection variables. For example, we can mimic what we did when we were designing knight's tours. Here we let t', t'', and t''' denote the tiles we obtain when we rotate tile t counterclockwise by $90°$, $180°$, and $270°$, respectively. If we rotate an $n \times n$ grid $90°$ counterclockwise about its center, we end up moving cell (i, j) to cell $(n + 1 - j, i)$. To detect instances of fourfold rotational symmetry, we therefore introduce a binary variable $r_{t,i,j}$ for each tile t and each cell (i, j), and impose the following linear constraints:

$$r_{t,i,j} \leq x_{t,i,j}, \qquad\qquad r_{t,i,j} \leq x_{t',n+1-j,i},$$

$$r_{t,i,j} \leq x_{t'',n+1-i,n+1-j}, \qquad r_{t,i,j} \leq x_{t''',j,n+1-i},$$

$$x_{t,i,j} + x_{t',n+1-j,i} + x_{t'',n+1-i,n+1-j} + x_{t''',j,n+1-i} \leq 3 + r_{t,i,j}.$$

The first four inequalities state that if the fourfold symmetry-detection variable $r_{t,i,j}$ equals 1, then all four of the tile-placement variables

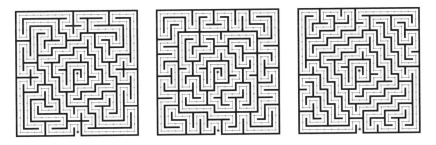

Figure 9.8: Three nearly fourfold labyrinths on a 17×17 grid.

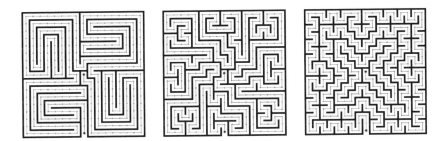

Figure 9.9: Three additional nearly fourfold 17×17 labyrinths.

that deal with the tile placement and its rotated counterparts must also equal 1. The final inequality handles the converse implication.

By maximizing the sum of the fourfold symmetry-detection variables, we can search for nearly fourfold labyrinths. But with twice as many binary variables and many additional constraints, it takes Gurobi considerably longer to solve these optimization models. After running Gurobi for one hour, during which it had imposed almost 2000 loop-elimination constraints, I had a collection of 30 nearly fourfold labyrinths on a 17×17 grid. After running it all night, I had obtained several hundred more, still an undoubtedly minuscule sample of the entire set. Although all of my nearly fourfold labyrinths have the same objective function value—the same number of tiles with all of their 90° rotational counterparts present in the labyrinth—some of them just look more symmetric, due to simple repeating motifs like crosses, T's, and staircases that catch the eye, than do others. Figure 9.8 displays three of my favorites.

Figure 9.9 displays three additional nearly fourfold 17×17 labyrinths. The left-hand labyrinth is the unique nearly fourfold 17×17 labyrinth that has 68 turns, the fewest number possible. The right-hand

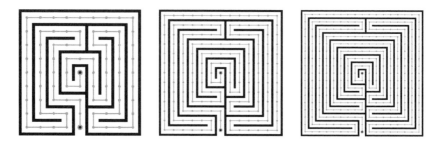

Figure 9.10: Three members of a family of nearly symmetric labyrinths.

labyrinth is one of eight that have 266 turns, the greatest number possible. And the one in the center has 164 turns, roughly halfway between the two extremes.

If we include even more binary symmetry-detection variables—$h_{t,i,j}$ and $v_{t,i,j}$ variables for detecting instances of horizontal and vertical mirror symmetry, in addition to the $r_{t,i,j}$ variables for detecting instances of fourfold rotational symmetry—we can design labyrinths that are even closer to being symmetric (in the sense of having a higher total symmetry score). But with even more binary variables and the constraints we must include to link them to the $x_{t,i,j}$ tile-placement variables, we must run Gurobi even longer to obtain optimal solutions: only 4 seconds (and 8 loop-elimination constraints) for the 9×9 labyrinth on the left in figure 9.10, 5 minutes (and 48 loop-elimination constraints) for the 13×13 labyrinth in the center, and just under 4 hours (and 90 loop-elimination constraints) for the 17×17 labyrinth on the right.

Mosaics with Side Constraints

In chapter 4 we adapted a model for the linear assignment problem—for determining a least-cost assignment of professors to courses—so that we could use it to solve instances of the cartoon-mosaic design problem. The left-hand side of figure 10.1 reproduces (for convenience) our cartoon-mosaic rendition of Frankenstein's monster. Each of the 10 building-block cartoons appears 33 times, as was desired. Unfortunately, the cartoons are clumped together to an undesirable degree. There is a large patch of Martha Washington cartoons in the monster's forehead region, for example, and there is a sizable cluster of Devo cartoons in the shadow of his chin. The right-hand side of figure 10.1, which shows gray tiles instead of the cartoons, makes the clumpiness easier to recognize.

Can we reduce the clumpiness? Better yet, can we eliminate it entirely, so that no cartoon (or gray tile) touches another of the same type (or shade)?

Map Coloring

The problem we face is similar to that faced by mapmakers, who routinely assign different colors to neighboring regions—whether they be countries, states, provinces, or counties—in order to make it easier for viewers to identify borders and distinguish neighboring regions. In fact, a map is said to be *properly colored* if no two neighboring regions have the same color. An example is shown in figure 10.2.

To produce a properly colored map via linear optimization, we introduce binary variables for keeping track of which colors are placed in which regions. We set $x_{c,r}$ equal to 1 if we decide to use color c for region r, and we set $x_{c,r}$ equal to 0 if we don't use this particular color–region pairing.

Figure 10.1: Frankenstein's monster as a cartoon mosaic in which each of the 10 cartoons (or shades of gray) appears the same number of times.

Figure 10.2: A properly colored map.

To ensure that the variable assignments will yield a properly colored map, we impose two types of constraints. The *region constraints* are akin to the block constraints we used in our model for the cartoon-mosaic design problem. For each region r, we impose a linear equation

$$\sum_c x_{c,r} = 1$$

to force ourselves to choose just one color c for region r.

The *map-coloring constraints* are what's new here. For each color c in our color palette and each pair of regions r and r' that share a border, we impose a linear inequality

$$x_{c,r} + x_{c,r'} \leq 1,$$

to prevent ourselves from setting both $x_{c,r}$ and $x_{c,r'}$ equal to 1. For example, for regions A and B, we impose

$$x_{1,A} + x_{1,B} \leq 1, \quad x_{2,A} + x_{2,B} \leq 1, \quad x_{3,A} + x_{3,B} \leq 1, \quad \text{and}$$
$$x_{4,A} + x_{4,B} \leq 1.$$

They tell us that we can't use color 1 for both A and B, we can't use color 2 for both A and B, and so on. If we have just four colors in our color palette, these inequalities will ensure that we choose different colors for A and B.

Consequently, to eliminate the clumpiness of the cartoon mosaic shown in figure 10.1, we can solve the following modification of the cartoon-mosaic design problem:

> minimize *total cost*
>
> subject to *the block equations,*
>
> *the cartoon/color equations,*
>
> *the map-coloring constraints,*
>
> *a binary restriction on each variable $x_{c,i,j}$.*

This optimization problem has many more constraints than the original one, as it has $10 \cdot 22 \cdot (15 - 1) = 3080$ map-coloring constraints for the horizontally adjacent pairs of neighboring blocks and $10 \cdot (22 - 1) \cdot 15 = 3150$ map-coloring constraints for the vertically adjacent neighbors. (Recall that there are 10 different types of cartoons and that the mosaic's dimensions were to be 22×15.) The original optimization model had only $22 \times 15 = 330$ block constraints and 10 cartoon constraints, so having an additional 6230 constraints is a huge increase!

Still, Gurobi obtained the optimal solution displayed in figure 10.3 in only 0.06 seconds using 647 iterations of the simplex algorithm. For the original version, Gurobi took 0.02 seconds and 221 iterations.

Figure 10.3: A map-colored cartoon mosaic of Frankenstein's monster.

In the original version of the problem, there is no harm in replacing each binary restriction $x_{c,i,j} \in \{0, 1\}$ with its continuous relaxation, $0 \le x_{c,i,j} \le 1$. If we use the simplex algorithm to solve the continuous relaxation, all of the variables will end up being integer valued (either 0 or 1) even though we didn't force them to be integer valued! This truly wonderful property of the original problem is *not* shared by the version with map-coloring constraints.

Still, even with the map-coloring constraints, not much branching is needed. For the map-colored mosaic of *Mona Lisa* shown on the left-hand side of figure 10.4, Gurobi needed to solve the continuous relaxation only, as its optimal solution was integer valued. For the mosaic on the right, Gurobi did need to branch, but not much; there were only 8 nodes in its branch-and-bound tree.

Artistic Effects

Once we have constructed a map-colored mosaic, we can produce a seemingly endless number of modifications by replacing its square tiles with other tiles that behave like squares, as demonstrated in figure 10.5.

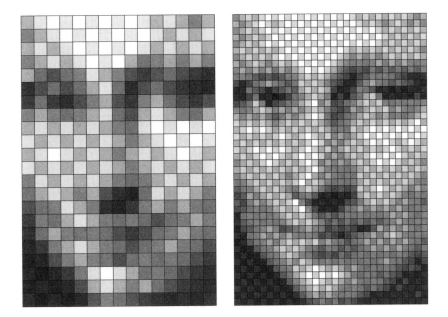

Figure 10.4: Two map-colored mosaics based on Leonardo da Vinci's *Mona Lisa*.

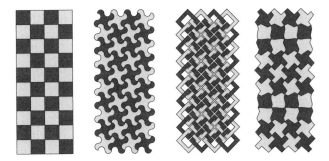

Figure 10.5: The tiling and three modifications.

Figure 10.6 displays four versions—with squares, fans, square rings, and a parquet deformation in which the tile shapes gradually change, depending on the row that the tiles are in—of our 10-color map-colored mosaic of Frankenstein's monster.

Figures 10.7 and 10.8 demonstrate that the same method can be modified to produce hexagonal map-colored mosaics. Here too, each hex-grid map-colored mosaic uses 10 colors (shades of gray), but here we dropped our requirement that each color appear the same number of times.

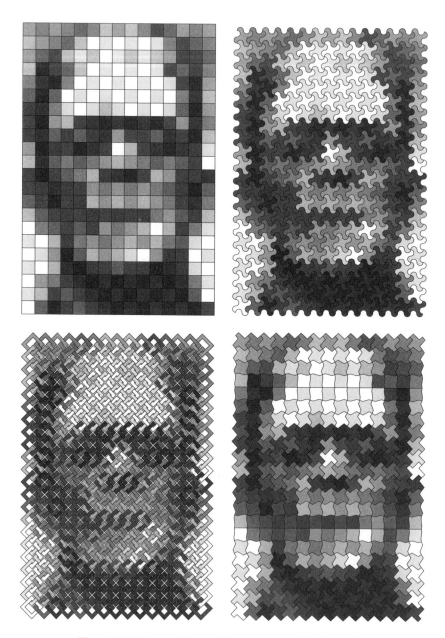

Figure 10.6: Four renditions of the same map-colored mosaic.

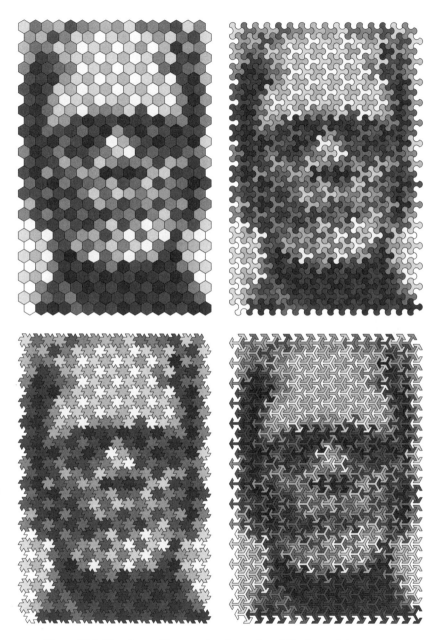

Figure 10.7: Four hex-grid map-colored mosaics of Frankenstein's monster.

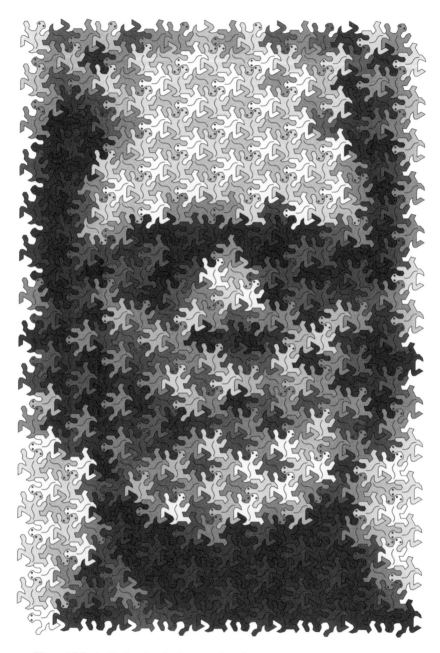

Figure 10.8: An Escher-inspired map-colored mosaic of Frankenstein's monster.

In the mosaic shown in figure 10.8, the tiles are lizards (not the lizards of M. C. Escher, but rather the result of a late night PostScript drawing session that was inspired by the work of the great tessellator).

And to conclude this section, we present evidence that it is possible to use not just shades of gray but also vibrant colors. The mosaic shown in figure 10.9 is another parquet deformation in which the tiling gradually changes from the top to the bottom. It is based on a section of Johannes Vermeer's *Girl with a Pearl Earring*, and it uses 25 different colors selected from a photograph of the painting.

Pattern Matching

Now we return to pattern-matching constraints, but this time for mosaicking. Figure 10.10 displays a collection of *shaded Smith tiles*. They are named after Cyril Stanley Smith, who suggested that they would be an interesting alternative to Truchet tiles. Smith's tiles are square, unshaded, and come in two forms. Each form is decorated with two circular arcs that join midpoints of consecutive sides of the square. In one form, the arcs join the top side to the left side and the bottom side to the right. In the other, they join the top to the right and the bottom to the left.

Smith's arcs divide his square tiles into three sections. When we colored them we allowed ourselves three colors—black, gray, and white—and we forced ourselves to give neighboring sections different colors. We ended up with 24 tiles and 6 distinct edge patterns. If we read the horizontal edge patterns (h_1 through h_6) from left to right and the vertical edge patterns (v_1 through v_6) from top to bottom, we can refer to the first edge pattern (horizontal or vertical) as the black–gray pattern, the second as the black–white pattern, and so on.

For each tile t, we let b_t stand for the brightness of the tile on our usual 0-to-1, black-to-white scale, and we compute these tile brightness values via the equation

$$b_t = 0 \cdot \text{AREA(black)} + 0.5 \cdot \text{AREA(gray)} + 1 \cdot \text{AREA(white)},$$

which follows the same principle we used for the flexible Truchet tiles back in chapter 2.

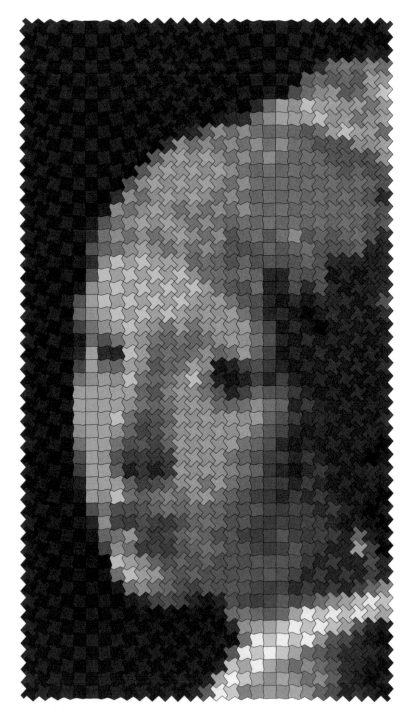

Figure 10.9: A map-colored mosaic based on Vermeer's *Girl with a Pearl Earring*.

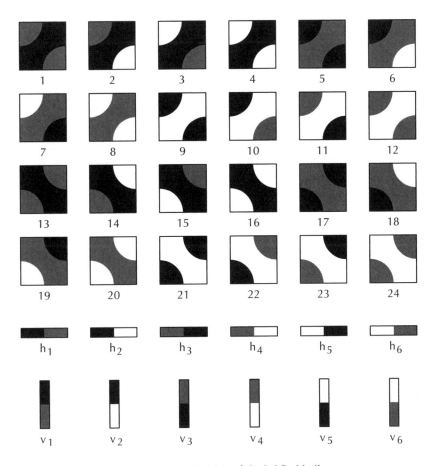

Figure 10.10: A collection of shaded Smith tiles.

Here we follow the example of cartoon and map-colored mosaics. We set $x_{t,i,j}$ equal to 1 if we place a copy of tile t in cell (i, j), and we set $x_{t,i,j}$ equal to 0 if we don't do this. If we go ahead and set $x_{t,i,j}$ equal to 1, then we must charge ourselves a cost for making this tile placement, and the correct value is the squared error $(b_t - \beta_{i,j})^2$, as cell (i, j) itself has a brightness value of $\beta_{i,j}$. The total cost is the sum of all of the individual costs.

For each tile t, we let TOP(t), RIGHT(t), BOTTOM(t), and LEFT(t) denote the edge pattern of, respectively, the top, right, bottom, and left edges of tile t. For tile 6, for example, we have TOP(6) = 1 (black–gray), RIGHT(6) = 4 (gray–white), BOTTOM(6) = 4 (gray–white), and LEFT(6) = 1 (black–gray).

To force pattern matching along the vertical edge shared by the left–right neighbors (i, j) and $(i, j + 1)$, we can impose an equation for each vertical edge pattern p:

$$\sum_t \left(x_{t,i,j} : \text{RIGHT}(t) = p \right) = \sum_t \left(x_{t,i,j+1} : \text{LEFT}(t) = p \right).$$

When $p = 1$ (in other words, when the shared vertical edge has the black–gray edge pattern), the horizontal pattern-matching equation can be rewritten in expanded form as

$$x_{1,i,j} + x_{3,i,j} + x_{17,i,j} + x_{19,i,j} = x_{5,i,j+1} + x_{6,i,j+1}$$
$$+ x_{13,i,j+1} + x_{14,i,j+1}.$$

Tiles 1, 3, 17, and 19 are the only tiles t with $\text{RIGHT}(t) = 1$, and tiles 5, 6, 13, and 14 are the only tiles t with $\text{LEFT}(t) = 1$. If the left-hand side of the equation evaluates to 1, then we can be certain that the tile placed in cell (i, j) is one of the four that has the black–gray pattern on its right edge. In this case, the equation requires that the tile placed in cell $(i, j + 1)$ has the black–gray pattern on its left edge. If the left-hand side evaluates to 0, however, then we know that the tile placed in cell (i, j) does *not* have the black–gray pattern on its right edge, and the equation ensures that the tile placed in cell $(i, j + 1)$ does *not* have the black–gray pattern on its left edge.

To handle the other type of pattern matching, along horizontal edges shared by top–bottom neighbors (i, j) and $(i + 1, j)$, we can impose an equation for each horizontal edge pattern p:

$$\sum_t \left(x_{t,i,j} : \text{BOTTOM}(t) = p \right) = \sum_t \left(x_{t,i+1,j} : \text{TOP}(t) = p \right).$$

To design the mosaics displayed in figure 10.11, we used Gurobi to solve the following optimization model:

minimize *total cost*

subject to *the block equations,*

 the pattern-matching constraints,

 a binary restriction on each variable $x_{t,i,j}$.

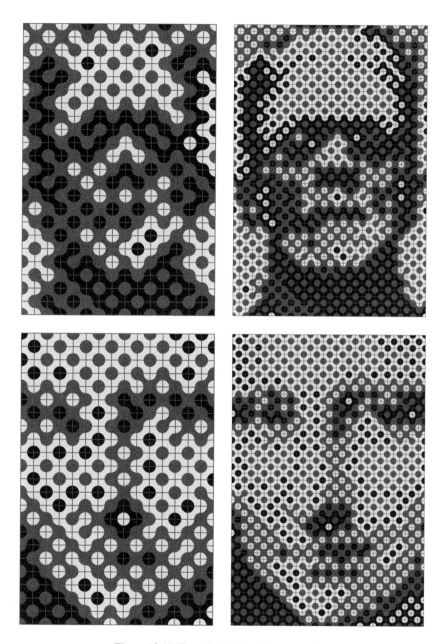

Figure 10.11: Four shaded-Smith-tile mosaics.

In each case, Gurobi needed only a fraction of a second (and no branching) to obtain an optimal solution.

Figure 10.12 displays a much larger collection of shaded Smith tiles. Here we used seven colors—black, white, and five shades of gray. Using the same coloring scheme as before, we ended up with 504 tiles. For the sake of variety (and to produce a more attractive border), we rotated each tile 45° and imposed a diamond-shaped grid on the target images.

Figure 10.13 displays four shaded-Smith-tile mosaics constructed with this larger collection of tiles. With many more tiles, the optimization models are much larger. For the high-resolution mosaics, the models have over 500,000 $x_{t,i,j}$ variables and more than 100,000 constraints! Still, for the high-resolution Frankenstein mosaic, Gurobi found an optimal solution in just under 6 minutes, and its branch-and-bound tree had only 13 nodes. For the high-resolution Mona Lisa mosaic, Gurobi needed less than 3 minutes with no branching at all!

As with the map-colored mosaics, numerous variations are possible. The mosaics displayed in figure 10.14 are made from the 9 *extended Smith tiles* drawn at the top of the figure. Each tile shows one way of joining together two or four midpoints of the sides of a square. The tiles are arranged from darkest to brightest, and the second and third are the original Smith tiles.

For the high-resolution Frankenstein mosaic, Gurobi obtained an optimal solution in less than 1 second, and its branch-and-bound tree had 55 nodes. For the high-resolution Mona Lisa mosaic, Gurobi needed almost 3 seconds, and its branch-and-bound tree had 1929 nodes.

The mosaics in figure 10.15 are made out of 16 *knot tiles*, related to Smith tiles, but instead of having black arcs and line segments on a white background, they have black or white arcs or line segments on a gray background, with notch-like markings to accentuate the interlacing of the knot segments.

For the high-resolution Frankenstein mosaic, Gurobi needed approximately 10 minutes, and its branch-and-bound tree had over 580,000 nodes! But for the high-resolution Mona Lisa mosaic, it needed only 4 seconds and 3786 nodes.

The mosaics in figure 10.16 are composed of a larger set of knot tiles in which the knot segments are allowed to be not only black or white but also light gray or dark gray. With more tiles and more edge patterns,

Figure 10.12: A collection of 504 shaded Smith tiles, each rotated $45°$.

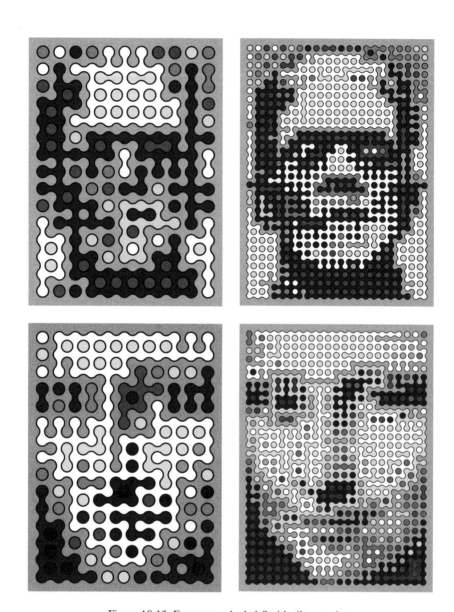

Figure 10.13: Four more shaded-Smith-tile mosaics.

Figure 10.14: Four extended-Smith-tile mosaics.

Figure 10.15: Four knot-tile mosaics.

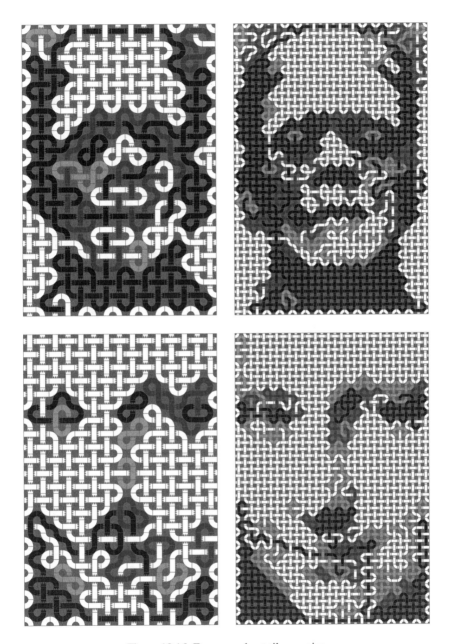

Figure 10.16: Four more knot-tile mosaics.

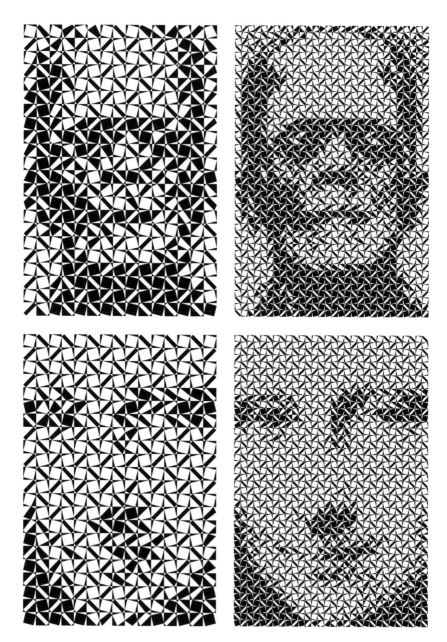

Figure 10.17: Four checkerboard quadrilateral mosaics.

the resulting optimization model has considerably more variables and constraints. For the high-resolution Mona Lisa mosaic, Gurobi needed slightly more than 7 hours, and its branch-and-bound tree had over 80,000 nodes. For the high-resolution Frankenstein mosaic, I terminated Gurobi's search after 10 hours. At this time, the branch-and-bound tree had over 120,000 nodes. Fortunately, the search had yielded a high-quality mosaic whose total error is within 0.5% of optimal, using a bound obtained from solving the continuous relaxations.

The mosaics displayed in figure 10.17 are composed of the checkerboard quadrilateral tiles that we discussed at the end of chapter 2. To be able to apply discrete linear optimization with pattern matching, I needed to severely limit the number of possible positions for the 4 vertices of a tile's quadrilateral. On each edge, I forced the slider to be in one of 4 positions. I obtained these positions by dividing each edge into 5 equal segments. The 4 positions are the fence posts that separate the 5 segments. With 4 positions per edge, we have 4 possible pattern values per edge. Given that there are 4 edges per tile, we end up with $4^4 = 256$ tiles.

For the high-resolution Mona Lisa mosaic, Gurobi needed less than 1 minute of computer time, and its branch-and-bound tree had 143 nodes. For the high-resolution Frankenstein mosaic, Gurobi needed about an hour and a half, and its branch-and-bound tree had 1100 nodes.

CHAPTER 11
Game-of-Life Mosaics

In 1970 John Horton Conway invented the Game of Life, a two-dimensional *cellular automaton* played on a grid of squares. At each time t, each square cell is either alive (and marked with a circle) or dead (kept empty). After constructing an initial pattern, the player repeatedly applies Conway's rules: If at time t cell (i, j) is dead and exactly 3 of its 8 neighbors are alive, then at time $t+1$ cell (i, j) will become alive (a birth will take place). If at time t cell (i, j) is alive and has either 2 or 3 living neighbors, then at time $t+1$ cell (i, j) will remain alive (it will survive). Otherwise at time $t+1$ cell (i, j) will be dead. Accordingly, the rules for the Game of Life can be denoted B3/S23, as they mandate *b*irth with 3 living neighbors, *s*urvival with 2 or 3, and death in all other cases.

Figure 11.1 displays four notable Game-of-Life patterns. In the top left we see what is known as the *pond*. The pond is a *still life*, a Game-of-Life pattern that remains unchanged after each application of Conway's rules. The pond has 8 living cells. Its density, $8/4^2 = 0.5$, is the largest possible for a stable pattern that fits inside a 4×4 region. In the top center we see the two phases of the period-2 oscillator known as the *blinker*, and in the top right we see the two phases of a *phoenix* (or *flip-flop*), a type of period-2 oscillator that alternates between two mutually exclusive sets of living cells. Cells marked with solid circles are alive at even times and dead at odd times, while cells marked with hollow circles are alive at odd times and dead at even times. On the bottom we see the four phases of the *glider*, a period-4 *spaceship* that (in this orientation) "moves" one row up and one column to the left every 4 time units. The pond and blinker were discovered by members of Conway's group at Cambridge in 1970. The glider was discovered by Richard Guy in 1970. The phoenix pattern (which is known as *Phoenix* 1) was discovered by members of Bill Gosper's research group at MIT in 1971.

Figure 11.1: The pond (top left), blinker (top center), phoenix (top right), and glider (bottom).

Still-Life Tiles

Early on it was observed that pond still lifes can be joined together to form larger still lifes. Three examples are shown in figure 11.2. The leftmost still life is 12 cells wide at its widest point and has 32 living cells. The center still life is 18 cells wide and has 72 living cells. The rightmost still life is 24 cells wide and has 128 living cells. Each of these still lifes can serve as a tile. By this we mean that if we place copies of the same tile next to one another, edge to edge, then each living cell will continue to have either 2 or 3 living neighbors, and no dead cell will have exactly 3. So the composite pattern formed by the tiles will also be a still life. (Incidentally, if we join together infinitely many copies of any one of these tiles, we obtain an infinite still life known as a *marshland agar*.)

We refer to the shaded cells in figure 11.2 as *border cells* and the unshaded cells as *interior cells*. If we kill off all the living interior cells, keeping all the border cells as they are, then we obtain new still lifes that have fewer living cells. These new still lifes, shown in figure 11.3, appear brighter to the eye. Because they have the same border pattern as the original still lifes, they can serve as tiles in the same way that the originals can. If we add them to our collection of tiles, we will have two levels of brightness to work with, and we will be able to use the tiles to approximate duotone (e.g., black and white) target images.

Figure 11.2: Still-life tiles (of widths 12, 18, and 24) formed by joining together pond still lifes.

Figure 11.3: Bright still-life tiles (of widths 12, 18, and 24).

If we restrict ourselves to tiles of width 12 that have the indicated border pattern, then we will be stuck with just two brightness levels. In other words, with the indicated border pattern, there are only two ways to "complete the interior" and obtain a still life: by placing a pond in the interior (as shown in the leftmost part of figure 11.2) or by making every cell in the interior dead (as shown in the leftmost part of figure 11.3).

If we allow ourselves tiles of width 18 that have the indicated border pattern, then it turns out that there are 1061 different ways (including rotations and reflections) to complete the interior. The number of living cells ranges from 40 to 72, with the following exceptions: 41, 42, 43, and 59. This gives a total of 29 brightness levels. In the next section we present a detailed description of the method we use to design the tiles and perform these computations.

If we use tiles of width 24, there are undoubtedly many thousands (and quite possibly many millions) of solutions, and there could be as many as 74 brightness levels. It turns out that there are no solutions with more than 132 living cells and no solutions with fewer than 56. Moreover, there are no solutions that have precisely 57, 58, or 59 living cells. This implies that there are *at most* $132 - 55 - 3 = 74$ brightness levels; there may be one or more gaps.

For the mosaicking work that follows, which was part of a collaboration with my former student Julia Olivieri, we decided to restrict ourselves to the tiles of width 24 that are *maximally symmetric*. These tiles, shown in figure 11.4, have 90° rotational symmetry as well as horizontal, vertical, and diagonal mirror symmetries.

We decided to force symmetry for several reasons. First, we consider symmetric tiles to be much more beautiful than asymmetric tiles. Second, we believe that viewers find them easier to process visually. Third, we consider symmetric tiles to be easier to work with. In particular, with symmetric tiles the selection of the best possible tile for a particular part of a mosaic requires only one piece of information: how bright the corresponding part of the target image is. For asymmetric tiles, other information is needed. Finally, with symmetry constraints we are able to find all solutions to the tile-design problem (the problem of "completing the interior") much more quickly than without them.

We chose the width to be 24 because it is large enough to give us an adequate number of brightness levels (19) in the maximally symmetric tiles, but small enough that we are able to display our mosaics without loss of detail (which cells are alive and which ones are dead). With a width of 18, there are only 7 maximally symmetric tiles and 5 different brightness levels.

Note that in figure 11.4 the tiles are arranged by number of living cells. The two tiles in the top row have 132 living cells, the six in the second row have 128 living cells, and the six in the third row have 124 living cells. As we move down from one row to the row below it, the number of living cells drops by 4. The tile in the bottom row has 56 living cells. There is one empty row, as there are no still lifes with the desired symmetries that have precisely 68 living cells. As there are 19 nonempty rows, each with a different number of living cells, this set of tiles gives us 19 levels of brightness.

Figure 11.4: All 85 maximally symmetric width-24 still-life tiles.

Figure 11.5 shows how we convert target images into still-life mosaics. We begin by placing a grid of diamonds on top of the target image. We then compute the brightness value of each diamond on a 1-to-20 scale, where 1 stands for white, 20 stands for black, and the intermediate integers stand for different shades of gray. We use this scale simply because there are 20 rows of still-life tiles in figure 11.4. The brightness value of the diamond tells us which row of figure 11.4 to use. Once we have the row, we pick a tile from that row at random. If the row happens to be the empty row, we flip a fair coin and move either up or down one row.

Figure 11.5: Converting a target image (left) into a still-life mosaic (right).

The small figure 11.5 still-life mosaic is based on a photograph of an apple. The larger figure 11.6 mosaic—based on Magritte's *Ceci n'est pas une pomme*—is titled *Still Life with Glider* and shows a Game-of-Life still life (which resembles a still life of an apple) that is about to be demolished by a glider (found in the bottom-right corner).

Constructing Still-Life Tiles

In a still life, there are three possibilities for cell (i, j): it could be dead and have fewer than 3 living neighbors (we call this *low dead*), it could be dead and have more than 3 living neighbors (we call this *high dead*), or it could be alive and have either 2 or 3 living neighbors. Accordingly, for each cell (i, j) we introduce three binary variables $L_{i,j}$, $H_{i,j}$, and $A_{i,j}$. In addition, we introduce notation similar to that used by some TSP researchers: if S is a set of cells, we define $A(S)$ to be the sum of all variables $A_{i,j}$ for which cell $(i, j) \in S$. Furthermore, we define $N_{i,j}$ to be the set of all cells that are neighbors of cell (i, j). As a result, we have

$$
\begin{aligned}
A(N_{i,j}) = \ & A_{i-1,j-1} + A_{i-1,j} + A_{i-1,j+1} \\
& + A_{i,j-1} \qquad\qquad\;\; + A_{i,j+1} \\
& + A_{i+1,j-1} + A_{i+1,j} + A_{i+1,j+1},
\end{aligned}
$$

Figure 11.6: *Still Life with Glider.*

which makes it clear that $A(N_{i,j})$ is a linear expression that counts how many living neighbors cell (i, j) has.

To ensure that setting $L_{i,j} = 1$ forces cell (i, j) to be low dead, we impose what we call a *low-dead constraint*,

$$4L_{i,j} + A(N_{i,j}) \le 6.$$

Note that when $L_{i,j} = 1$, the low-dead inequality implies that cell (i, j) has at most 2 living neighbors, and when $L_{i,j} = 0$, it implies that cell

(i, j) has at most 6 living neighbors, the maximum possible for a still life.

Similarly, to ensure that setting $H_{i,j} = 1$ forces cell (i, j) to be high dead, we impose what we call a *high-dead constraint*,

$$4H_{i,j} \leq A(N_{i,j}).$$

Note that when $H_{i,j} = 1$, the high-dead inequality implies that cell (i, j) has at least 4 living neighbors, and when $H_{i,j} = 0$, it states the obvious, that cell (i, j) has a nonnegative number of living neighbors.

Next, because we do not distinguish between the living cells that have 2 living neighbors and the living cells that have 3 living neighbors, to ensure that setting $A_{i,j} = 1$ forces cell (i, j) to be alive, we impose a pair of what we call *stayin'-alive constraints*,

$$2A_{i,j} \leq A(N_{i,j}),$$
$$3A_{i,j} + A(N_{i,j}) \leq 6.$$

When $A_{i,j} = 1$, the stayin'-alive constraints reduce to $2 \leq A(N_{i,j}) \leq 3$, and when $A_{i,j} = 0$ they reduce to $0 \leq A(N_{i,j}) \leq 6$. In other words, when $A_{i,j} = 1$ we can conclude that cell (i, j) has either 2 or 3 living neighbors, while when $A_{i,j} = 0$, all we can conclude is the obvious, that cell (i, j) has at least zero and no more than 6 living neighbors.

And finally, to ensure that cell (i, j) is low dead, high dead, or alive, we impose what we call the *precisely-one-of-these-must-happen constraint*,

$$L_{i,j} + H_{i,j} + A_{i,j} = 1.$$

Consequently, the problem of finding the maximum density still life (the one with the greatest number of living cells) contained within a specified region R can now be written as a discrete linear optimization problem:

maximize $A(R)$, *the total number of living cells in R*

subject to *the low-dead constraints,*

 the high-dead constraints,

 the stayin' alive constraints,

the precisely-one-of-these-must-happen constraints,

$$L_{i,j}, H_{i,j}, A_{i,j} \in \{0, 1\} \text{ for all } (i, j) \text{ in } R.$$

Of course, if we want to construct a symmetric still life, we can include constraints that will guarantee the desired type (or types) of symmetry. If the symmetry maps cell (i, j) to cell (i', j'), then we set $L_{i,j} = L_{i',j'}$, $H_{i,j} = H_{i',j'}$, and $A_{i,j} = A_{i',j'}$. Similarly, if we want to construct a still life that has a particular border pattern, we can include constraints that force certain cells to be alive, others to be low dead, and yet others to be high dead.

For the width-24 still-life tiles displayed in figure 11.4, the region R is diamond shaped and contains 312 cells, which lead to our model having 936 binary variables and 1560 linear constraints. When we included our symmetry constraints and border constraints, Gurobi's powerful preprocessing routines were able to reduce the model to a considerably smaller one, having 273 binary variables and 505 linear constraints. Gurobi was able to obtain an optimal solution (the top-left tile in figure 11.4) to this smaller equivalent model without performing any branching. It required 484 iterations of the simplex algorithm and only a fraction of a second of computer time. (Incidentally, without the symmetry constraints, Gurobi required approximately 5.8 million iterations of the simplex algorithm and just under 15 minutes of computer time to explore the branch-and-bound tree, which had over a quarter million nodes!)

To obtain additional still-life tiles, we constructed linear constraints to rule out previously obtained solutions. Let P denote the set of cells that are alive in one particular previously obtained solution, let \overline{P} denote the complement of the set P (the set of cells in R that are not in P), and let $|P|$ denote the size of the set P (the total number of cells in P). Then the previously obtained solution violates the linear inequality

$$A(P) \le |P| - 1 + A(\overline{P}),$$

but all other still lifes satisfy it. If we impose this inequality when we solve the model a second time, we can find a new still life (if one exists). By repeating this process over and over again, we were able to find all 85 tiles that satisfy our symmetry and modularity constraints. The entire search took less than 1 minute on my laptop.

Phoenix-Tile Mosaics

Many other Game-of-Life mosaicking systems can be designed by solving discrete linear optimization models. Figure 11.7 displays a mosaic of Buddha made out of phoenix tiles. In this mosaic, the background is black, and each solid white circle denotes a cell that is alive at all even times and is dead at all odd times.

Figure 11.7: *Phoenix Mosaic of Buddha.*

Here, all the living cells immediately die out, but some of the dead cells—those with 3 living neighbors—become alive. They immediately die out, but then we see reincarnation: the cells that had been alive become alive once again!

Two-Frame Animations

Figure 11.8 displays the frames of a period-2 Game-of-Life oscillator/animation based on motion-studies photographs taken by Eadweard Muybridge.

Figure 11.8: The two phases/frames of *Running Cat (After Muybridge)*, a period-2 Game-of-Life oscillator/animation.

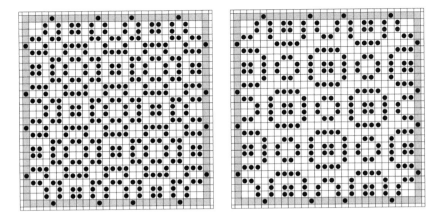

Figure 11.9: The high and low phases of the HL/LH tile, a 28 × 28 period-2 oscillator. The high phase (left) has 352 living cells and the low phase (right) has 288.

The figure 11.8 mosaic is composed of 14 rows and 28 columns of square tiles. There are four types of tiles—each designed by solving a discrete linear optimization problem—and each one fits in a 28 × 28 square. The *HL/LH tile* shown in figure 11.9 is a period-2 oscillator that has 352 living cells in its "high" phase and 288 living cells in its "low" phase. Due to its having 22.2% more living cells in its high phase than in its low phase, this oscillator appears noticeably brighter in one of its phases than the other. The border pattern (which is shaded light gray) and the "moat" of half cells that surrounds these tiles allow us to place any two copies of either form of this tile side by side and be sure that the resulting pattern is also a period-2 oscillator.

To find the HL/LH tile, I searched for period-2 oscillators with *maximum contrast*, the largest possible difference between the number of living cells in phase 1 and the number of living cells in phase 2. My model has two binary variables per cell: $x_{i,j}$ is either 0 or 1 depending on whether cell (i, j) is dead or alive during the first phase, and $y_{i,j}$ is either 0 or 1 depending on whether cell (i, j) is dead or alive during the second phase. In terms of these variables, the contrast is $\sum_i \sum_j (x_{i,j} - y_{i,j})$. I maximized this linear function subject to linear constraints that enforce Conway's rules. After considerable experimentation with the model, I discovered a pattern that I was then able to extend into the HL/LH tile.

I then searched for *LL tiles*: 28 × 28 period-2 oscillators that have precisely 288 living cells in each phase, have the same symmetry as the

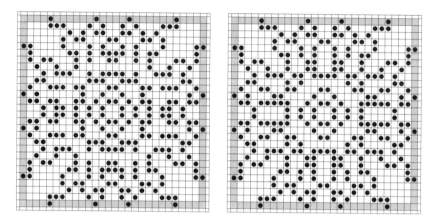

Figure 11.10: The two phases of one of the LL tiles. Both phases of this 28×28 period-2 oscillator have 288 living cells.

HL/LH tile (to reduce the size of the search space), and have the same border pattern as the HL/LH tile. One is shown in figure 11.10. Here my goal was to maximize the *heat* of the pattern, the number of cells that change state, so here I used a formulation that has more binary variables per cell. In addition to the $x_{i,j}$ and $y_{i,j}$ variables, there are $AL_{i,j}$, $AO_{i,j}$, $LA_{i,j}$, $OA_{i,j}$ variables (and others as well). The $AL_{i,j}$ variable is 1 if cell (i, j) is alive in the first phase but dies from loneliness (from having too few living neighbors). The $OA_{i,j}$ variable is 1 if cell (i, j) is alive in the second phase but dies from overcrowding (from having too many living neighbors). Here I maximized the linear function

$$\sum_i \sum_j \left(AL_{i,j} + AO_{i,j} + LA_{i,j} + OA_{i,j} \right)$$

subject to linear constraints that enforce Conway's rules.

By including constraints that prohibit previously discovered solutions, I was able to find additional LL tiles, and by repeating this process over and over again, I ended up with a large collection of them. The search took a considerable amount of computer time (many days' worth), and I aborted it when I decided that I had accumulated enough tiles. The discrete linear optimization problems were not easy for Gurobi to solve, as their continuous relaxations do not provide good upper bounds on the maximum heat.

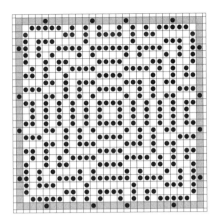

Figure 11.11: One of the HH tiles. This 28×28 still life has 352 living cells.

Table 11.1: The two-frame-animation tile-selection scheme

Image I_1	Image I_2	Tile for block (i, j)
$\beta_{i,j}^1 < 0.5$	$\beta_{i,j}^2 < 0.5$	HH
$\beta_{i,j}^1 < 0.5$	$\beta_{i,j}^2 \geq 0.5$	HL form of HL/LH
$\beta_{i,j}^1 \geq 0.5$	$\beta_{i,j}^2 < 0.5$	LH form of HL/LH
$\beta_{i,j}^1 \geq 0.5$	$\beta_{i,j}^2 \geq 0.5$	LL

Finally, I used a discrete linear optimization problem to search for HH (high–high) tiles: 28×28 period-2 oscillators that have precisely 352 living cells in each phase, have the same symmetry as the HL/LH tile (again to reduce the size of the search space), and have the same border pattern as the HL/LH tile. As with the LL tiles, I maximized heat. Here I was disappointed to discover that for HH tiles, the maximum heat is zero. This means that all of my HH tiles are actually still lifes—they are not true period-2 oscillators. One is shown in figure 11.11.

To create a two-frame Game-of-Life animation like the running cat displayed in figure 11.8, we take two grayscale images I_1 and I_2 of identical size and partition each one into m rows and n columns of square ($k \times k$) blocks of pixels. If necessary, we crop the images. For each $k \times k$ block of pixels in image I_1, we compute the average brightness value $\beta_{i,j}^1$

Figure 11.12: A final low-resolution two-frame Game-of-Life animation.

of the pixels in the block, using our usual 0-to-1 black-to-white scale. We do the same for image I_2 to obtain its brightness values (denoted $\beta^2_{i,j}$).

To design a period-2 oscillator that resembles I_1 in phase 1 and I_2 in phase 2, we need rules for determining which tile—the HL form of the HL/LH tile, the LH form of the HL/LH tile, the LL tile, or the HH tile—should be selected to represent block (i, j). If we draw living cells in black ink on a white background, then we can use table 11.1 to select the best tile for block (i, j).

Because the tiles are modular period-2 oscillators, any Game-of-Life pattern formed from them will be a period-2 oscillator. A final low-resolution example is shown in figure 11.12. The frame on the left reads, ever so faintly (and aptly), "Fin", while the frame on the right suggests nothing more than a blank screen.

Beauty and Utility

Some say that mathematics is beautiful. And it is, most definitely. Some say that mathematics is useful. And it is, without a doubt. And some even go as far as to *define* a pure mathematician to be a mathematician who is drawn to the beauty of mathematics and an applied mathematician to be one who is motivated by its utility. But here, I cannot agree.

I am much more of an applied mathematician than a pure one. (My PhD is in operations research, an interdisciplinary field that lies within a Venn-diagram intersection of mathematics, computer science, and economics.) But if I've had any success here at putting my thoughts down on paper, it should have come across that I love both the beauty of my chosen branch of mathematics, linear optimization, and also, in equal measure, its awesome applicability. Yes, I am obsessed with using it to make visual artwork—flextile mosaics, cartoon mosaics, domino mosaics, TSP-derived continuous line drawings, knight's tours, labyrinths, map-colored mosaics, and Game-of-Life mosaics—but I also find the subject of linear optimization itself to be beautiful.

I even find some of its seemingly less glamorous applications to be beautiful. Consider one last time the LEGO problem, a literal "toy version" of a real-world problem, the product mix problem. The fact that we can take such a problem, express its most important features in mathematical notation, interpret the mathematical model both geometrically (convex polyhedra!) and algebraically (systems of linear equations and inequalities!), and design algorithms that we can use to solve the problem—algorithms that exploit both the geometry and the algebra—what's not to love about that?

And what about the TSP, the problem of finding the shortest tour through a collection of locations, a problem so easy to describe yet so hard to solve, a problem that is inherently discrete yet can be successfully tackled using purely continuous methods? To me and many others in my

field, the TSP itself is beautiful! And the ideas that have been developed in attempts to solve it—cutting planes and branch and bound, for example—are not only beautiful but have proven to be of enormous value for many other discrete linear optimization problems (and non-linear ones as well). Applied mathematics is not only useful, but it is often beautiful as well.

This book has been a tour of linear optimization, some of its traditional (or "classical") applications, and also my ongoing efforts to adapt these applications to design visual artwork. For me, the tour will not end. Thank you for joining me on this part of my journey.

BIBLIOGRAPHY

[1] E. R. Berlekamp and T. Rodgers, eds. *The Mathemagician and Pied Puzzler*. A. K. Peters, 1999.

[2] D. Bertsimas and J. N. Tsitsiklis, *Introduction to Linear Optimization*. Athena Scientific, 1997.

[3] R. Bosch, "Domino Artwork: The Mathematical Art of Robert Bosch," http://www.dominoartwork.com.

[4] R. Bosch, "Constructing domino portraits," in *Tribute to a Mathemagician*, B. Cipra, E. D. Demaine, M. L. Demaine, and T. Rodgers, eds. A. K. Peters, 2004, pp. 251–256.

[5] R. Bosch, "Opt Art," *Math Horizons* 13, no. 3 (2006), pp. 6–9.

[6] R. Bosch, "Edge-Constrained Tile Mosaics," in *Proceedings of Bridges Donostia: Mathematics, Music, Art, Architecture, Culture*, 2007, pp. 351–360.

[7] R. Bosch, "Connecting the Dots: The Ins and Outs of TSP Art," in *Bridges Leeuwarden: Mathematics, Music, Art, Architecture, Culture*, 2008, pp. 235–242.

[8] R. Bosch, "Simple-Closed-Curve Sculptures of Knots and Links," *Journal of Mathematics and the Arts* 4, no. 2 (2010), pp. 57–71.

[9] R. Bosch, "3D Printed Tours," in *Proceedings of Bridges 2017: Mathematics, Art, Music, Architecture, Education, Culture*, 2017, pp. 335–338.

[10] R. Bosch and U. Colley, "Figurative Mosaics from Flexible Truchet Tiles," *Journal of Mathematics and the Arts* 7, no. 3-4 (2013), pp. 122–135.

[11] R. Bosch, S. Fries, M. Puligandla, and K. Ressler, "From Path-Segment Tiles to Loops and Labyrinths," in *Proceedings of Bridges 2013: Mathematics, Music, Art, Architecture, Culture*, 2013, pp. 119–126.

[12] R. Bosch and A. Herman, "Continuous Line Drawings via the Traveling Salesman Problem," *Operations Research Letters* 32, no. 4 (2004), pp. 302–303.

[13] R. Bosch and J. Olivieri, "Designing Game of Life Mosaics with Integer Programming," *Journal of Mathematics and the Arts* 8, no. 3-4 (2014), pp. 120–132.

[14] R. Bosch and A. Pike, "Map-Colored Mosaics," in *Proceedings of Bridges 2009: Mathematics, Music, Art, Architecture, Culture*, 2009, pp. 139–146.

[15] V. Chvátal, *Linear Programming*, W. H. Freeman, 1983.

[16] "Concorde TSP Solver," http://www.math.uwaterloo.ca/tsp/concorde.html.

[17] W. J. Cook, *In Pursuit of the Traveling Salesman: Mathematics at the Limits of Computation*, Princeton University Press, 2012.

[18] W. J. Cook, "Mona Lisa TSP Challenge," http://www.math.uwaterloo.ca/tsp/data /ml/monalisa.html.

[19] "Michael Curry Mosaics," http://www.michaelcurrymosaics.com.

[20] D. Doüat, *Methode pour Faire une Infinité de Desseins Différens, avec des Carreaux mi-partis de deux Couleurs par une Ligne Diagonale: ou Observations du Père Dominique Doüat, Religieux Carme de la Province de Toulouse, Sur un Memoire inseré dans l'Histoire de l'Académie Royale des Sciences de Paris l'Anneé 1704, Présenté par le Reverend Père Sébastien Truchet, Religieux du même Ordre, Academicien Honoraire*, Paris, 1722.

[21] "Gurobi Optimizer," http://www.gurobi.com/products/gurobi-optimizer.

[22] C. Jordan, *Running the Numbers: An American Self-Portrait*, Prestel Publishing, 2009.

[23] C. S. Kaplan and R. Bosch, "TSP Art," in *Renaissance Banff: Mathematics, Music, Art, Culture*, 2005, pp. 301–308.

[24] "Ken Knowlton: Mosaics," http://www.knowltonmosaics.com.

[25] D. E. Knuth, *The Stanford GraphBase: A Platform for Combinatorial Computing*, Addison-Wesley, 1993.

[26] J. MacQueen, "Some Methods for Classification and Analysis of Multivariate Observations," in *Proceedings of Fifth Berkeley Symposium on Mathematical Statistics and Probability (Volume I: Theory of Statistics)*, 1967, pp. 281–297.

[27] B. D. McKay, "Knight's Tours of an 8×8 Chessboard," Technical Report TR-CS-97-03 (Department of Computer Science, Australian National University), 1997.

[28] N. Pendegraft, "Lego of my Simplex," *ORMS Today* 24, no. 1 (1997), p. 8.

[29] D. J. Rader, *Deterministic Operations Research: Models and Methods in Linear Optimization*, Wiley, 2010.

[30] J. Salavon, *Brainstem Still Life*, SoFA Gallery & Earl Lu Gallery, 2004.

[31] C. Smith and P. Boucher, "The Tiling Patterns of Sébastien Truchet and the Topology of Structural Hierarchy," *Leonardo* 20, no. 4 (1987), pp. 373–385.

[32] S. Truchet, *Mémoire sur les combinaison*, Mémoires de l'Académie Royale des Sciences (1704), pp. 363–372.

[33] R. J. Vanderbei, *Linear Programming: Foundations and Extensions*, Springer, 2014.

[34] H. P. Williams, *Model Building in Mathematical Programming*, Wiley, 2013.

INDEX

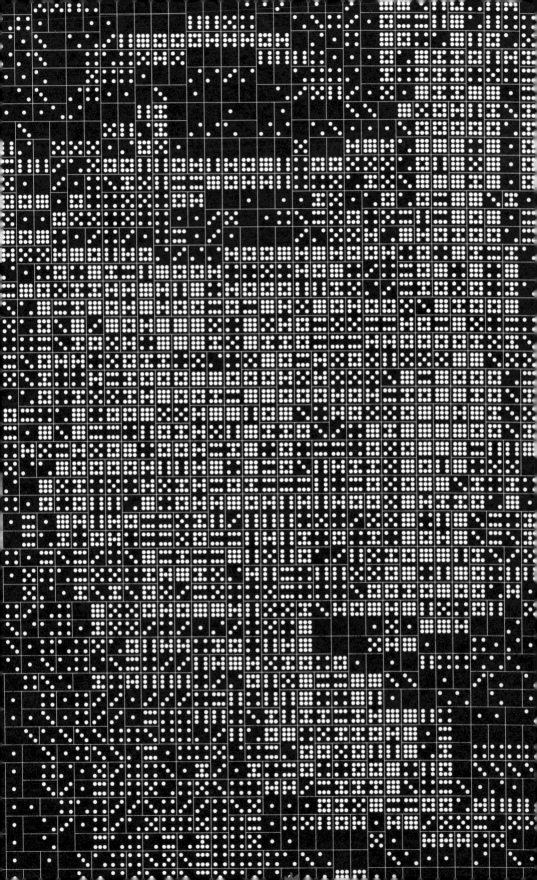